A PHILOSOPHICAL TESTAMENT

BOOKS BY MARJORIE GRENE

Dreadful Freedom: A Critique of Existentialism (University of Chicago Press, 1948; reissued as *Introduction to Existentialism,* 1959; Midway paperback, 1984)

Heidegger (Hillary House, 1957)

A Portrait of Aristotle (University of Chicago Press, 1963; reissued in Phoenix paperback, 1967; Midway paperback, 1979)

The Knower and the Known (Basic Books, 1966; University of California Press paperback, 1974; reprinted by University Press of America, 1983)

Approaches to a Philosophical Biology (Basic Books, 1969)

Sartre (Franklin Watts, 1973; nominated for National Book Award. Reprinted by University Press of America, 1983)

The Understanding of Nature: Essays in Philosophy of Biology (Reidel, 1974)

Philosophy In and Out of Europe (University of California Press, 1976)

Descartes (in the Philosophers in Context Series, edited by S. Körner, Harvester Press and University of Minnesota Press, 1985)

Descartes Among the Scholastics (Marquette University Press, 1991)

Interactions: The Biological Context of Social Systems (with Niles Eldredge, Columbia University Press, 1992)

A Philosophical Testament (Open Court, 1994)

Edited Books and Journal Issues

From Descartes to Kant (with T.V. Smith, University of Chicago Press, 1940; reissued as a two-volume paperback under the title *Descartes to Locke: Berkeley, Hume, Kant*)

The Anatomy of Knowledge (University of Massachusetts Press, 1969)

Knowing and Being, by Michael Polanyi (University of Chicago Press, 1969)

Interpretations of Life and Mind (Humanities Press, 1971)

Spinoza (Doubleday, 1973)

Topics in the Philosophy of Biology (with E. Mendelsohn, Reidel, 1975)

Dimensions of Darwinism: Themes and Counterthemes in 20th-Century Evolutionary Theory (Cambridge University Press, 1983)

Spinoza and the Sciences (with Debra Nails, Reidel, 1985)

Descartes and His Contemporaries (*The Monist 71,* 1988)

Philosophy of Biology in Historical and Cultural Contexts (with Richard Burian, *Synthese 91,* 1992)

A PHILOSOPHICAL TESTAMENT

MARJORIE GRENE

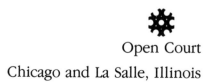

Open Court

Chicago and La Salle, Illinois

OPEN COURT and the above logo are registered in the U.S.
Patent and Trademark Office.

First printing 1995

Printed and bound in the United States of America.

Library of Congress Cataloging-in-Publication Data

Grene, Marjorie Glicksman, 1910–
 A philosophical testament / Marjorie Grene.
 p. cm.
 Includes index.
 ISBN 0-8126-9286-1 (cloth).—ISBN 0-8126-9287-X (pbk.)
 1. Philosophy. 2. Knowledge, Theory of. 3. Realism.
 4. Persons. 5. Grene, Marjorie Glicksman, 1910– . I. Title.
B945.G733P48 1995
100—dc20 94-44887
 CIP

For my family,
both Irish and American

CONTENTS

ACKNOWLEDGMENTS

This book owes a great deal to a great many people; here I can only acknowledge with gratitude the help of a number of them. Some years ago, Jonathan Hall read a lecture I was to give at Penn State and suggested that it contained the makings of a book. What follows here is the result of that suggestion. As I was writing, Doris Zallen, Dan Kolb and Nicholas Grene read each chapter in manuscript and offered extremely valuable criticisms, almost all of which I happily accepted. Obviously they are not responsible for any remaining follies, obscurities, or errors. My colleagues Moti Feingold and Peter Barker read some chapters and encouraged me to continue. John Christman read Chapter 9, which lies (self-referentially) especially heavily on my conscience. Chapter 1 was originally a lecture given at Monmouth College when I served as visiting philosopher there through the program of the Council for Philosophical Studies; it was then presented as Mellon Lecture at Tulane University, and I am grateful to their Graduate School for permission to reprint it here. Phi Beta Kappa, and in particular the Davis chapter, gave me the opportunity to present Chapters 2, 3 and 4 as Phi Beta Kappa Romanell lectures at U.C. Davis, and I wish to thank them, the Davis Philosophy Department, and my friend and hostess Ruth York, for their generosity and hospitality on that occasion. Chapter 5 was presented as a lecture for the Phi Beta Kappa chapter at Virginia Tech and Chapter 6 at seminars at Virginia Tech and Cal Tech. I have benefited from the discussions on all these occasions. The faculty and staff at Virginia Tech have offered me a kindly working environment, and I thank them all for their friendship and support. Carolyn Furrow, in particular, has been an angel at the computer in helping me get the manuscript into its final form.

Blacksburg, Virginia
February, 1995

INTRODUCTION

What is this book about? It's an *apologia pro philosophia sua*, I suppose. But why? Purely out of self-indulgence, perhaps, because it's fun to sit at one's computer and chatter on without responsibility to any allegedly scholarly commitments or teaching or publishing deadlines. I have already been accused by my critics in British philosophy of having a 'chatty style', and rather than making liars of my colleagues I may as well justify their complaint with bells on. I never claimed to be a scholar in any case; so I haven't that reason to write stuffily. And by now (or at least for now) I might as well give up all pretence and appear as what I am: a very aged, rather weary teacher of the history of philosophy. There are three things I remember very clearly about Davis, where I taught, with some spells off for good (or bad) behavior, for thirteen years—my longest term in any of the twenty institutions I've taught in—back in the long ago days when we had our offices up on the top floor of UCD's only quasi-skyscraper. One is the way, when the smog lifted, the Sierra suddenly appeared at the end of the corridor; another is the time Ernst Mayr (who was there as Storer Life Sciences Lecturer) came to see me in order to tell me that I knew nothing about biology (which, effectively, is true) and should stay away from tinkering with evolutionary questions (which I didn't). Now, I'm proud to proclaim, Mayr agrees that it was all right that I didn't; even relative ignoramuses can sometimes do useful conceptual analysis, as long as they respect and listen to some people who do know. And the third—which is what I was after here, still explaining who I am, professionally speaking, and why (if it's not a wholly 'irrational' enterprise; I have never understood what 'rationality' means, so perhaps don't understand its contrary either) I am writing this—the third is a conversation with Bert Dreyfus on the tie line from Davis to Berkeley. I said something about not being very confident about giving graduate seminars, and Dreyfus replied, quick as a wink, "That's right, Marjorie, you and I have upper-division minds." I'll even settle for lower-division, if it's history, preferably early modern, and not Intro, which I dislike and have never learned how to do right.

But then the obvious question is, who cares about the reflections or

recollections of a schoolmarm? (That is, I am told, an offensive sexist
term, but a teacher is what I am, and a female teacher used to be a
'schoolmarm'. I am old enough not to mind old-fashioned terms.) I
find it incredible that ordinary and often rather silly people write their
memoirs, as if anybody should be interested in such humdrum and
boring lives, or even in such neurotic and 'Oh tell me who I am' lives.
What does it matter, except to them? So I wouldn't dream of writing my
memoirs, in the usual sense; that would be ego-inflated and stupid.
And since I have always been a maverick in philosophy, taken, most of
the time, with unacceptable minority positions, and also (as women so
often have been) totally outside professional life for many years, it
seems questionable whether I can have anything to say philosophically
to anybody except for a very few friends, especially those who agree
already with the odd point of view I mean to try to articulate.

Those all seem very good reasons *not* to write this book. Why
should I write it? I have nine nice chapter titles and three nice part
titles; but that's not much of a reason. On the rare occasions when I try
to sort out the papers in my study, I keep coming across delightful
tables of contents for other books I never wrote; so why write this one?
Partly, I've told a lot of people I was going to. Partly, I suppose (and I
hope, but am not sure, this is a better reason), if (Western) philosophy
is a conversation that goes back to Thales, in which any one of us who
thinks about it may take a place, then I may venture, in my old age, to
take a small place in that continuing dialogue. I certainly do not
believe, and do not for one moment wish to give countenance to the
belief, that 'philosophy' is something 'done' (what a silly verb in this
context!) by anybody who is qualified (*via* a Ph.D., in my time in
nothing but a very little bit of very crude history: the superficial study of
a very few documents, though admittedly, remarkable documents, and
by now in clever know-nothing logic chopping, though, sometimes, I
am happy to say, in more accurate and enlightened history or in
'philosophies of . . . ' supported by some knowledge of the discipline
they are 'of . . . '). I still hold, and hold more than ever, to the maxim
with which I used to shock one of my Davis colleagues: that the more
eminent a person is in academic philosophy, the more likely it is that
he (or she) is a fraud. I hope that's not libellous; my adages, surely, are
not sufficiently authoritative to do any one any harm. And the same
goes, in my idiosyncratic view, for 'fields' or 'problems' in philosophy:

the more fashionable they become, the more likely it is that they're phony. This very day there's a noon meeting here on connectionism; what a silly fad! In part it's just grantsmanship; but it's one of the many expressions, more fundamentally, of the misbegotten notion that philosophy, like scientific disciplines, is a 'field' or family of fields, in which one 'does research' and 'advances knowledge'. What patent nonsense! Research fields, disciplines with developing traditions capable, through experiment, theory, and/or observation, of adding to the body of human knowledge, have been dropping out of philosophy like flies for several centuries. First we lost the natural sciences, then the social sciences and psychology. What we have left, as academic philosophers, is the history of our own literature, conceptual analysis of disciplines beyond philosophy that throw up problems we can help with, or, if by any chance any of us happen to be *really* philosophers and not just teachers of philosophy, original reflection on fundamental, usually insoluble, problems. The rest of our posturing is just plain rubbish, often fashionable, status-conferring, even (relatively speaking) money-making rubbish, but rubbish all the same. So am I here just wanting to add to the rubbish? And sloppily, not with the analytical sophistication of my cleverer colleagues? Possibly. But if we can take seriously the dialogical view of our philosophical tradition, it may be reasonable for even a very unimportant participant in this generation-by-generation conversation to try to report where she believes it stands, or ought to stand, about now. That's about what I want to do, if I can.

The problems that have interested me most persistently in philosophy have, at their core, to do with the problem of knowledge: *what is it to make a knowledge claim?* And since science is the most conspicuous example of knowledge in our society, it is a problem continuous with questions in the philosophy of science. The epistemic question, in turn, however, needs to be asked with due attention to historical contexts. There is no *philosophia perennis.* There are claims to knowledge that are reasonable, or unreasonable, in a given intellectual situation. This is not, however, as I shall keep saying, I'm sure, a confession to (or boast of?) relativism. We take *our* knowledge claims seriously, knowing that they may be, and in part will be, modified, possibly (not probably) even overturned. As I have been telling my students for many years, remember, I am a dogmatic *fallibilist!* But we have to take others' claims seriously as they assessed them, and to

evaluate them, judiciously, from within the framework of our own responsibly held beliefs—which include some manner of understanding, through an imaginative grasp of their way of seeing things, beliefs that in some respects, often in very basic respects, disagree with ours.

Seeing knowledge claims in historical context means, further, seeing them as the activities of persons. This is an even harder row to hoe. To approach the question of knowledge claims in relation to the hopes, aspirations, defeats of those who claim, have claimed, will claim to know some aspect of reality appears to many, especially, so far as I can tell, to 'sociologists of knowledge' or of science, to mean asking about the causes of such claims, whether 'internal' or 'external', and abandoning the reasons. But that is to abandon the philosophical question at the core of my interest and it is also to abandon the very concept of an 'activity' or a 'person'. Knowledge claims are made, responsibly, by responsible agents, whom we call persons. To take some judicious position about what persons are (a position, I suppose, in what my colleagues, heaven help them, still quaintly call 'philosophy of mind') is therefore a necessary condition for understanding that particular activity of persons called 'knowing' or 'claiming to know'.

Maybe, on the other hand, knowing and being-a-person are just two different philosophical themes I have happened to have an interest in. I'm not sure. I have dabbled, for my sins, in what is sometimes called in Europe 'philosophical anthropology'; it's one of the subjects, or non-subjects, I once thought I was going to write a book about. And it seems to me that anyone interested in any aspect of the philosophical tradition except pure logic *ought* to have some interest in the question of personhood, responsibility, agency. I did try years ago now to read some of the literature on 'action theory'; it, too, and it perhaps especially, seemed to wax hyperacademic and hypertrivial, so I abandoned it, as I have so many other subject-matters. Nor have I followed this literature and its problems in any depth or detail in the direction of the metaphysical question of freedom or of any ethical question—the last because professional ethics seems to me either Socratically embarrassing (who am I to teach virtue?) or infuriatingly trivial and boring. When I returned from Ireland in 1965 everybody was asking about the difference between act and rule utilitarianism—how deadly dull! So as my patchy career has gone, I have got myself entangled with epistemic questions in the context of questions about what persons

can do, ignoring other activities of persons one might want to inquire about, like making moral judgments or founding societies or creating works of art. I'll return to think about this a little more in my last chapter.

The reflections and recollections that follow weave in and out of various episodes in a patchy and rather incoherent professional life. Both to confirm my hunch that a straightforward 'story of my life as philosopher' would be rather dreary and to guide my reader through the chronology and geography of my text, let me just outline what in fact I have been doing in the past sixty-plus years in (and out of) philosophy. After graduating from Wellesley as a zoology major in 1931, I went to Freiburg as an exchange student and attended Heidegger's lectures there; that was the start of my study of philosophy. The next year I studied with Jaspers at Heidelberg, although in view of Hitler's rise to power in 1933 not much study was possible. In 1933–35 I took an M.A. and Ph.D. in philosophy at Radcliffe, as close as females in those days got to Harvard. In 1935–36 I visited Denmark as Alice Freeman Palmer Fellow from Wellesley, in order to study Kierkegaard. I had written a hasty and atrocious dissertation on *Existenzphilosophie,* in order to get out quickly and get a job, but for women in those days, and especially in the depression, there were none. Indeed, when I had passed my final orals for the doctorate I was told: 'Goodbye; you're a bright girl but nobody gives jobs to women in philosophy.' It seemed reasonable then, for the moment, to go on, or back, to Kierkegaard, though I had little if any sympathy for that particular gloomy Dane. The book I wrote, probably fortunately, was never published. The next year, after spending some months at home in Madison, writing and job-hunting, I made do with a strange job as Director of Residence in a junior college in Southern Illinois, and then managed to get to Chicago as a T.A. in order to participate in Carnap's research seminar. (I got that job, it appeared, because T.V. Smith pointed out to the department that they had never hired a woman and perhaps should do so—a noble experiment.) I was assistant and then instructor at Chicago until MacKeon had me fired in 1944. From then until 1957, when I went to work in Manchester as Polanyi's research assistant, I was out of academic life except for occasional lectures and translations and stabs at writing, mostly stuff I was asked to do about existentialism. Most of my time was taken with marriage, family and farming, the last first in

Illinois, from 1940 to 1952, and then in Ireland, where I lived from 1952 to 1965. I returned to teaching, by a set of curious chances, only in 1959 in Leeds and then moved to Belfast as lecturer, chiefly in Greek philosophy, in 1960. In 1965 I went to Davis and retired from the University of California system in 1978.

So much for the bare bones. Now let's begin.

PART 1
KNOWING

Knowledge, Belief, and Perception

What I want to do first is to give a summary statement of where I stand on the traditional problem of the relation of knowledge to opinion and of the role of perception in knowledge. Then I want to back off from this statement in order to expand on and explain it in relation to some other problems or perspectives, both within philosophy and stemming from or supported by some other disciplines.

It seems to me that the clearest account I have given on this central question was in a lecture from which this chapter takes its title, and I shall reproduce it here with a few minor revisions and some comments that indicate how, by now, I might have done it a little differently. I wrote this lecture for a two-day visiting philosopher stint at Monmouth College in northern Illinois, and gave it again as a Mellon Lecture at Tulane University in the fall of 1978. Tulane University's graduate school publishes these lectures, but that has scarcely made it eminently visible, so I venture (with their kind permission) to repeat it once more. It is the one publication of mine wholly without footnotes or references (except for reviews and occasional pieces long ago in the *Irish Times* in my years of rural isolation in County Wicklow—those, if I recall, were mostly recipes, aimed at bringing in a guinea or two). So it seems appropriate as a starting-point for this intentionally unscholarly production. I wrote the piece, I believe, in Paris, looking out of a west window at the scaffolding on the building opposite, which was being renovated; that's where the sparrows were. But the camelias in the case belong in the backyard of my house in Berkeley (where I lived from 1974 to 1980); the former owner, I was told, had been vice-president of the American Camelia Society, and he had left behind what had become a wilderness of those shrubs. I agree wholeheartedly with Kathy Wilkes in preferring real cases, even humdrum ones, to science fiction counterexamples. The latter are, indeed, one of the sad

afflictions of what Merleau-Ponty once called "la philosophie américaine analytique-universitaire."

'Before it divides, the normal human cell contains forty-six chromosomes.' What kind of claim am I expressing when I make that statement? I am claiming to say something that's true of the real world. But I've never counted the chromosomes in a human cell; I'm just taking it on authority that there are forty-six of them. When I was an undergraduate zoology major at Wellesley I was taught—equally on the authority of science and scientists—that the correct number was forty-eight. Shall I say that I used to know there were forty-eight and now I know there are forty-six? Of course not. Well, then, I used to believe there were forty-eight, or to be of the opinion that there were forty-eight, but now I know there are forty-six: will that formulation do better? It's certainly a common locution. Dalton believed that atoms were arranged neatly in little heaps, like piles of cartridges. We know that particles of matter are in constant motion in every direction. Descartes believed the heart was a furnace; we know, following Harvey, that it's a pump. But when does belief become knowledge? In the case of the chromosome count, better staining techniques and better magnification, I'm told, have combined to make the difference —and to shatter at last the authoritative and nearly unanimous claim by cytologists to have *seen* the larger number. But we trusted the experts wrongly before; why trust them this time? Even they are relying heavily on inference, on consensus, on the fallacious notion that successful predictions actually *prove* hypotheses. In short, most if not all of what we accept as scientific knowledge is no more than what Spinoza called "knowledge by hearsay or vague experience"—and that's not knowledge at all, really, but just what we happen to have been told on what we happen, given our historical situation, level of education and so on, to believe to be good authority. We seem to be trapped in a quicksand of guesswork. Nor are the experts, on principle, on solider ground. They have interiorized more firmly a more complex web of beliefs, which they express in technical language and strengthen with the aid of cunningly designed experiments. But if you question them about the foundation of their so-called knowledge they usually admit that it's really all conjectural, logically no different from the other kinds of

beliefs we entertain. After all, if, as in the case of the human chromosomes, they can't even count right, what *can* they tell us that we appropriately consider to amount to more than conjecture?

In what follows, I want to do several things. First, I shall distinguish four ways in which we could assess the relation between knowledge and belief. Second, in the light of my conclusion about that relation, I want to say a little about the place of perception in knowledge. In the course of my remarks on these two questions, I shall also try to indicate how the view I am defending, far from encouraging a sceptical position, amounts to a defence of realism, and in particular I shall allude briefly, in conclusion, to the bearing of the epistemology I am outlining on the traditional problem of the existence of natural kinds.

My first question, then, concerns the relation between belief and knowledge. I am not, of course, speaking here of religious faith, although that has been one notorious example of belief that may or may not be separated from knowledge. I am speaking on the one hand, in general, of the holding of an opinion that something is the case and on the other of the knowledge that something is the case, as in my example of chromosome number. 'I believe that *p.*' 'I know that *p.*' What cognitive difference if any is expressed by this difference in usage?

There are, I said, four obvious ways to answer this question. (Maybe there are more, but four makes a neat number, and I can't for the moment think of any others. Nor, some years later, do any others spring to my attention.) First, let's divide the possible answers into two. Either knowledge and belief are different in kind, or they are not. It is the first of these two possibilities that has been accepted in the tradition. Plato insisted on it over and over. Knowledge is indefeasible, as unchanging as the really real of which it is the comprehension. Opinion is as shifting as the unstable appearances it tries to grasp. However radically he may have modified his philosophical views, Plato never, so far as I can tell, abandoned this distinction. The cleft between the real and the apparent, the eternal and the evanescent, appear, indeed, as ancillary to that most fundamental dichotomy, which they are designed to support: the differentiation between what is truly known and what is merely believed. It was this distinction that Plato needed, in the beginning, in order to justify against the opinionated accusers of Socrates, and the jurors who voted him to death, the real nobility and

goodness of his master. Plato *knew* Socrates to be of all the men of his time "the noblest and wisest and best", yet his fellow citizens condemned him for his seeming impiety and corruption of the young: a seeming impiety that was the deepest piety and a seeming corruption that was in fact education: the path to self-knowledge. Thus his knowledge and their opinion were in sharp contrast. To justify that conviction, Plato had to split reality into two: the real world of eternal forms, which the soul has known before birth and strives to recollect, and the phenomenal world of changing things, of all that is always becoming and never really is. Plato himself transcended the moral motivation of his two-world vision, and may even, in his old age, have modified if not renounced altogether his divided ontology. But the radical cut between knowledge and opinion he never abandoned. Nor did Aristotle, for all his this-worldliness—relatively speaking; there is nothing very 'this-worldly' about the Unmoved Mover(s). All the way to Kant, and in some cases even later, as we shall shortly see, the basic distinction between really knowing and merely believing remained fundamental to the theory of knowledge and, one way or another, to the metaphysics on which it rests. And ultimately what grounds the distinction is the very commonsensical insight from which we began: I don't say: 'I used to know that *p,* but now I know that *non-p';* I do say: 'I used to believe that *p,* but now I know that *non-p'.* In terms beloved of Gilbert Ryle, 'know' is a success word, 'believe' is not. There are lots of beliefs knocking about, say, about the cause of cancer; many are false, some are true, but they are not *known* to be true unless something happens to shift them—so it is alleged—from the class of beliefs to the very different category of items not believed but known. Now of course it may turn out (indeed it has turned out, as Hume demonstrated) that no empirical 'knowledge' (or so-called knowledge) ever makes it out of the class of mere opinion into that of what on the traditional view is really knowledge. Nevertheless, the conceptual distinction can still be maintained; in fact, Hume's argument for scepticism itself depended on it. If custom, the great guide of human life, produced knowledge, rather than mere opinion, there would be no need for scepticism, whether extreme or mitigated.

So then, let's ask: if we accept the distinction between knowledge and belief, what can we say about the possibility of knowledge? Here our first answer to the general question about belief and knowledge

again divides into two. Either there is knowledge, as distinct from opinion, or there is none—and so no knowledge at all. The first of these two alternatives, again, was the common view in traditional philosophy. Descartes's enterprise in the *Meditations* was based on the search for certainty and universality, knowledge carrying, somehow (God willing!), its own guarantee of constant and unshakeable truth. It was certainty in physics he was primarily after, and he believed he had achieved it. His immediate successors, too, were convinced that they had found a path to real, that's to say certain and universal, knowledge of nature—even though their concept of the royal road to such knowledge differed from his. By now it is entirely clear, however, that empirical knowledge—all knowledge of particulars—falls short of the traditional ideal. All empirical generalizations outrun their evidence: that the sun has always risen in the morning is no logical guarantee that it will rise tomorrow. We are habituated to expect it, but habituation—like the tricks of performing poodles in a circus—is at best a knowing-how, a trick for getting on in life, not a knowing-that: a rational, guaranteed claim to be able to assert veridically that so-and-so. Given this Humean insight, can we find knowledge in the traditional sense anywhere? In mathematics, it might have been supposed; but since Gödel that escape route, partial as it was, appears to be blocked.

Nevertheless there have been in this century defenders of knowledge as apodictic and incorrigible, notably Husserl and his followers in phenomenology. I find their claims and their method extremely difficult to understand, but I have to include them, partly for the sake of tidiness, partly also because Husserl's influence on recent European philosophy is so pervasive that he simply cannot be ignored. Husserl's intent, it seems, was to discover a sphere of pre-empirical, pre-mathematical or logical, even pre-commensensical knowledge, which would have the character of necessity and universality that philosophy from Plato onward had claimed knowledge ought to have. He found it, or alleged he had found it, in the field of consciousness itself, in the structures of thought and its relations to its intended objects, quite apart from any question whether such objects might in fact exist. A search for pure structures of consciousness, however, was almost bound to issue—as it did in Husserl's case—in a culminating idealism that cuts off the question of knowledge before it can be asked. Husserl, last of a long line, was bent on finding, and founding, philosophy as

"apodictic science" (*apodeiktische Wissenschaft*). (Granted, *Wissenschaft* is not exactly science, as we usually understand it, but if we include 'social science', perhaps it's close enough; in any event, I don't know of a better rendering.) What he came to, after a tortuous trail of horrendously technical distinctions, was the constitution of consciousness by itself, by a Transcendental Ego, a mythical beast whom, like the famous purple cow, one never hopes to see. If you cut off the mind from reality at the start, that's all you *can* end up with. So much for the *cogito* as the starting point of philosophy! Indeed, it is here that the anti-Cartesian turn needs to start: with the rootedness of 'mind' in reality, not with the ready-to-hand, which deals only with the things available to *Dasein*—Heidegger's anti-Cartesian turn in *Being and Time,* but with the very structure of persons as being-in-a-world. That is one of the themes I shall return to, often enough, below. Despite the importance of the basic concept of intentionality, in the sense of intensionality, not the more restricted sense of purposiveness, which Husserl had borrowed from his immediate predecessors, and despite the brilliance of some of his particular analyses, therefore, the enterprise of Husserlian phenomenology as a search for knowledge in the strict sense of the tradition cannot be said to have succeeded.

Perhaps, then, there is no knowledge. That has always been the position of sceptics, who recur in every age and in every philosophical style. And that is of course the other half of our first pair of alternatives. Knowledge, by definition, is unerring. But the senses, the intellect, the imagination, all are fallible: so there just is no knowledge. We muddle along in a practical way, by means of what Russell called animal inference, and that's the best we can do. Such arguments have once more become fashionable, or had done when I first wrote this, among so-called 'analytical' philosophers. It seems that the conceptual distinction between knowledge and belief has taken such deep roots in our thinking that, rather than abandon it, we would deny the existence of any knowledge whatsoever. So all the sceptical tropes turn up again: how to tell perception from hallucination, or sleep from waking—*is* this a dagger that I see before me? There is one member of a distinguished philosophy department who has been hallucinating tomatoes all his professional life. Theories, however precise and elegant, fit the real world only approximately. They *might* all be wrong. After all, Newtonian mechanics, allegedly the greatest theory in the

history of science, turned out to be mistaken. So why not abandon the claim to knowledge altogether?

If we insist on the difference in kind between knowledge and belief, as a matter of fact, it seems to me, there is nothing else we can do. But why should we stubbornly retain that distinction, if it leads us to reject as illusion all that we are most confident we know: everyday objects, the people around us, the natural mechanisms we learn about from science, our history and that of nations and of species? There is no refutation of the determined sceptic, but his effort seems to me as fruitless as Hume himself found it. Our answer, however, should not be, like Hume's, to play backgammon with our friends, or to split atoms and/or write anti-novels, or pursue whatever alternate games we like. Our answer, as philosophers, should be to reconsider the premise from which Hume's inquiry began, and from which every sceptical inquiry begins: the premise that, knowledge being necessary and universal and belief contingent and parochial, the two have no connection with one another. Instead, let's look at the knowledge claims we make and see how they are structured if we take them, not as separate from, but as part of, our system of beliefs. What could it mean, after all, to know something but *not* to believe it? If I know the heart pumps blood, I can't at the same time not believe that it does so. If common sense tells us that knowing is not the same as believing, it also tells us that knowing entails believing. True, again, admittedly, we don't want to equate belief with knowledge: not all beliefs count as knowledge. I may believe that the election of a Fianna Fáil majority made no difference to the political situation in Ireland, but I don't really know. On the other hand, some of my friends believe all Irishmen are murderers; and I know they're mistaken. Of course, they in turn believe they know that I'm mistaken—but I know that belief is mistaken, too. Admittedly, we do seem to be getting into quicksand here. If one wants to take knowledge to be a class of beliefs, just what class is it? How does one mark it off from opinions not to be counted as constituting knowledge? There is no simple answer. I shall put forward two, one that was standard for a while in recent epistemology, and a modified version of it that leaves us in a less than satisfactory situation, the one in which, I believe, we do in fact find ourselves.

Knowledge, it has often been alleged, is justified true belief. First, knowledge must be true, not false. One can't be said to know what isn't

so. A knowledge claim is a claim to veridicity, and, as we have seen, we count it a correct claim only when it succeeds. I can be said to know there are forty-six chromosomes if and only if there *are* indeed that number. Second, we count a belief as knowledge only when there is good reason to hold it true. Without having heard the news, I might have guessed that Fianna Fáil was returned to office, and so have happened to entertain a true belief. Or I may guess correctly that the card hidden in your hand is the King of Diamonds, and so entertain a true belief about a matter of fact without being said to know it. In either case, I have no good reason for my belief; I'm *just* guessing. And that's not knowledge. Knowledge, then, on his view, is the subset of beliefs that are both true and justified.

For a long time this seemed to me a plausible notion. It got into trouble in the trade, thanks to some ingenious but trivial counter-examples; that's worrying only with respect to the character of academic philosophy. But in a more global way, there does seem to be something wrong with the 'justified true belief' formula. What is it? That knowledge is belief of some kind is clear. That when I say 'I know that *p*', I am *claiming* to make a true statement, is also clear. The trouble seems, at first sight, to be connected with the need for justification. What kind of justification? Universal Kantian *a prioris* have failed us; empiricism, which would justify cognitive claims by reference to 'pure' sensory givens, has broken down altogether (more about that in Chapter 3). It's all very well to say 'knowledge is justified true belief', but what on earth does the 'justified' *mean?* Sometimes it does seem to be perception that settles the matter. If I want to know whether it's a ninety-six or an eighty-six bus coming, when I see it closely enough to read the numbers, I say, yes, it's an eighty-six. Of course, to justify my belief, I must be able to count and read—and know what a bus is, and so on and so on—still, in this case seeing is believing, and the kind of believing that amounts to knowing. In many other cases, like that of chromosome number or my birthday, for example, I have to rely on authority. I feel my age, but only on authority do I know exactly how old I am. What authorities are really reliable enough to enable me to trust them as guides to knowledge? Or as Plato asked in the *Meno* and again in the *Theaetetus,* how can we tie down belief to restrict it to the truth? Plato's answer, of course, was that knowledge can be achieved only through recollection of the really real

that our souls glimpsed in a previous existence. Our answer, in contrast, can only be a differently historical one. We have abandoned the search for knowledge in Plato's sense—a grasp of truth indefeasible and unconnected with our bodily being—and we admit that we are destined to seek, gropingly but not unreasonably, the best clues we can find to the truth about any question that concerns us. Whether it is perception, inference, imagination, or authority that guides us depends both on the kind of question we are asking and on our capacities and our training in the appropriate disciplines or areas of common life. That's the best we can do with the problem of justification—and it's not too bad. There are philosophers who can help us articulate this general kind of view: Merleau-Ponty or Polanyi, for example. Formerly I included Heidegger in this list; that was before I went through *Sein und Zeit* with a group of college teachers for a third time and discovered that even the very small portion of that work that does not rest on Heideggerian punning and pontificating is etiolated by its inattention to *Leiblichkeit* and vitiated by its fanatical nationalism. All teachers know we only learn what we teach; and working through familiar texts with colleagues, as in a summer seminar, is even better than teaching. But more of that in Chapter 4.

Nevertheless, the formula 'justified true belief' still leaves one dissatisfied. The trouble is: it's not really 'justified' that's troublesome, it's 'true'. What keeps eluding us is a way to check our beliefs against reality and find out, once and for all, whether they *are* true. It's been tried, both logically and quasi-psychologically, to devise a means for such a comparison, but it just hasn't worked. For we can't get *outside* all our beliefs at once in order to check them. That is the paradox Polanyi was trying to respond to in *Personal Knowledge*.

Then, you may say, we are back with scepticism. 'False knowledge' is a contradiction in terms. So if I can't ever tell definitely whether my beliefs are true, I can't tell if I ever know anything, and I might as well give up. But such arguments depend on a misreading of our situation. *Why* can't we check our beliefs against reality? Not, as sceptics believe, because we can't reach out to reality, but because we're part of it. We are not Gods or Laplacean observers, who can take a stand outside the world and say, there is truth and there on the other hand is error. We are living beings seeking, in our funny, artifactual, language-borne way, to orient ourselves in our environment: an environment that includes,

in our case, laboratories, law-courts, schools, supermarkets—and above, or before, all, natural languages. Language, Wilhelm von Humboldt said, is a true world that man puts between himself and reality. That's correct, but also misleading. The world of language, and more generally of culture, is one sphere, so to speak, of our surroundings—the one closest to our existence as historically developing and developed beings. But the sphere of culture in which we find ourselves is itself contained in nature: not so much a screen between ourselves and nature as a variant of it: a variant that we have made and that at the same time makes us—and that serves us as a glass, now telescope, now microscope, through which we grasp the realities around us, both cultural and natural. This is the theme I shall try to articulate somewhat more fully in Parts II and III.

How then are we placed with respect to the veridicity of our beliefs? Each of us, in his own given situation, has to do his (her) best to shape and reshape critically his (her) own beliefs in the light of what, in all conscience, (s)he takes to be relevant and sufficient evidence. There are no exact rules for doing this; each area of knowledge, like each field of practical skill, has its own procedures, which the learner has to interiorize first as apprentice and then as discoverer. That there are no exact rules for acquiring knowledge, however, does *not* mean that the whole matter is arbitrary or subjective; far from it. Objectivity—the contrary of subjectivity—is not something somewhere totally detached from human practice: it is the supreme virtue of all the cognitive disciplines. But a virtue is a developed human capacity: in this case, the developed capacity to make judgments in accordance with the evidence. Again, there is no formula for doing this, although those philosophers and cyberneticists whom I have christened algorithmaniacs may (falsely) believe there is. Through the concepts and judgments and techniques appropriate to a given discipline or sphere of life, one does one's best, in Polanyi's phrase, to make contact with reality. One may succeed or fail. In the light of the growth of scientific and historical knowledge, it seems only reasonable to assert that success is fairly common, if never total. One can never know, in the old-fashioned sense of 'know', that this is so; but one has very good reason to hope it is. We count as knowledge, then, such beliefs as we hold, in good conscience, to be justified. Knowledge is justified belief.

Then what happens to the veridicity of knowledge? Did Newton

know there was absolute, true, and mathematical space, while we, since Einstein, know there isn't? Again, this is where the crunch comes, but it's the crunch we're in and we can face it (or whatever one does with a crunch) without falling back into scepticism. If I assert that I know p, or confidently assert p, which comes to the same thing, I do so correctly only if p is in fact the case. 'p' is true if and only if p. Fair enough. And when, from my limited point of view, I assert p as an item of knowledge, following as best I can the available evidence, I do assert it as true—as universally true. And yet I can't be logically certain; I *might* always be mistaken. What I am doing is to assert a given proposition, as Polanyi put it, with *universal intent,* in confidence that anyone with the same evidence and the same standard of objectivity would make the same assertion—and would be correct in doing so. But this is always an *intent,* not a guaranteed fulfillment.

Then what about our earlier remark that knowledge is a 'success' word? We have two choices here. We can say we often have good reason to hope we know, and so are justified in claiming to know, although we may be mistaken. So we count our justified beliefs as knowledge, even while reserving the possibility of error. To say I know is to make a reasonable *claim* to success, not to guarantee it. Or we could say, somewhat more conservatively, that we believe we know a good deal—we could assert confidently that many of our beliefs are true—but that this meta-belief, that we know a good deal, cannot be definitively vindicated once and for all. So we know that we know only in the sense of holding a justified belief. I'm not sure there's very much to choose between these two formulations. I do somewhat prefer the former, which straightforwardly equates knowledge with justified beliefs, beliefs we have reason to hope are true, instead of sidestepping fallibility by a shifting of logical levels. Either formulation unsettles in some way the foundation of knowledge in truth. Either formulation, on the other hand, allows us to include scientific knowledge in knowledge and that, it seems to me, is an advantage. None of the other three answers to the knowledge-belief question allows us to do this, the first because it is after an infallible knowledge quite different from anything claimed by science, the second because it denies the existence of any knowledge at all, and the third because there seems to be no satisfactory way to cash out 'truth' in the justified-true-belief formula. So it's the fourth answer we're left with. It's a somewhat uncomfortable

answer—but, despite Boethius, philosophy has seldom, when awake, been a comforting subject.

So much for my remarks about belief and knowledge. In sketching the fourth, and, as I believe, correct, answer to this question, I have also given an entrée to the third point I wanted to touch on: the defense of realism. I shall return to that shortly, and at greater length in a later chapter. Meantime, I want to say a little—also very sketchily—about the relation between knowledge and perception. For the realistic interpretation of the thesis that knowledge is justified belief, which I am supporting, depends also on one's reading of perception and its relation to more 'intellectual' cognitive claims. (Here I am trying to say what I believed about perception before 1980, when I first read, and tried to assimilate, the chief conclusions of, J.J. Gibson's *Ecological Approach to Visual Perception,* which was published in 1979. I had read, but not understood well, his 1966 *Senses Considered as Perceptual Systems.* It is still difficult, for me, at any rate, to put clearly and persuasively the philosophical lessons to be derived from this perceptual theory; so I think it may be of some use if I restate here, with minor revisions, my, so to speak, pre-Gibsonian position, returning later, in Chapter 7, to try to make more explicit what I have since learned through studying and teaching Gibson's work and talking, as I have had the privilege of doing, with Eleanor J. Gibson about the Gibsons' theory of perception and perceptual development.)

In the traditional conception, which, as we saw, considered knowledge unerring and radically different from belief, sense-perception had a peculiar place—or better, two peculiar places. Most major thinkers, I believe it is fair to say, followed Plato in sharply separating knowledge, not only from opinion, but also—and *a fortiori*—from sense-perception. The Aristotelian tradition, for example, stresses the need for us, in our place in the natural world, to begin the path to knowledge from perception. But sense-perception is not by any means to be equated with knowledge. Sense-perception, according to Aristotle, grasps the sensible forms of things without their matter; the intellect, in knowing, is identified with the intelligible forms of its objects—and that's a very different story.

Yet although both Platonic and Aristotelian thinkers—and innovators like Descartes and Spinoza, too—emphasized this differentiation in one way or another, the analogy of perception, and especially of

visual perception, played a crucial role in their conception of knowledge. *Theory* originally means *seeing:* knowing is a kind of intellectual vision, in which the mind, turned away, it is true, from ordinary seeing, hearing, and the like, inspects the real essences of things, or even Being itself. As late as Husserl we still find this notion of knowledge as intellectual vision, and much recent writing about the end of philosophy or 'deconstruction' and the like consists basically in a rebellion against this traditional faith.

On the other hand, from early on a minority of thinkers, and in recent centuries many, perhaps the majority, of English-language philosophers, have in fact identified knowledge in the last analysis with what is given by, or fairly directly derived from, sense-perception. When such empiricist views are developed, however, they tend to become rather bizarre constructions or to collapse into scepticism. If, in terms of the theories of perception traditionally available, one really wants to confine oneself to what is sensed, one has to ask, what is the strict, literal content of what the senses tell us? Then one contrasts—or so many empiricists have done—what *sensation* provides: flat patches of color or bits of noise—with the interpretations or judgments we impose on it in order to produce what we ordinarily call *perception*. Every one, I am sure, knows this story in one guise or another. Descartes said, I don't really see men passing by the window; I see hats and cloaks and judge that there are men in them. (See Chapter 7 below.) In fact, on this view, he didn't 'really' see hats and cloaks either, but patches of colored shapes, which he judged to be hats and cloaks, which he judged to contain men—and so on. Push this story to its logical conclusion and you have as the ultimate content of experience pure uninterpreted sensory bits: Hume's simple impressions, or the sense-data of some philosophers earlier in this century. And then by some hocus-pocus our ordinary perception of things, let alone scientific knowledge, has to be built again on this flimsy foundation. Over and over again, this road has been tried, only to lead to disaster, that is, as with Hume, to scepticism. This happens for two reasons. On the one hand, there are no sense-data: experience just isn't built of bits like after-images. And on the other hand, even if experience were made of such disparate tidbits, there would be no rational way to proceed from these to anything worth the name of knowledge—not even to reasonably justified beliefs, let alone knowl-

edge in the older necessitarian sense, which most empiricists were still in search of.

Why this tirade? Because I want to show you that neither the intellectualist nor the empiricist branch of the philosophical tradition has taken seriously the role of perception in knowledge. For the Platonic-Aristotelian-Cartesian tradition, knowing is like seeing in its directness: we must come intellectually face to face with Being, as we come face to face in daylight with the things around us. Yet at the same time, whether by slow steps or by a more radical conversion, we must proceed from sense perception to intellect, from the unreliable and unsteady dictates of the senses to the firm beam of intellectual vision and the higher realities it illuminates. For empiricists, on the other hand, the base that is taken to carry our cognitive claims, though supposedly identified with sensory experience, is in fact a mockery of it, a kaleidoscope of bits and pieces bearing little resemblance to the coherent, solid perceptions of things of which most of our everyday being-in-the-world consists, and on which all our knowledge, however abstruse, is built.

The twentieth-century philosopher who has best expressed the nature and role of perception is Merleau-Ponty. Against both intellectualism and empiricism he argued for what he called the primacy of perception: the priority of embodied being-in-the-world and of the way things come to us, and we to them, through sensory channels. The lesson he teaches us, in the *Phenomenology of Perception,* moreover, is convergent with the argument of Michael Polanyi's *Personal Knowledge,* or its summary in the first chapter of the *Tacit Dimension.* Before I try, however, to put briefly, in my own words, the view of perception expressed in both these works, I would like to turn to an ancient source—unlikely, perhaps, in view of my assertion that knowledge is not in fact different from belief—and that is Aristotle. (What follows is, I now believe, a badly mistaken, or at least incomplete, report of Aristotle on perception. When I attended some of the sessions of Miles Burnyeat's seminar on the *De Anima* at Cornell a few years ago— sessions in which Deborah Modrak also participated—I was forced to acknowledge, unhappily, the other side of Aristotle's account of perception, his thesis that perception, when taken strictly, is unerring —and insofar as it is uneering, 'subjective'. I 'knew' those texts were there but hadn't wanted to face them. What to make of the whole

account after that I just don't know; but since some of my own reflections are woven into the following very inaccurate statement, I include it, with an adjuration to the reader not to take it seriously as a report of Aristotle! Modrak's book can be consulted for a more accurate account. What I am doing is really just wandering off on my own starting from what Aristotle says about the "common sense".)

Although, two centuries after Hume, Aristotle's doctrine of scientific knowledge is no longer available to us, his account of perception (as here bowdlerized!) can help us, I believe, to stabilize the notion of knowledge as justified belief by showing us how to locate the information we receive about things and events firmly in a real and organized nature. Aristotle distinguishes between perception by the individual sense organ and what he calls the common sense. Perception by a single organ is a process in which the appropriate sense organ—eye or ear, for instance—receives, through the appropriate medium—light or air in these cases—information about the sensible properties of the object, such as color or sound. Perception is passive in that it is a reception, not a production: it doesn't do anything to the camelia bush for me to see it, as it would if I were to water it or give it camelia food. Seeing the camelia bush is something that happens to me. At the same time it is an achievement of mine, in a way, for it is the fulfillment of a possibility of seeing peculiar to my development as a sensing being. A normal human being is in the most general sense capable of sight from conception, in a more developed sense from birth, and in a yet higher degree when he opens his eyes in the light and achieves contact, through that medium, with the visible forms of things. This is no subjective play of images, but a process of interaction between the visible aspect of real things and the real sense organs of the real living animals that possess these organs and the capacity to use them. The so-called 'common sense', in contrast, unifies the presentations of the single senses: then a round, green, hard, tart apple is experienced by sight, touch, and taste as having all these qualities. Further, common sense permits us to perceive that we perceive, so that perception, far from being pure interaction, can be instead awareness-through-interaction. Finally, common sense enables us to compare the presentations of one sense with another: as size can be seen or felt, motion seen or heard.

Now Aristotle's physiology was notoriously bad: he considered the

brain a cooling organ, located thought and awareness in general in the heart (because he had so carefully watched the development of the chick embryo, and seen the little blood spot growing, as it seemed to him, the center of life), and if he located his common sense at all, it was also in the heart that he placed it. But oddly enough, he was just so good at describing how perception works that his account of it fits strikingly into that of neurophysiology in our day. The sensory areas in the brain peculiar to each sense, it seems, work, in perception, by passing on their limited information to the transmodal areas that co-ordinate the 'data' received by eyes, ears, nose, skin and taste-buds, so that we in fact achieve perception of things and events as coherent entities and processes. Indeed, it takes a special kind of attention to abstract from this organized actualization of sensory awareness and pick out, as such, a pure 'given' of a single sense. Of course sensation happens as a set of specialized physiological processes; but what we become aware of as we rely on our sense organs to help us find our way in the world around us is things and processes with certain sensible characters. We are organized living beings with the capacity to orient ourselves, through the co-ordination of sensory information, in an ordered and relatively stable world. Such perceptual orientation can, it is true, mislead us, when something goes wrong with a sense organ, or with an object of sense, or with the appropriate medium. I can't see the squirrel on the christmas-cherry tree if my sight is failing, or if the squirrel has climbed to the other side of the tree, or if it's pitch black night outside. But on the whole we make pretty good contact with our environment through the integration of special sensory information into a perceived awareness of our surroundings.

Once we look at perception this way and, I believe, correctly, we can understand how it is that we form our opinions about the things and events in the world around us through perception, and, even in the most exalted flights of intellect, on the ground of perception, not only in analogy to it. I shall return later, in reflecting on the Gibsons' ecological theory of perception, to the question of an analogous structure of intellectual and perceptual knowledge. Here we are, embodied beings in a world open to the forays of sight, hearing, smell, taste and touch: inside this world we find our way, more or less tentatively, or with more or less confidence. The artifactual, language-

mediated world, too, within which, as human beings, we are destined to become the persons we do become: that world, which has been and is always being constituted by human symbol-giving and symbol-reading acts, has been and is always being so constructed *within* the ordered natural world and through the use of the sensible things and events that nature makes available to us. We are rooted through our senses in reality. Language and the creation of culture have loosened our links to it: there *is* a world we place, so to speak, between ourselves and things. But language too is perceptible speech, which must be said (and heard), or written (and read); the symbols that constitute the arts, religion, social institutions must all be capable of mediation through sensory channels, must use sensible counters—colors, shapes, sounds, and movements—if they are to function even as conventions: a white flag of truce, the gold of the Olympic winner's medal, the halo of a saint, the red of a traffic light, the two lines that make an equal sign in a mathematical equation or the three that form an arrow in a chemical one. The artifactual devices we interiorize as we learn our way around a given discipline or acquire a given skill, however theoretical, are themselves alterations of, tinkerings with, perceptible, embodied things as much as we ourselves who do all this tinkering are animals finding our way through reliance on our integration of sensory inputs in a perceptible and therefore intelligible habitat. As there is no sharp cut between belief and knowledge, so there is no sharp cut between perception and belief. Perception is both primordial—the most primitive kind of knowledge—and pervasive: the milieu, on our side, within which we develop such information as we can obtain, such beliefs as we can articulate, concerning the places, things and processes among which we live, move and have our being. That is, I think, something like what Merleau-Ponty meant by "the primacy of perception". It is also the necessary foundation for Polanyi's doctrine of tacit knowing. I shall not go into the latter here; but it seems to me that the argument in *Personal Knowledge* from commitment to embodiment—the christening of epistemology as 'ultrabiology', for example—clearly shows the convergence of Polanyi's view with that of his French contemporary. Knowledge is justified belief, which we have good reason to believe, but can never 'know' for sure, is true. Belief, in turn, however carefully defended, however critical, is the elaboration by a sentient, embodied

being of its perceptions of the structures of its environment. That's why there is always a tacit foundation of knowledge: it cannot be detached from the efforts of living, sentient beings to orient themselves among the salient patterns of things and events offered by a real perceptible world.

It should be clear by now how, in my view, the thesis of the primacy of perception can tie down the conception of knowledge as justified belief, and keep us from drifting into subjectivism. It should also be clear by now that both the justified belief formula and the thesis of the primacy of perception must be understood in a realistic sense. We dwell in human worlds, in cultures, but every such world is itself located in, and constitutes, a unique transformation of, some segment of the natural world, which provides the materials for, and sets the limits to, its constructs. Aspects of this theme will recur, I hope not *ad nauseam,* in what follows. Ever since the first time I read the *Meditations,* and wondered how anyone could ever have taken the *cogito* seriously, something like this is what I have been wanting to say.

That brings me to my third and concluding point. (A point I now wish I hadn't tried to make, since in the face of all the 'species as individuals' literature that has sprouted since, and had begun to sprout even then, I can't just flatly make it without being labelled a hideous reactionary; but if I haven't the courage to elaborate and defend it, neither have I quite the cowardice to suppress it altogether.) It is, I believe, only on the basis of some such ecological epistemology, as one might call it, that one can deal intelligibly with the traditional problem of natural kinds. When I see sparrows alighting on the scaffolding of the house across the street, I do indeed see sparrows, not moving and then resting brown spots that I take for sparrows. To justify my statement, I don't need to hold with Plato that there are forms separate from these particular flying objects, nor, with Aristotle, that kinds are eternal, existing forever in their perishable individual specimens. But I do need to assert with Aristotle that there are kinds—relatively stable, though not eternal, as he thought—to one of which I myself belong: a kind gifted with the power to tell one kind of being from another, through learning to perceive differences and likenesses in individuals and at the same time, inseparably from that same perceptual process, through learning to develop, express, criti-

cize and improve, by discursive as well as sensory means, a set of reasonable beliefs about the way in which, so far as I can tell, the natural as well as the human world is organized. Knowledge is justified belief, rooted in perception, and dependent for its possibility on the existence in reality itself of ordered kinds of things, including the kind that claims to hold justified beliefs.

Rereading Kant

L ooking back for the roots of my consuming interest in the problem of knowledge, I find its starting point in a fascination with Kant, in particular with the *Critique of Pure Reason,* and there in particular with what seemed to me its central argument, that is, the argument of the Transcendental Analytic, in which Kant expounds, and justifies, the mind's contribution to the objectivity of experience. In my callow American youth, I must confess, I found Kant's ethics of duty, in contrast to his theory of knowledge, entirely unbelievable. I had been raised with an apologetic attitude to an inherited Jewish conscience: it was presented to me as a burden that more fortunate people (even more fortunate Jews) could happily slough off. I used to return undeserved nickels to a pay phone and feel guilty about my superhonesty. The idea of Obedience to the Moral Law, of the Good Will as the only good, in opposition to inclination or desire: such a notion appeared downright absurd. And so when I first read Kant's *Foundations of a Metaphysic of Morals* I was wholly baffled. It seemed to me in those days that Kant had let in by the back door, in his treatment of morality, what he had sharply turned away from the front steps, in his analysis of knowledge. Analogously, as an undergraduate, I had found the remarks of my Italian teacher (a refugee from fascism) entirely unintelligible. "What does it matter", she said, "if the Italian people are happy? They're not free." To a naive young American it seemed obvious that everyone wanted to be happy; I suppose we took political liberty entirely for granted. I understood her point only years later, during the war, when I heard R.H. Tawney refer to Hitler as "that wretched man". And only then did I understand as well Plato's argument in the *Gorgias* that it is better to suffer than to do injustice. Obviously, one would rather be right than president. But it wasn't obvious (to me) when I began studying philosophy; and in any event, as I have already confessed, it was the question of knowledge rather than good or right that awakened my philosophical interest, and Kant's Transcendental Analytic was the document that seemed most clearly to

be probing, if not to its resolution, at least to its enlightenment. Although it would be difficult to recapture that first fine careless rapture, I want here at least to indicate how a Kantian theme still forms, for me, the starting point for philosophical reflection.

Bertrand Russell once remarked that some day he would become truly famous by writing a book without a word of sense from beginning to end, like the *Critique of Pure Reason*. Unforgiveable! His *History of Western Philosophy,* written, I believe, some years after I heard him make that remark, has *got* to be atrocious. Of course I never read it and wouldn't dream of doing so. In contrast to Russell's blasphemy, Peirce said somewhere that every student of philosophy should spend an extended time studying the *Critique of Pure Reason*—it was either three hours a day for five years or five hours a day for three years, I forget which. But I subscribe wholeheartedly to his adjuration, whichever form it took (though I'm lazy enough to prefer the former; three hours a day seems easier than five, even though they sum up to the same time in the end). It is still the Enlightenment, I believe, that provides the source for our philosophical problems. It was the eighteenth century that generated our utopian hopes for the advance and spread of knowledge as well as for moral enlightenment, and it is the same century, as well as those same aspirations, that forces us still to face the appalling difficulty of realizing such nearly impossible dreams. And Kant's first *Critique* is the culmination of Enlightenment philosophy. Nineteenth-century positivism, nineteenth-century idealism, are, equally, programs fuelled by self-deluded unwillingness to face the questions their forerunners had bequeathed to them, if they had dared to listen, and so, still, to us. Both Mill and Comte presented systems whose impossibility David Hume had already demonstrated a good century before them. And as for Hegel! J.L. Nancy has argued that philosophers invent reality, and that (as indeed is obvious and undeniable) Hegel's invention rested solely on the threefold meaning of the German *Aufheben:* preserve (or pickle!), raze or destroy, and raise or elevate. "Das Sein selbst geht über" and all the rest: what appalling hybris! Yet people keep reviving that superteutonic professional perversion; not to mention that half the world has been ruled by the same invention, turned the other way up. One can only conclude,

after Gilbert and Sullivan, that every little boy or girl who's born into this world alive is either a little Kantian or else, alack and alas, a little Hegelian. The present writer emphatically belongs to the former kind.

Sometimes, admittedly, looking back over sixty years, it's hard to know why. Why one is not a Hegelian is clear, as I have just suggested, but why one is, in some strange sense, a Kantian, or a person who starts philosophizing with or from Kant, is more difficult to remember. The distinction between appearances and things in themselves in the radical way Kant made it now seems untenable; there is no such unbridgeable gap between what appears to us and what there is. Lord Lindsay published a book about Kant in which he took things in themselves as a limit to our knowledge, asymptotically approached. That would be fine, but it is definitely not the thesis Kant put forward. For him, there was a definite, impassable boundary between appearances and things in themselves.

What one does distill from Kant's doctrine is that one never knows the real world *wholly.* Kant attempted in the first part of the *Critique,* the Transcendental Aesthetic, to establish the *forms* of space and time as the necessary 'pure' ingredients of our sensibility: all our perceptions are both temporal and spatial. In the Analytic, secondly, he argued for the existence of pure concepts and principles underlying our experience, though always valid only for appearances rather than things in themselves. Thirdly, in the Dialectic of Pure Reason, he followed the course of Pure Reason's doomed yet ineluctable quest for knowledge of the really real: of self, of nature, and of God. The second part of this development, the dialectic of Nature, Kant christened "Antinomies", since in each of these cases, he argued, we have a principle that seems reasonable but can be shown to contradict itself. The first of these cases sets up against the thesis that nature is finite, the antithesis that nature is infinite. The same situation obtains also in the second case: matter is made up of least parts; matter is infinitely divisible. So long as we seek causal explanations *within* nature, we can increase the scope of our knowledge indefinitely. But when we ask *absolute* questions about nature as a whole, as one reality, we run into inescapable difficulties. What one accepts from these antinomic arguments is the acknowledgement that one can never know all of reality at once, or know reality exhaustively, out of all relation to one's own perspective on it. Knowledge is always partial.

That's fine. No one who has taken Kant seriously could tolerate for long the naiveté of the Unity of Science movement, once so popular among philosophers of science. Recent, more informed and pluralistic work in the philosophy of science resonates to that Kantian thesis. At the same time, however, the thesis that there is no one complete system of natural knowledge appears in the Kantian text as but one consequence of the fundamental distinction between appearances and things in themselves. It seems odd to accept the consequence without its premises. Come to think of it, it's the same with Hume's argument about induction: his conclusion is correct, but its foundation in psychological atomism is gravely mistaken. Still, the argument can be established without his mistaken psychology: inductive inference always goes beyond its evidence. One need not break down experience into tiny subjective bits, as Hume did, to gain that insight. (I shall say a little more about that in later chapters.) In Kant's case, however, the conclusion that knowledge is always partial, in the form in which he drew it, seems to rest squarely on the unacceptable distinction between appearances and things in themselves. I'll return to this point, too, after the rereading I hope to undertake here; meantime I'm just reflecting on the ways in which I must admit that, despite a chronic fascination with the Analytic, I have probably never been a thorough Kantian, or have always taken from Kant what I wanted, not what the text, or its creator, offered.

Admittedly, in my erring youth, I was fascinated both by logical positivism in its first beginnings and by C.I. Lewis's "conceptual pragmatism". These could both be taken as legitimate transformations of Kant's position. Vaihinger's *Philosophy of As If,* a positivist reading of Kantian appearances, was still influential when I was a student, and his textual dismemberment of the text of the *Critique* provided the foundation for Kemp Smith's commentary, the then authoritative English help to following Kant's argument. And Lewis certainly held himself indebted to Kant; his epistemology simply substituted analytic for synthetic a prioris (a fateful change, Kant would presumably have found!). But I suspect that my sympathy for these views was more a reaction, in the first Hitler years, against German *tiefere Bedeutungen* than it was an acceptance of a Kantian phenomenalism. Lewis's interpretation of knowledge of the past purely in terms of its confirmation in the future cured me of belief in his view. This was the time of

the great to-do about the kidnapping of the Lindbergh baby, and one asked, did Hauptmann murder the child or did he not? He did or didn't; a statement one way or the other could not be equated with the tests one might make in the future in order to reach a judgment. Trying to find out about the past is not the same as the truth about the past. My interest in the new positivism, moreover, died quickly when, in Carnap's research seminar at Chicago in 1938, I was confronted with his purely extensional interpretation of property terms. To a former zoology major that was sheer nonsense: if all and only all mammals have a true diaphragm and all and only all mammals have hair, then, on the Carnapian view, having a true diaphragm and having hair were the same property. Like the morning and the evening star. Impossible.

But to return to Kant. Even in those unregenerate days, my reading of Kant was realistic: I worked hard at making him come out with an Adickes (realistic) rather than a Vaihinger (as if) reading. Perhaps, as Dan Kolb has almost persuaded me (though some Kantian texts persuade me back the other way), Kant was at bottom an idealist; after all, appearances are our "representations", in some vague sense notions that are subjectively ours. That sounds idealistic enough, alas. (I must remark in passing that 'representation' is a poor rendering of the term *Vorstellung;* a Vorstellung is just any old 'mental' content, not necessarily representative. Much harm is done in English thinking about Kant by the inadequacies of the translations of his vocabulary. But that's another story.) At the same time, however, even the most idealizing reader must admit that appearances are appearances *of* things in themselves, even though, *as* things in themselves, those objects of appearances or causes of appearances are never accessible to us. In any event, the message I gleaned from the *Critique,* and particularly from the Analytic of Principles, was rather a realist than a phenomenalist one. It is after all an objective spatial-temporal nature of which synthetic a priori judgments enable us to construct the form. The whole, informed matter, realized form, is a real, even *the* real, world, seen, or in a sense 'made', our way. Paton's commentary was not available when I was a graduate student, but I took readily in later years to what I supposed to be its major theme. Meantime as a graduate student I had spent hours and days trying to make out the fate of the 'transcendental object' in the second edition. In the first (A) edition Kant had balanced the ultimate uniting feature of experience, which

he called the Transcendental Unity of Apperception (the fact that I could unite all my experience with an 'I think') by referring also to a 'transcendental object = X' as the pole to which, on the objective side, all experience refers. It would be so tidy, and so comforting to my propensity toward realism, if there were such an object = X to balance the transcendental unity of apperception! If I remember rightly, the pertinent passages in A were not expunged, but neither did the new arguments of B retain the concept; what replaced it was 'possible object of experience'. I have not followed the Kant literature and do not know if this controversy has been settled or simply forgotten; but I still hanker after the Transcendental Object = X as the right and proper counterpart to the Transcendental Unity of Apperception (the 'I think' that can accompany all our experiences). I don't know if such a reading undercuts the sharp division between appearances and things in themselves; if it does, and if Kant did drop the Transcendental Object, perhaps that's why.

In addition, of course, even the most enthusiastic student of Kant could hardly buy the tables of fours and threes and dozens into which Kant organizes absolutely everything. The four kinds of nothing seemed but the culmination, indeed, the *reductio,* of this nearly compulsive aspect of his thought. In this connection, Heidegger's early Kant book seemed definitive: there were two strands in Kant, the truly original one, forging courageously ahead to a new insight, and the conservative, frightened one, taking shelter in 'rigorous' constructions to protect their creator against the radical implications of his truly innovative insights. I don't suppose I ever accepted Heidegger's thesis that what was truly new in Kant was the insight into radical finitude — next thing to Being-to-Death; but I did gain comfort from the excuse that Heidegger presented for ignoring the systematic side of Kant's argument.

In short, I always had problems with Kant's fundamental ontological dichotomy, as well as with his oversystematization of everything in sight. Nor, I admit, can I accept nowadays the sharp distinction, as Kant insisted on it, between perception (or, more generally, 'intuition', *Anschauung*) and thought (concept, *Begriff*). As a more general distinction, analytically pursued, between the matter and form of experience, it is indeed fruitful. But if thought without perception is empty (as it is), perception, on the other hand, is always already in

some primordial way 'thoughtful' or 'conceptual'. Except for the indispensable mediation of the imagination and its Schematism, that mysterious power 'deep in the human soul', Kant seems to have entertained no concept of tacit knowing. We have either simple affection (being affected by . . .), which is not cognitive, or the function of judging, which is. As I have already suggested in my first chapter, that division is unfair to perception, which is already cognitive and, indeed, the foundation of, and model for, all knowledge. But I don't think I saw that in my Kantian days. Kant's position leads easily to Helmholtz's theory of sense perception, with its unconscious inference, a view no one in those days had thought to criticize, let alone reject. All I recall in this context is that I always found the Transcendental Aesthetic somehow irrelevant and boring. It is the transmutation of time and space in the argument of the Analytic that captivates.

There is a terrible gap in my life, however, in which its captivation escaped me. My first ten years farming I found I had lost any ear for the sacred text. We had a great gray Percheron mare named Kitty; I couldn't look at her and ask, was she an appearance or a thing in herself. Of course the question is equally absurd for a gnat or a mouse; but somehow a ton work horse seems more absolutely real, out of all relation, or relativity, to our mode of perception, than smaller critters. Come to think of it, I don't know why one's offspring don't have the same effect: babies are not just phenomenal either (or not in the Kantian sense!) Whatever the reason, there it was: agricultural duties and critical philosophy didn't mix. It was like being bereft of one of one's senses. And when I could read Kant again, later on, it was perhaps the immersion in farm life that made my rereading even more radically realistic than it had been when I had come to the Analytic first, as an agriculturally naive student of philosophy.

Be that as it may, I still find Kant's Analytic, rather than the *cogito* (let alone some dialectic leading to the World Mind), the proper starting point for philosophizing. For one thing, as would-be knowers (and, *contra* Kant, also as moral agents) we begin and remain where we are, within a concrete, orderly experience, but nevertheless experience. There is nowhere else to be. Descartes's effort to lead the mind away from the senses, if fruitful at the time for the construction of classical physics, was philosophically disastrous. As Merleau-Ponty put it, there is no *survol,* no Lucretian plateau from which to survey with

total detachment the crowds doing battle on the plains below. We start from and return to experience—sensed experience—as our base and our medium. That much there is that is true in Kant's doctrine of appearance. Not that we are radically cut off, as he believed, from things in themselves; but things as we perceive and learn to understand them are always things in the limited perspective *through* which we have access to them. That's why, also, knowledge is always partial, the real never exhausted through our lines of access to it, however sophisticated and ingenious they become. But neither is our experience atomized, meaningless, without ordering principles, as the empiricist tradition would have it. The place we start from and return to has its recognizable shapes and ways of being and becoming. It is a question, as Benjamin put it in a different context, of remaking the concept of experience.

It is because we are firmly rooted in experience, moreover, that the proper form of philosophical argument is *transcendental* in Kant's sense of that equivocal term. Perhaps I should say, parenthetically, that, so far as I can tell, Kantian transcendental argument has no connection whatsoever with what was called 'transcendentalism' in nineteenth-century America—I don't claim to understand it at all (as I do claim to understand, and reject, German idealism), but so far as I can tell it's yet another form of Victorian waffling. Nor, despite a small effort on his part to connect them, has the Kantian sense of 'transcendental' any connection with the medieval 'transcendentals', one, good, and true. It's very simple. In Kant's view, transcendent truth is beyond us: that is, we have no insight whose content is wholly detached from our contingent, factual ways of experiencing things and events. As Kant puts it, we are not intuitive intellects, with direct, unmediated access to absolute reality. To put it crudely, we are not God. Whether or not He exists (and Kant of course never questioned that He did, or does), there is an infinite distance between us and Him. On the other hand, our solid, objective experience of an ordered reality rests on *some* principles: it is clearly not just Humean chaos, irrationally associated into a comfortable enough dwelling place by mere force of habit. As philosophers, we want to search, reflectively, for those principles: we want to seek out the necessary conditions indispensable to the kind of experience, the kind of well-ordered experience, the *objective* experience, we in fact have. So we try to probe back of experience to find

those sources. When we find them, however,—and this is the trick of transcendental arguments—they will be valid, not absolutely, but only for the experience whose founding principles they are.

That may seem obvious, but it doesn't correspond to most contemporary philosophy. Many would reject any search for 'foundations' of any kind, and of course if 'foundations' are to be wholly detached from any connection with experience they are right. But most contemporary philosophy, it seems to me, is glaringly detached from experience in another sense. Few if any contemporary thinkers are looking for the kind of 'foundations' seventeenth- and some eighteenth-century, philosophers still sought for. It was that kind of irresponsible metaphysics, in its Wolff-Leibniz form, that Kant himself was opposing. At the same time, philosophy now vaunts itself to be pure argument: skill in constructing ingenious intellectual constructs and deconstructing those of others, with no connection whatsoever to any reality except that invented by science fiction writers. All that possible world stuff! A Kantian, or quasi-Kantian, form of transcendental argument could serve, I should think, as a corrective to that kind of professional frivolity. There is an actual world that we happen to be part of and philosophy is, or ought to be, the practice of asking questions, at a reflective level, about it and about the activities and interests of us who are in it. Possible world parlor games may get you tenure; so much the worse for our universities and our philosophy departments. I have been reproached for making snide remarks about 'analytical' philosophy, on the ground that it will soon fade away. But I see no sign of such a benign event. Even in the treatment of 'applied' problems, one can get away with any degree of irreality, so long as one is clever.

That's a dismal subject; back to Kant. Kant sets the overall problem of the *Critique* with reference to the question whether metaphysics as a science is possible. Now science, or anything worthy the name of knowledge, for Kant, as for most philosophers in our tradition, must be universal and necessary, as well, of course, as more than trivial. It must say something true about nature in a way that holds undeniably and in all circumstances. Statements, or judgments, as Kant calls them, can be interpreted in the Aristotelian manner as bringing in each case a predicate to a subject: bodies are extended, or bodies have weight, or every effect has a cause—and so on. In every judgment, moreover, the predicate either adds something to the subject or it does not. In the

latter case we have an *analytic* judgment, as in, say, that all triangles have three angles. Such judgments can be made *a priori,* independently of experience, but they are trivial. Judgments of the former kind Kant calls *synthetic:* they are such that some new predicate is added to the subject; so they really tell us something. But how? If they do so on the basis of experience—*a posteriori*—they are, as Hume has shown, merely probable—matters of opinion, not knowledge. For a seeker after knowledge, that is, after judgments that are necessary and universal, neither trivial nor possibly mistaken, therefore, the leading question is: *are synthetic a priori judgments possible,* judgments that have content but do not depend on the particulars of experience for their justification? According to Kant, we do in fact possess such judgments in two areas, mathematics and pure natural science (that is, the foundational portion of physics not based on empirical data and so "pure"). So we can ask how these judgments are possible and then apply our answer to the assessment of the claims of metaphysics. I shall not be concerned here either with mathematics (the sciences dealt with in the Aesthetic) or with metaphysics (the subject of the Transcendental Dialectic), but only with the question of the founding of pure natural science, and, as it turns out, at the same time with the grounding of experience as such. How does Kant establish synthetic a priori judgments in this area?

Synthetic a priori judgments are possible, Kant argues, only when some 'third' is available with reference to which we can legitimately unify subject and predicate. In the case of mathematics, he believed, it was our pure 'intuitions' (*Anschauungen*) of space and time that made such unification possible. In the case of metaphysics, of course, the trouble is that there is no such third something, and so, although metaphysics as a natural drive is inevitable, it will never issue in a science except in the very limited area prescribed by the principles of the Analytic, with some restricted empirical material built in, as in the *Metaphysical Beginnings of Natural Science.* Neither of these two subject matters need concern us here. What happens in the Analytic, in the search for synthetic a prioris appropriate to pure natural science? We must have some third something, as we have seen, that justifies our synthesis of subject and predicate. What Kant finds, he believes, as the third that permits synthetic a prioris here is, in the First Edition, the Transcendental Object = X, in the Second, "any possible object of

experience". Referring to such possible objects, we can claim to know, in advance of any particular experience, that in all appearances, objects have both extensive and intensive magnitudes, that in all changes there is a cause that necessarily precedes the effect, and so on. Kant of course sets out these principles in his usual four triads, a systematic outcome we have no hope of retaining. But what about the alleged universality and necessity of his vaunted principles?

That is a question we will have to return to. Meantime let's look very roughly at the general course of the argument in the Analytic, particularly at the transcendental deduction of the categories. In any transcendental argument we start from something we have and ask about its necessary conditions. Here we are looking for the necessary conditions of the objective experience of things and events in space and time that we in fact have. The principles Kant discovers in his search for the necessary conditions of experience as we have it are principles supplied by the constitution of our minds, in the case of the Analytic, which is all I am concerned with here, by the constituting *activity* of our minds. I don't know why, even if cloaked by a theoretical veil of ignorance, the characters and behavior of things shouldn't also be contributing to the way we experience them. Here I am betraying, again, my weakness for the Transcendental Object. I shall return to this question shortly. Meantime, however, I want to stress the significance, for our grasp of what it is to make a knowledge claim, of Kant's insistence on the knower as agent. Even if things also set conditions for our knowing them (as indeed they must), it is an inestimable step forward in our conception of knowledge to recognize that our activity does indeed *inform* our understanding and so reality as we understand it. Humean experience, Humean habit, Humean inference, permits no agency at all (Hume does indeed speak occasionally of "acts of the mind", but in his own terms there is really nothing he can mean by such a phrase). On his account, there is nobody there to make any inference, nobody there to know. Kant's fundamental move beyond the empiricist, associationist tradition was to recognize the role of human beings as actors in the construction of knowledge, in the reading of reality. Seventeenth-century thinkers spoke of reading the book of nature. Empiricism abandoned the reader (who, admittedly, is no Cartesian pure thinking substance or Spinozistic active intellect) and so lost both nature and her book. This aspect of Kant's teaching is

found in its simplest and clearest form in his remarks, in the Preface to the second edition, about how it is in every case the activity of human inquirers that has set a discipline, in his words, "on the sure path of a science". As against Kant, of course, Hume was right in finding such paths not sure: in terms of Kant and the tradition, indeed, there is no knowledge, as radically distinguishable from opinion. One has only to notice that Kant counted Stahl, the "discoverer" of phlogiston, as one of the few, along with Euclid or a proto-Euclid, and Galileo, who had thus initiated a new highroad of science, to be pretty sure he must be wrong. But if he was mistaken in persisting in the quest for certainty, he was profoundly right in stressing *our* ordering of experience as a source, if not the source, of its objectivity. He made it possible to return to our cognitive inquiries the persons whose inquiries they are.

As Kant put it in the Analytic of Principles, "the grounds of the possibility of experience itself are at the same time the grounds of the possibility of the objects of experience." Although it is quite beyond our powers to manufacture experience as we would like to have it, it is nevertheless our ordering of experience, our giving of rules to it, that makes it the objective experience it is. What is given us is always given in, or through, the forms we have already given to it. We approach nature using rules that we have legislated for understanding her. Kant formulates those rules, first, in terms of what he calls Categories: concepts like substance, cause, unity, plurality and so on through which we grasp whatever confronts us empirically. Each of these fundamental concepts, he argues, provides a *function* for ordering experience. But all these functions in turn presuppose a further unity: my experience is held together ultimately by the fact that I could unite all my experience with an 'I think'. Kant christened this deepest presupposition the Transcendental Unity of Apperception. He approached it, especially in the first edition, through a difficult and devious set of arguments (the Subjective Deduction of the Categories) with a strange psychologistic slant, as well as through the more straightforward Objective Deduction. To put it very simply, what he does is to show that even the subjective succession of experiences in time: first I see a cloud, then a patch of blue sky: even such a subjective succession is possible as a coherent segment of experience only through my imposition on my fleeting percepts of substantive, causal, unifying relations: an imposition I have always already made, prior to

this particular instance of temporal flow. And all these ordering functions, in turn, are united, in the last analysis, by the way they belong to *me*. The Transcendental Unity of Apperception is the final, unifying agent in the scene before me—not only in my 'inner' apprehension of it, but in its very thereness: its objectivity as really before me, in the valley and the hill beyond my window. Note, this is by no means a question of a Fichtean positing Ego (though when one puts it very bluntly as I have just done, one can scarcely blame Fichte and his ilk for taking off in the mad direction they did take). We are in fact in a world that is made an *objective* world through the ways in which we have always already organized it, the ways in which we approach and assimilate it. We are in the world, willy nilly; but the way we apprehend it is something we have imposed on it, indeed, cannot help imposing on it. And at bottom that means that the very fact of being able to give rules to experience, of being a unifier of experience, is the last, most fundamental necessary condition we find to make possible the experience we in fact have. This is no absolute, it gives us no access to a possibly immortal Cartesian Mind, but it obtains, always and everywhere, for the unification, the significance, the very object-character of things as they appear to us.

Now that I have located the T.U.A., I want to perform some rather strange transformations in Kant's argument by thinking about it differently. For someone who considers herself an historicist (in the sense of finding history primary, and here, particularly, in finding the history of philosophy primary for any exercise of philosophical reflection), this is a singularly unhistorical manner of treating one of our great texts. I can't help it. Kant began by distinguishing questions of fact from questions of justification; what other philosopher could help one make that move? Kant himself has shown the impossibility of metaphysical speculation in the grand tradition; no use going back to Spinoza, as I sometimes wish one could, for inspiration, let alone to earlier, perhaps medieval sources, which have never spoken to my condition. And on the other hand, it is necessary, if one is to reflect to any purpose nowadays about human knowledge or human agency, to move firmly beyond the naiveté of empiricism, just as Kant did against Locke. I shall come back to that theme in the next chapter, but for now I want to show, if I can, how Kant's transcendental argument can be heard (to adopt Langer's long ago phrase) in a new key.

One parenthesis, just in case I am accused of not having noticed: what looked like such a move back to Kant was made several decades ago in a paper by Konrad Lorenz that was translated and widely circulated and which in fact became, alas, the foundation for that thoroughly unphilosophical movement called evolutionary epistemology. Kant's a prioris are there demoted (or promoted?) to our genetic endowment and away we go: a geneticization of Locke lacking any soupçon, so far as I can see, of a Kantian question *quid juris?* There is by now a large body of literature in this unfield; I see no reason to deal with it, just because in its early days Kant's name was invoked on its behalf. Granted, what I want to do (and have tried to do before now, twice, with a fifteen year interval) is to try my own rereading of the Analytic, with, admittedly, a very non-Kantian outcome, but I hope in something like a Kantian spirit.

Who is the T.U.A.? That's the question I start from. For Kant, the Transcendental Unity of Apperception, of self-awareness, we might want to say, is a mere fact that I could unite all my experience by an 'I think'. It is a mere pinpoint of unity. Were I to claim for it a content, a character, I would be setting forth on the uncharted sea of pure speculation, claiming to develop a "rational psychology", as Kant calls it, a theory of the being-in-itself that causes, somehow, the feelings, beliefs, percepts I successively entertain. *Verstand,* intellect, 'understanding' as we mistranslate it, can apprehend only the fact of such a unifying principle, never ground it, theoretically, in a noumenal reality. But what if the T.U.A. were, neither on the one hand a mere fact that . . . , nor on the other a self-knowing, thinking substance such as Descartes claimed to have discovered by the Sixth Meditation, but something more ordinary: a real, live, breathing, perceiving, exploring *animal,* destined to seek, and find, its way in a real, existent, challenging, but up to a point manageable environment? What happens then to Kant's picture?

First, such a seeker for knowledge is alive, and therefore (if in the human case, differently) historical. There is nothing eternal about the T.U.A. It develops, dies, is replaced by others. Obviously, further, the target of our search for knowledge, my beloved Transcendental Object, is no longer a 'mere' appearance. The possible objects of experience become, after all, things in themselves, things we cannot penetrate to their hearts' core, but nevertheless real things that we, as live,

exploring animals, confront in our inquisitive way when we try to discriminate this from that in our surroundings. They are in part familiar, in part mysterious, but they are real. And the order we give them is really their order, some aspect of their order, grasped in relation to us as knowers, but still theirs, not in any arbitrary way ours. We don't after all just throw things together in the manner of a Chinese Encyclopedia. By asking nature the right questions, by performing experiments appropriate to a concrete cognitive problem, we may find, often do find, though of course always within the context set by our questions, trustworthy answers. Nature replies to those who inquire of her shrewdly and reasonably, within the framework of a discipline aimed, with some past success, at seeking and finding answers. We are real animals using our perceptual as well as more cerebral capacities to seek enlightenment in, and about, the real nature that surrounds us.

Thus there are two radical transmutations effected by my answer to the question of the T.U.A.'s identity. On the one hand, we are organisms seeking to orient ourselves in our environments, full-blooded, living, hoping, sometimes despairing entities, doing our best to make sense of things. On the other hand, the nature we confront in our efforts at orientation, the place we find ourselves in, is every bit as real as we. In the case of scientific inquiry, in particular, we are trying to orient ourselves with some theoretical rather than strictly 'practical' aim. Instead of trying just to recognize what's food, what's a predator, what's a mate, we are trying in some special respect to find out something about how things work. But in every intellectual as well as every more humdrum 'practical' exploration, both we and the objects we are concerned with have lost their condition of being mere facts-that or mere X's and have taken on full actuality.

Third, and just as important, we ourselves have become, clearly, part of the nature we are seeking to interrogate. Both the moves I have suggested are already, though triggered by a reading of the Analytic, thoroughly unKantian, since we are fleshing out both the T.U.A. and its correlate in nature in a way Kant would have found entirely inappropriate. But the third move, which makes us part of nature, seems even more heretical. When Kant talks about body (his body), as he seldom does, it appears as part of the *external* world. Over against that small East Prussian with his daily walks and sparkling dinner table wit, there is a world of Pure Reason he was investigating: a realm of the Mind with

its own topography, its own systematic unity. When it comes to the mind-body relation, Kant, like most thinkers up to our own time, however shrilly some of them deny it, is still irredeemably Cartesian. But if we are, as seekers after knowledge, real explorers of a real nature, we are so because we ourselves are part of nature: in it, not over against it.

What remains in all this of Kant's laboriously elaborated argument? Three essentials remain, it seems to me: the active role of the knower in making experience objective, the inexhaustibility of the known, and the indissoluble connection between knower and known. Kant has indeed shown us the way, as he meant to do, to move between Wolffian-Leibnizian dogmatism on the one hand and Humean scepticism on the other. Admittedly, we have done this by abandoning both his objective and his means to it: the aim of establishing a universal field of pure intellect where the truths on which all human knowledge is based are safely preserved forever and ever and the rigorous dichotomy between appearances and things in themselves that was to mediate that achievement. But we have found a way to restore significance and objectivity together to experience as neither dogmatic metaphysic nor blind empiricism is able to do.

Admittedly, not only the systematic table of Kant's principles, but their universality and necessity must now be sacrificed. If the knowing agent is a bodily-sentient animal trying to orient itself in a real environment, there is little hope that the principles by which it guides itself have such indefeasible or universal standing. Living things don't last forever, and neither do the ways they do things. Are there then no synthetic a prioris at all, and are we back with Hume and scepticism? Kant would surely have said so; we have abandoned the cut between knowledge and opinion, so where else can we be? Nevertheless, it seems to me that we can historicize Kant's synthetic a prioris, as we have the T.U.A., and still retain the basic structure of his transcendental argument. Every human being, every human society, goes about its approach to natural knowledge (as to other, less cognitive activities, like political life or artistic creation) from some starting points that it takes as given: so *a priori* in its peculiar circumstances. There is no 'human mind' as such, as Kant believed, whose eternal structures we could investigate; but there are human beings responsibly trying to approach nature objectively, along the lines prescribed in each case by

the maxims, techniques, beliefs of a given scientific culture. This is not to conventionalize the search for knowledge, but to set it, concretely, with the horizon of history. A now fashionable writer in science studies proclaims, "Nothing is known, only realized in a trial of strength." Nonsense, indeed pernicious nonsense! Much is known, even if it is never inalienably known once and forever and even if its acquisition, as one kind of *praxis,* of course includes and entails all sorts of all too human manoeuvering. But at any given time the Kantian structure of presuppositions serving as necessary conditions for empirical inquiry, and valid only for those, still holds. The historicization of knowledge need not lead to its denial. Instead, I hope that my admittedly drastic rereading of the Kantian Analytic can serve as a reasonable taking off point for further reflection about the nature and upshot of our cognitive claims.

Beyond Empiricism?

The rereading of the Analytic that I have undertaken demands, further, a difficult revision, or redirection, of reflection about knowledge. What we have to do, as Whitehead argued in *Nature and Life,* is to reintroduce the category of the living into a dead Cartesian nature, where there are separate minds and mechanized matter and nothing else. Much of the chapters to follow in these musings will be concerned with concepts and disciplines that can assist us in this effort. For the moment, however, I want to think back a little about one at least of the difficulties that has stood in the way of such a new beginning. To put it very schematically—and saying again, of course, what many others have been saying for many decades—before we can take a step forward, we must get ourselves out of the double dead-end the Cartesian tradition has led to, or the Cartesian alternative, as Plessner called it: idealism or subjectivism on the one hand and on the other an alleged objectivization that also shrinks into the subjective presentation of 'observables'. It is the latter that, with the exception of the Hegelian interlude of a century ago, has chiefly characterized the English-language tradition. As thinkers in this tradition, then, we need to transcend the null-point of empiricism. This has been argued for often enough, and even, some people think, achieved often enough. But let me think about the problem once more, as it appears to me or has appeared to me in my wanderings in and around philosophy.

One of the lessons to be learned by rendering the Kantian argument as I have done is the recognition that knowing is an activity. To ask about knowing is to ask about something we, and some other animals, do. Epistemology is a branch of ethology. In the same spirit, Polanyi called the problem of knowledge *ultrabiology,* and my colleague Harlan Miller refers to *zooepistemology.* However, epistemology is not, be it noted, a branch of evolutionary theory: it's a question of certain kinds of activity, not of the causal sequences in the course of earth's history by which they got there. Ernst Mayr makes a distinction

between 'proximate' and 'ultimate' questions (and answers). In these terms, only evolutionary questions are ultimate. The question how it works or what it means or the like is proximate only. The final question is: how did it get that way? Philosophical questions are, in the terms of Mayr's distinction, merely proximate, not ultimate. But I would venture, with respect, to suggest that which is which depends on one's own interests. From my present, reflective point of view it's the question what it means to make a knowledge claim that's ultimate. Of course our phylogeny has a bearing on this question: it sets the stage for it, if you like. But it doesn't give us any answers or even tell us how to look for them. In any event, the point here is simply that we are asking about a kind of activity characteristic of certain living beings, including ourselves. Never mind how we came by it; now that we have it, how does it work, what are its claims?

At the same time, it took some pretty strange maneouvering on my part to get out of Kant's central argument an acknowledgement of the other, equally fundamental factor in any adequate account of what it is to know: the reality of the nature that is both the object and the location of our cognitive activities. We have to notice, to ask, to say, to put assertion signs on our sentences; but all that noticing, asking, saying is *about* something. To use a much touted philosophical term, it's intensional. Granted, 'intensionality' has been used in the Husserlian tradition to 'bracket' or suspend reality for the sake of getting at some elusive 'field of consciousness'. The sense I have in mind is cruder and even, some would hold, question-begging (more of that, too, later). Our cognitive activity, I want to claim, is intensional in being about realities prior to it and in which it is included. A decent account of knowledge (I hesitate to call it a theory of knowledge, because I don't think there are such things as philosophical theories)—a decent account of knowledge, to be an account of *knowledge,* must be indefeasibly, undeniably, incurably *realistic.* More of that, too, in a later chapter. For the moment, I want only to try to wrestle, or, chiefly, to point to some of the conspicuous thinkers who have wrestled, with the *Leitmotif* in our tradition that has made it so difficult for us to articulate a reasonably realist epistemology. And that, of course, as I have already suggested, has been the dominance, or at least, the constant recurrence in our tradition, of empiricism, or of philosophical styles akin to empiricism.

Viewed in a somewhat broader context, indeed, as I have just remarked, empiricism is but one wing of our Cartesian legacy. There is mind on the one hand, matter on the other, with God to harmonize the two. When the self-evident existence of a Maker recedes from view, philosophers try to construct a whole world of one finite substance or the other. Mind can be swollen up to Hegelian Spirit if one is willing to fool oneself sufficiently. But matter, on the other hand, tends either to be supported by a dogmatic physicalism, as in many thinkers from Hobbes to present-day reductive materialists, or to shrink, when honestly examined (in the light of traditional concepts of perception), to mere subjective data. It is that issue in subjectivism or in a naively reductive materialism that makes empiricism so problematic.

"Is the cow really there?" That question, asked at the outset of E.M. Forster's *The Longest Journey,* is emblematic for English-language philosophy in our century. I think of it whenever I go by Parker's Piece in Cambridge. The cows have vanished from that particular scene, although they still come into view from other parts of Cambridge; undergraduates can still pose that question if they so please. Maybe nowadays they don't; the cow was, and some cows still are, really there, and contemporary philosophy prefers to break its head on science fiction counterexamples of a more exotic nature. Nevertheless, skipping the interlude of British Hegelianism—which spread, over here, at least as far as St. Louis, where the *Journal of Speculative Philosophy* was founded—Forster's question fairly represents the spirit of our tradition back to Hume. Hume himself deplored the failure of his *Treatise,* which fell, as he said, dead born from the press; yet Mill, while ignoring Hume's argument on induction, accepted his phenomenalism: the view that all we really have to sum up to experience is little inner somethings, impressions and their faint copies, ideas, which somehow cohere together, through the gentle chemistry of association, to make what we happen to call 'things'. For Hume, our beliefs about the world around us are produced by our propensity to feign; for Mill, objects are but permanent possibilities of sensation. At bottom there's not much to choose between those formulations, except that Mill optimistically supposes incorrigible science can construct itself on such an unlikely foundation, whereas Hume knew better. For Kant, in

contrast, objects are at least empirically real. And it's true, too, of course, that in a vague way Kantian concepts influenced for a time British thought and even (through Coleridge) British poetry. Nevertheless, Humean phenomenalism, the sceptical-subectivist strand in Hume's philosophy, is at least a strong recurrent theme in our philosophical tradition (and even Coleridge's son was named for the founder of associationist psychology, which in turn derives from Hume). In my own long lifetime, sense-data theories, their refutations and revivals, scepticism and the trumpeting of ignorance have all had their day. Russell's last philosophical works, *An Enquiry into Meaning and Truth* and *Human Knowledge: Its Scope and Limits,* were both dedicated, their author acknowledged, to applying the tools of modern logic to the philosophy of Hume. Indeed, despite the common notion that Russell kept changing his position (as he certainly did in some ways), his Humean starting point is already apparent in the famous question about the penny: is it 'really' circular when I see it 'as' elliptical, or does it consist rather in a whole series of perspectives dependent on the angle of my vision? Let me call this attitude, for short, and in honor of Forster's cow, the anti-bovine attitude.

That I raise here once more the challenge to that kind of question does not mean, on the other hand, that we should not take seriously the problems raised, half-heartedly by Locke, quixotically by Berkeley, and consequentially by Hume. We can no more transcend empiricism by ignoring Hume than we can transcend the Cartesian dilemma by ignoring its Cartesian source. The thought, power, influence of Descartes should be faced squarely; so should the challenge of Hume's arguments.

We could, of course, as is now so fashionable, renounce philosophizing altogether and just talk, deconstructively, pragmatically, post-deconstructively, in other words, meaninglessly, as the mode of the day happens to dictate. But although I have always been sceptical of philosophy as a discipline, I still have a weakness for its perverse sort of question, and particularly a prejudice in favor of asking our kind of question within our kind of history—up to a point (not including every writer who has ever published in a philosophical journal or even every philosophy professor prominent in academic debate!) So, for the

moment, back to Hume and recent challenges to the empiricist (that's to say, in my view, Humean) tradition.

In speaking of Kant in his 1932–33 lectures, Jaspers contrasted the grand and fruitful circle of the transcendental deduction of the categories and principles with what he called, I thought, the *Kaninchenkäfig,* the rabbit cage, of Hume's argument. A German friend tells me it must have been a hamster cage. In any event, the image was of a small animal running up and down over and over in silly little circles: all an English-language philosopher would be capable of doing. Even then, in 1932, although I had not yet read Hume, I felt queasy about this allegation and when I came home from Germany the next year and read the *Treatise,* for all my fascination with Kant, I was indignant at this instance of German condescension. Of course we must take Hume seriously—as Kant himself did: he is one of the grand figures in our tradition who takes up from his predecessors a major strand of philosophical reflection and carries it through to its logical, and in this case (as in some others) impossible, conclusion.

Admittedly, I didn't understand the *Treatise* all too well when I first read it: witness the fact that some years later, in 1940, when I included selections from *Book One* in an anthology, I omitted the statement of one of the three premises on which its central argument rests. I did a better job, I think, in my chapter on "Hume's Premises" in *The Knower and the Known,* twenty years later. Without repeating that exposition I may just say here briefly what every one knows or ought to know—and what I have suggested several times already: that for Hume the character of human experience follows from three principles. First, all its content consists of something like psychological atoms: bits of sensed experience, immediately presented, which he calls impressions, and their fainter copies, or ideas. Second, any one of these impressions or ideas is separable from any other. True, complex impressions or ideas, compounded of such simples, may have parts they inherently contain. But no piece of experience as such necessitates the occurrence of any other. Third, however, these separable subjective items do cohere together along lines of association: when some of them keep turning up in conjunction, we expect them to do so again. Custom, says Hume, is the great guide of human life.

Now, once again, what Hume established that is not to be gainsaid is that in building up empirical knowledge, or in other words in

inductive inference, our conclusions always outrun our data. Both logical analysis and the history of science make that clear. But the aspect of Hume's epistemology (as well, of course, as the psychology of Berkeley, who in fact influenced the first experimental perceptionists; one shouldn't blame the whole disaster only on Hume)—the aspect of Hume's argument that has hogtied philosophy is the subjective nature of his starting point. Those men in cloaks passing by Descartes's window, which might, he said, be not men, but automata, have withered away to bundles of sensation. And sensations have no meaning and little content. As Descartes and all his heirs have insisted, far from seeing with our eyes anything as complicated as human beings, we have to *judge* that they are men. I had a little to say in my first chapter about the priority of full-bodied perception to mere sensation (let alone judgment) and I will return to that thesis later on. Meantime let me look back at my own patchy experience both with twentieth-century empiricism—or meta- or para- or pseudo-empiricism—and with some of its seeming refutations.

In reaction to its Hegelian period there were, in the first decades of this century, a number of philosophers active in Britain, especially in Cambridge, who belonged at least vaguely to the native empiricist tradition. But the ruling figure in British, and for a while in American, philosophy in this century has been the Austrian Ludwig Wittgenstein. For a time one almost had to be what A.J.P. Kenny calls a card-carrying Wittgensteinian in order to exist in British philosophy at all; this was certainly the case while I was living in Ireland, beyond the outer fringes of British philosophy. By now I see Wittgenstein as one of the thinkers who has tried to transcend the limits of empiricism: that's what his metaphor of letting the fly out of the fly bottle seems to mean. But that wasn't always so obvious, to me, or to many of his supporters. Indeed, while it existed, the fashion for Wittgenstein mystified me entirely.

There are special moments of non-communication that stand out in one's life. Some time, I think it must have been in the summer of 1933, Alice Ambrose and I met at the home of E.B. McGilvary, a University of Wisconsin philosopher. Ambrose had just returned from Cambridge and Wittgenstein and I from Germany and Heidegger (also, in a

shadowy way, Jaspers, but that didn't count). McGilvary was an old-fashioned epistemologist, who published an article, for example, demonstrating that even on Humean premises there must be at least one universal, that of resemblance. I think, in his kind way, he believed that two young women who had been studying philosophy abroad would have much to say to one another. But at that stage in our careers neither of us could articulate a single sentence to explain to anyone, let alone to one another, what we had been doing. So far as I know (which is very little), Ambrose has spent a lifetime explicating Wittgenstein and I, with enough distance and disillusion, have done something, now and again, to elucidate Heidegger's *Being and Time*—though seldom on my own initiative. At that point, however, for all we could say to our host or to one another, we might as well have been cinematic Aliens.

Wittgenstein's *Tractatus,* the only work he was to publish in his lifetime, as it turned out, was the Bible of the logical positivists in the mid-thirties. So, of course, I read it when (as I have already confessed) I developed a passing interest in this debunking form of philosophy: a "passing interest" from my present perspective, though it lasted several years, tempered, even then, by interests in rival points of view like those of Bergson or Whitehead. So, again, I read the *Tractatus,* but without understanding. All that stuck, really, was the dictum: "Whereof one cannot speak, thereof one must be silent", where what one *can* speak of was the subject matter of the sciences. By now I am pretty sure that the adherents of the Vienna circle misunderstood Wittgenstein's argument. I doubt that his 'atomic sentences' were anything as simple or obvious as positivists' observation sentences like 'this here now red'. In any case, at the time the *Tractatus* was just there, as one of those sacred objects one neither understood nor questioned. Since then I have read a number of allegedly authoritative interpretations of the *Tractatus,* yet I would never dare to put forward any reading of my own.

There were also the dreary people I used to refer to as the monosyllabic Englishmen: Moore and Broad and Stout and Ward. I didn't understand them either and didn't see why I should. A decade later, when I heard Moore speak in Chicago, I did understand him and that was even worse. It was all in the spirit of "Is the cow really there?", even though Moore was later to admit, famously, that his hands *were* really there and that the earth existed long before he was born. What a

concession! Hands—one's own hands—were obviously thought to be more convincingly real than the cow in Parker's Piece, although I suspect that to any one who has ever tried to milk a cow (by hand), her hands and the cow—that lowing, looming, kicking presence—were equally insistent in their reality. Yet even Moore's cry, "these are my hands!" and his still more daring guess that the earth existed before his birth seemed extravagant to many. Following Russell, I believe, many philosophers—philosophers of history, no less—used to argue interminably about the question, whether we knew anything had existed more than ten minutes ago. I'm happy to accept that subjectivistic kind of argument—once and for all—from David Hume, who could never get a job in philosophy, but two hundred years later, from a bunch of too-clever academics? No, thanks.

Yet the spirit of empiricism, or of other dispositions allied to it, was for many decades all-pervasive in English-language philosophy, so far as I saw anything of it. For a long time, admittedly, that wasn't much. When I started teaching and (at the same time) threw off the shackles of positivism, I took to working largely on historical questions, and so far as I noticed there was nothing whatsoever of interest going on in current philosophy. Of course I tried reading Dewey and even Mead, attempting to be a good American, I suppose, but I soon found them as dim and dated as I do nowadays. From 1944, when McKeon had me fired from the University of Chicago by his stooge in the College, I was quite out of things; and when I floated back at least to the cloudy rim of British philosophy, in the early fifties, it was already emphatically the Wittgenstein era. Wittgenstein's 'Blue and Brown Books' were being circulated in mimeographed copies. Alas, I found nothing in them but perplexity—and not even intriguing perplexity.

I was to meet them again, briefly, in 1967 when I went for a visiting year to the University of Texas at Austin. O.K. Bouwsma, who was one of the chief American disciples, was giving a seminar on those texts, by then published, and I thought, *now* I'll have the master properly elucidated. Bouwsma began by declaring: "Plato was an old man who thought there were chairs in heaven with gold knobs on; ha, ha!" I returned no more, and have never again tried to comprehend those strange documents. My only other philosophical encounter with Bouwsma occurred when he asked me, on some social occasion, what I was interested in. I said, for example, in the problem of explanation:

what makes a scientific explanation explanatory? Bouwsma, looking out the window at a curving street beyond, inquired: "If a car swerved there and you asked why and I said because the road was slippery, would that be an explanation?" I suppose so, I admitted. Well, then, he said, what's your problem?

Earlier, in 1953, when the *Investigations* were published, I had read that collection with a kind of fascination—chiefly wondering how so deeply Germanic a thinker could so captivate the English. But I'm afraid that I, like so many others, misunderstood their import. The language game gambit seemed to me then behavioristic: Do you want to know the difference between gymnastics and chemistry? Look at the difference in the corresponding language games. Doesn't that sound like behaviorism? And it seemed to me that Peter Strawson's prestigious review of the *Investigations* gave the same message. I suppose I must have been wrong on both counts. But that wasn't the only option. If to some Wittgenstein seemed a behaviorist, to others he was a Thomistic realist. And for many he was just a nice cheerful common-room commonsense type, pooh-poohing metaphysics. This seemed a repetition of Hume's "To live at ease ever after": philosophical analysis leads to scepticism; so give it up, chaps, forget philosophy and play another game of squash. Indeed, that was on the whole the spirit of British philosophy for many years, the era of 'ordinary language philosophy'. Philosophy became clever reflection on English idioms or for that matter English behavior: when Aristotle's puzzle about weakness of will turned into the question, would J.L. Austin take a second, and the last, slice of bombe, I think it was, and would he slaver at the mouth while he did it? All good fellows together, what? It was almost a Bertie Wooster season in philosophy. I wondered at the time, how the British, who had survived the horrors of a second world war and been close enough, many of them, to the worst excesses of twentieth-century inhumanity—how they could be so superficial and so cheerful in their academic parlor games. Perhaps it was a case of their turning their backs on what they were too tired to face. I don't know; there is always, it seems, something specially inbred and unreal, if not surreal about Oxbridge philosophizing. That is still the case, so far as I can tell.

In those days, moreover, there was not only the restriction of philosophical reflection to games with everyday idioms, but also the firm conviction on the part of all concerned that philosophy was a

game wholly disconnected from scientific, or any other kind of, knowledge. The task of philosophers, after all, is argument: we have no special subject matter we know about better than other people. So the less we know about any subject matter, the better (and for most, that included the history of philosophy as well.) The distinction between the conceptual and the empirical was absolute. And this attitude of course only increased the narcissism of the profession.

Believe it or not, I am still talking about variants of the empiricist tradition. Banning 'the empirical' and sticking to the conceptual means, not rejecting, but retaining the ground in everyday experience characteristic of this tradition from Locke onward. Things go on all right if one just doesn't try to penetrate, to undermine—to understand? Think about the logical behavior of words and phrases; classify speech acts—all this is amusing enough and harmless. Grand metaphysical systems, prating of Being and Non-Being, Appearance and Reality, all that sort of stuff must go. Language, on the other hand, is a harmless medium to play with. It's not so much, as Humboldt would have it, a true world we set between ourselves and things, as it is a sort of Peter Pan world we can float away and play in, safe from interruption by reality. The Master Wittgenstein did after all talk about language games, so that must be the way to go.

The ordinary language era has gone the way of other academic fashions. More recently, establishment philosophers have become much more sophisticated in their mastery of the esoteric discourse of mathematical logic. They are extremely subtle and ingenious, but it is difficult for the uninitiated to understand what they are talking about, if anything at all. Fortunately, however, that is not my theme here. I want to go back to a few decades ago and consider what avenues were opened to us in the literature of Anglo-American philosophy that might have helped us evade the narrowness and superficiality of our major tradition.

When I began to think about this question recently, looking back from my present vantage point, there seemed to be three thinkers who might have done the job. Gilbert Ryle, in *The Concept of Mind,* was certainly waging war against the search for secret inner bits of mental life as the foundation for knowledge. But rereading the book now, I'm afraid it was too much just touting the ordinary language line to be of much use. Allegedly, Ryle was attacking Cartesian dualism, interpreted

as the doctrine of 'the ghost in the machine'—a wholly unhistorical reading of Descartes, of course: for Descartes, cogitating mind was every whit as real as extended matter. At the same time, Ryle was, almost incidentally, unconcerned with 'sense data' or other empiricist will-o'-the-wisps. But what he substituted for Humean impressions was a reliance on the behavior of words and idioms that simply bypasses the problem. As I remarked earlier, the problem is to develop a new concept of experience, not just to let a superficial and convention-carried well enough alone.

From my point of view, once again, the crucial step is to begin with the recognition that we, like other animals, perceive, and interact through our perceptual and motor systems with, things and events in our environments. In this context, a work by J.L. Austin, another leader of the then philosophical elite in Britain, at first sight appears more promising. In *Sense and Sensibilia,* a posthumous edition of some of his lectures, he did indeed attack head on the anti-bovine attitude as exemplified in the work of two of his contemporaries, Ayer and Price. Pigs figure prominently here, instead of hands or cows—real, not apparent pigs. Cows in Cambridge, pigs in Oxford? One may wonder why. At any rate, in a time when sense-data 'theories' were current, Austin's pig was welcome. It not only ate like a pig, or smelled like a pig, it *was* a pig.

Yet one can't get much of anywhere with this essay either, I'm afraid, for two reasons. For one thing, Austin was concentrating too exclusively on the esoteric reflections of two other pure philosophical professionals, Ayer and Price. Of the two, I found Price more impressive, since, rather like Kant, he seemed to be truly wrestling with what appeared to be a vexing philosophical problem, starting from a traditional dichotomy between belief and knowledge which he could not abandon and an equally ingrained confidence in the anti-bovine beginning of philosophy. By now I question his starting point, but with respect. Ayer, however, was a pure posturer, skillful, in a glib way, at adopting and adapting the fashion of any given moment. I remember hearing of a remark of his made on a journey to Russia during the decades in which he held a chair at Oxford: asked what was happening in Western philosophy, he replied, there is only one school of any significance and that is the one of which I happen to be head. Socratic self-questioning, in which our tradition has its root, has given way to

common-room complacency. Maybe it needs an eristic like that of Socrates to undermine it; but Austin seems to work in the same spirit as his opponent. It's an inbred academic game, turning in on itself perpetually.

In particular, also, Austin's criticism still floats, like Ryle's, on a linguistic level: 'real' is a trouser word, or a substantive-hungry word, and so on. It's the behavior of idiomatic English, especially the sort spoken by Oxford dons, that matters. (Cambridge, it was said, is just a place where a couple of chaps chase one another's entailments. Come to think of it, University College London could also serve as a way station from and back to Oxford; but philosophy was Oxford philosophy. Alas, Ayer was right about that. Times have changed, though; it's now American visitors that Oxonians flock to hear.)

Back to my question: was there any way out of the prevalent anti-bovinism suggested by anyone in Anglo-American philosophy in the fifties and sixties?

To answer that question, I have to return, very briefly and sketchily, to Wittgenstein, seated, one is told, on a camp chair in an otherwise bare room in Cambridge (it was only in his very last years that he settled in Oxford, and it is Cambridge and in particular the Cambridge of Russell and Moore that sets the scene for his philosophizing), thinking very hard indeed in German, to the fascination of all those oh-so-clever English speakers. If I will never in the least understand the *Tractatus* and if as an outsider to the charmed circle of *Wittgensteinkenner,* I will never be able to offer an authoritative reading even of the later work, I do now believe I have some inkling of what Wittgenstein was trying to do. The fly he wanted to let out of the fly bottle was the empiricist tradition itself, with its secret inner somethings and its symbol systems. When he accused "philosophy" of addiction to those two concerns, it was the empiricist tradition he was attacking. Sense data or pretty logical schemes: that's all that is available. The fly bottle metaphor is a good one, for philosophy in the style of latter day empiricism is indeed buzz, buzz, buzz. Though come to think of it—for I don't really know what a fly bottle is or how it works—where does the fly go when liberated? Presumably it flies away, being evicted somewhere out in the open air. That would give us Hume's solution: be sceptical in your study if you must, but come out and play backgammon and forget it. And that is indeed how the

ordinary language people read the message. But it's not as easy as that. Instead of answering the standard sense-data arguments, as Austin was to do, for example—and so putting on a dazzling but relatively painless philosophical tennis match—Wittgenstein took the empiricist habits of thought just as far as possible, with a Germanic seriousness quite foreign to the spirit of the amiable Hume. He made it all hideously difficult: a kind of practical, rather than explicit, *reductio.* I used to wonder why he was so fascinated by examples of pain and other patently subjective sensations. By now I think it's not so much that *he* was, as it is that others were. Wittgenstein spent years away from England, in Austria, in Norway, in Ireland; but for the most part his contact with, immersion in, academic philosophy was British. And that meant contact with, immersion in, empiricism. When I got back into teaching in Leeds, everything was Wittgenstein, not, so far as I can tell, with a very deep understanding of the master; but when I moved to Belfast, in 1960, where philosophy was not so far 'advanced', the whole syllabus was still grounded first, last, and foremost in British empiricism. That's where one began and that's where one ended. And of course when Wittgenstein moved to philosophy, in Cambridge, it was exactly the quintessentially empiricist style that reigned. Was that cow really there? Hume's "closet" was doubtless more comfortable than Wittgenstein's Cambridge quarters and he moved out of it more easily. Nor, it seems, except to go to Westerns or Fred Astaire movies, did Wittgenstein always abandon philosophical reflection even when he did emerge from seclusion; I heard one faithful follower tell another, some years ago: "One day Wittgenstein was walking along King's Parade and a sparrow lit on his shoulder, and he said—" Alas, I don't remember the rest of the anecdote; perhaps it was completed in a whisper, so that non-believers wouldn't hear. However, the point here is only that, like Fichte in 1800, Wittgenstein in this century took the traditional subjective rendering of 'experience' to more painful lengths than its British (or of course its French) supporters had ever done.

But I am asking here not who was the most thoroughgoing empiricist, but who showed us a possible way out of the empiricist fly-bottle. And my answer is Wittgenstein—maybe! The ordinary-language version of his cult would get no one anywhere. Nor does it seem to me reasonable to turn him back into a Thomistic realist (much as I value realism!). Nor was he *exactly* a behaviorist. Yet the way to an

escape from the albatross of empiricism is at least indicated, I think, in three features of Wittgenstein's later philosophy, all connected with the concept of language games: the argument against the possibility of a private language, the concept of a 'family' of games and the idea of language as a form of life. Needless to say, these have all been treated at infinite length by Wittgensteinian party members. With the apologies due from an outsider, I take the liberty of touching on them here in the context of my own reflections.

First, the language game theme, with its attack on the very idea of a private language, did have the advantage of combatting the emphasis on privacy characteristic of the empiricist tradition. A great physicist like Wigner could still argue that his science is concerned only with his own sensations. That has got to be nonsense, but it's been a persuasive form of nonsense on and off for a very long time. One of Descartes's ploys to play down the role of sense perception in knowledge, for example—to lead the mind away from the senses—was to stress the pure subjectivity of sensation: my impressions of color, heat, odor, and such are acceptable only if taken as just inwardly mine, with no claim to public acceptability. Yet such little inner bits are all the information about the outside world I really have. Locke attempted to enumerate, very commonsensically, the building blocks of knowledge in terms of what sense provides (along with "reflection", our inner awareness of our mental activities) but it was all too easy for his successors to transform those starting points, as Berkeley or French empiricists did, into little bits of sensation, each yours or mine. Only God or habit or pure convention could combine these purely inner bits into something describable as knowledge. Thus, as I have remarked earlier, the 'objective', would-be scientific side of the Cartesian dilemma turned out to be just as 'subjective' as the mental. For when you try to find the counters to build our knowledge of the world out there, you seem to have available only little bits in here: this mark perceived at this point on a thermometer, for example. But then, what's a thermometer when you analyze it? It's as bad as Forster's cow, worse even, since it's man-made, the product of convention, not reproduction. One is left with Mach counting his sensations—back in Vienna, where Wittgenstein started. Trying to throw out mentalistic or metaphysical fantasies, and start from 'experience', we find only bits of color, heat, odor, taste.

Perhaps you may ask, isn't shape better? After all, there are

supposed to be primary as distinct from secondary qualities; that is one of the boasted features of this 'scientific' world view. But think again of Russell's penny: what shape has it *really?* And in any event, if one is looking for 'pure' givens, it's only little bits, Humean simple impressions that are given; a shape, which has extension, and is divisible, must consist of a lot of little bits—of what? Well, that's a secret, for I can't really tell you exactly how red or loud or hot or fragrant or putrid looks or feels or smells to me as against you or Jack or Jill.

Wittgenstein harped persistently on philosophers' obsession with the search for such "secret inner somethings". Perhaps the fascination with language is in part a device to turn our attention away from these merely private aspects of our lives. Every human practice is social: more than merely mine or yours. But language, in its human syntactical-semantic form, is certainly the most conspicuous feature of our special life style. And language, as Wittgenstein shows through instance after instance, is always at least a two-person affair. One can talk to oneself only because there is a medium of language in which, from which, to restrict the ordinary range of discourse to just one speaker-and-hearer. Even the simple game of calling 'slab!' requires two players: a boss and a laborer, or some such. A child playing such a game alone would be clearly imitating a community activity. In general, one might say, children's imaginary games, including the elaborate invention of imaginary friends, import the norms of social life into the life of the individual. There would be no way to swell out my inner life into a world of games or friends, were not the public world of 'they' and 'them' and 'we' and 'us' already in place as a real arena for these 'private' imaginings. The 'linguistic turn', envisaged as a turn against metaphysics and toward a concern with language only, was another philosophical cop-out, but it had, or might have had, its role to play in the attempt to escape the pure subjectivity in which our tradition seems, again and again, to find its inevitable issue.

Not that I saw this at the time. In the period—in the fifties and early sixties, I suppose—when Wittgenstein's *Investigations* were the Bible of philosophy, I had no idea why this should be so—nor, I suspect, did many of the practitioners have much good reason for their fanaticism. Those who had known Wittgenstein were clearly fascinated by the person; the others seemed to be following a rather foolish fashion. It was only much later that I saw at least something of what might have

lain behind the intensity of his thinking. The struggle to escape from subjectivity seems one such *Leitmotif.*

There were two preoccupations of philosophers, however, from which, it seems, Wittgenstein wanted to release them. Along with secret inner somethings, there were symbol systems: formal systems that substitute for understanding. The best known tag here is the famous slogan: 'The meaning of a word is its use.' This sounds purely pragmatic, and in its most obvious meaning it certainly fed into the ordinary language fashion. Nevertheless, there is a lot more hidden here than in the grab-bag philosophies of James or Dewey, let alone in the myriad little articles of the ordinary-language school. In particular, the concept of a *family* of language games or a family of meanings of a term or phrase can serve to free us from the search for exact, wholly explicit definitions of the words and phrases we use in everyday or in more esoteric forms of discourse. Wholly exact language, as even Russell noticed, can say nothing; there has to be some flexibility in order to allow the application of a term to a reality which is always only approximately what the definition demands. All right: these are either two apples or three apples, not sort of two and maybe a bit threeish. Perhaps the number system is at the limit of the 'family' concept; but a great many everyday expressions and a great many scientific ones as well exemplify it. Think of the concept of selection in evolutionary literature, for instance. Indeed, as Mort Beckner argued for biology in general, many of its terms are, as he called them, polytypic.

Wittgenstein's favorite example of a 'family' was the concept of 'game' itself. There are two-person zero-sum games, there are round games where nobody wins, war games, team games with complicated scoring systems and immensely subtle tactics, and so on. They are all games; how and why? Nobody can say exactly. That doesn't mean that we have to fall over into pure sloppiness, or even Humpty-Dumpty language, which is as exact as you like, but arbitrary. What it means is that we ought to overcome our fascination with purely explicit, formal systems. If thought can deal only with what can be made precise, it can deal with nothing. It is not so much vagueness as the kind of flexibility inherent in the practice of a skill, linguistic or otherwise, that must be acknowledged if we are to make sense of things, or to accept the sense *of* things. In terminology introduced by Gilbert Ryle, one could say that there is no knowing that without some knowing how: and

knowing how can never be made entirely explicit. You have to do it—to be trained, as Wittgenstein insisted, not just to be told—in order to master a linguistic (or any learned) skill.

Again, this is not pragmatism: it is not just saying, if it works, it's O.K. That is a necessary, not a sufficient, condition for knowing what one is saying or what one means. Even the most esoteric and theoretical disciplines involve this less than—or more than—explicit ingredient. That is the thesis Michael Polanyi struggled to give voice to both in *Personal Knowledge* and in *The Tacit Dimension* and some of his later essays. It seems paradoxical to try to articulate the significance of the inarticulate, but that is what the concept of tacit knowing was intended to do. And this effort, I think, was convergent with the spirit of Wittgenstein's family concept, although, admittedly, Polanyi never had the faintest glimmer of such a convergence, nor did I at the time I was working with him. Indeed, he thought all those other people were 'positivists', and one couldn't tell him otherwise. Come to think of it, it was what appeared to me a knock-down refutation of positivism that first appealed to me in Polanyi's early essays into philosophy (in his Riddell lectures, *Science, Faith and Society,* first published in 1946). And as I have already confessed, during the reign of Wittgenstein I had no idea, either, what the fuss was about (though I did know it wasn't positivism!).

Back to Wittgenstein: as I said, there were three concepts in his later work that could have led us out of the empiricist dead end. The third, and most important, in my view, though least developed, is his concept of a form of life. If language games are forms of life, they should be thought of in a more than merely verbal, and certainly more than subjectivist (in my present lingo, anti-bovinist) spirit. Indeed, some notion akin to the concept of a form of life, or mode of living, needs to be applied to our reflections on human activity in general, to rituals, customs, ways of apprehending reality like science, the arts, and so on and on.

What does it mean to consider a human practice as a form of life? Dilthey, in the late nineteenth century, developed a *Lebensphilosophie;* but 'life' to him, it seems to me so far as I understand the matter, meant something like feeling. His thought was still confined within the subjective tendency characteristic, as I have been stressing, of both the idealist and empiricist branches of our tradition. To be alive, however,

is to be somewhere, responding somehow to an environment, and in turn shaping that environment by our way of coping with it. To study human practices, including language, as forms of life is to study them as activities of the particular sort of animal we find ourselves to be. While the chapters that follow will attempt in one direction or another to elaborate this thesis, drawing on the sources that happen to have helped me think about, or around, it, I want here just to acknowledge that a Wittgensteinian might have found the starting point for such reflection in the concept of language as a form of life—though I don't know of anyone who did.

One warning, however: for making remarks like the above I have been accused of 'biologism'. That is mistaken. I am not advocating the reduction of philosophy to the study of genes and their selfish endeavors to perpetuate themselves, nor to the study of neurons and their connections now fashionable in San Diego. To think of ourselves as alive, as part of the living world, it is not necessary to know a lot about biology. It is just necessary *not* to reduce everything there is to either machines or feelings (or to machines, feelings, or verbiage). In short, let us put what we feel, what we do, what we apprehend around us, back into the living world, where it belongs. Only by such a move, indeed, made carefully and wisely, can we evade the blinkers that still seem to confine our vision.

PART 2

BEING

Being-in-the-World

To know ourselves as knowers, we need to know we are alive. But living things are defined by where they are. They are entities striving to orient themselves in an environment. True, our way of placing ourselves appears to differ oddly from the self-locating methods of other animals. We have, for one thing, a funny habit of reflecting, of wondering who we are and how we do what we do. Of course for all we know other highly cerebral animals, like dolphins or elephants, may do that, too. We have no direct way of putting ourselves in their places and many animal lovers will insist that we mustn't even hazard a guess that we are in any way different from our cousins. But on the face of it, we have produced, for good or ill, all sorts of records of our presence on the earth, and that patent fact suggests that we are at any rate rather odd animals. What we are *not* is pure Cartesian separable minds and bare spread out, unfeeling, unbreathing, non-striving bodies somehow entangled together.

To describe our condition positively I have found Helmuth Plessner's philosophical anthropology useful. All living things, he suggested, show what he called "positionality": they set a boundary between themselves and their surroundings. All animals, further, exhibit centered positionality: they live out of a center from which they act on and respond to their environment. They both are and have bodies. What distinguishes human animals, in Plessner's view, is that we can in turn stand aside from this situation and take a position about it. He calls this "eccentric positionality". We are capable of a kind of mediation between ourselves and ourselves, so to speak. The existence of symbol systems, of rites as well as languages, testifies to this indirectness in our way of being. I shall say more of that in a later chapter, where I will consider some of the themes offered to philosophers by cultural anthropology. For now, however, I am looking for a more directly philosophical way to describe our situation in post-Cartesian and *a fortiori* post-empiricist fashion. As I said, Plessner's

account is appealing, and I may return to some features of it. The trouble is, though, that Plessner did not really develop his view philosophically; he is best known in fact, in Germany, for his work in sociology: a kind of European sociology that I for one find almost unintelligible. Besides, his chief philosophical work, *Die Stufen des Organischen und der Mensch,* had the misfortune to appear in 1928, the year after Heidegger's *Sein und Zeit,* which swept all before it.

When I think of it now, I don't really know why, although I suppose I was part of the sweepings. Heidegger's lectures, which I heard in 1931–32, were not quite in the same vein as his best-seller. They were anticipations of works published later. The lectures on truth, if I remember rightly, were included in the *Letter on Humanism* (although the account of truth in *Being and Time* was in part repeated in the lectures), and the lectures on 'The Beginning of Western Philosophy' were repeated in the iniquitous *Introduction to Metaphysics,* published, unblushingly and with no apology for its sick Germanism, in 1945. The most chauvinistic passages of the book were not, I must add, included in the lectures I heard; if they had been, perhaps I would have recognized sooner the radical evil in Heidegger. As it was, like all good philosophy students in Freiburg, I read *Sein und Zeit* slavishly, if with little understanding. I remember struggling through it faithfully on the deck of the *Bremen* or whichever ship it was I sailed home on in the summer of 1932, between my two years in Germany. I also took detailed notes on the lecture courses, and typed them up and had them bound. They are now long since lost, along with other notes and papers from my youth and early middle age.

By 1934, however—to continue these rambling recollections—I was thoroughly disillusioned with all these 'deeper meanings'. It was out of necessity—or sheer historical contingency, which is a kind of necessity—that I returned to Heidegger's work and to literature in some ways akin to it, in other words, to what is called continental as distinct from analytical philosophy. Since I had studied with Heidegger, and the following year with Jaspers, I was asked to write about these people when they came into vogue among us after the war. And since I had lost my job and was tied down by farm and family so that I couldn't wander off looking for another position, I thought I should do whatever I was asked to do that was in any way philosophical, in order

not to get lost altogether from any contact with my profession. Every time I wrote about the stuff, I said, 'Ugh, never again.'

Not until a quarter of a century later did I discover that I had learned something from that style of philosophy and that it could be used to a better purpose than that of its originators: I mean Kierkegaard, Heidegger and even in a way Sartre. When I was working on this material in the late forties, dutifully reading all of Sartre so far as that corpus then existed, I recall holding in my hand something by one Maurice Merleau-Ponty—whether it was his major work or just some articles in *Les Temps Modernes* I don't remember—and thinking, Oh, another of Sartre's Marxists, I can't take that. In 1960–61, belatedly, I somehow stumbled on the English version of *The Phenomenology of Perception,* originally published in 1945. I had been working through most of the fifties with Michael Polanyi on what was to be *Personal Knowledge* and Merleau-Ponty's book seemed to me to convey the same message, but in the opposite order, and in a language that I could both understand and use (or so it seemed at the time). The basic concept in which Merleau's description of human existence is grounded is that of being-in-the-world. The expression owes its origin to Heidegger, but both in Heidegger's exposition and in Sartre's it seemed, and still seems to me, defective. Merleau-Ponty took what was right in it and placed it in a more appropriate context. As he uses it, it appears to me by far the best concept available for the rethinking of philosophical questions about human beings as responsible agents and in particular as knowers.

What I want to do here is to compare the three chief versions of this concept, those of Heidegger, Sartre, and Merleau-Ponty. As I have already suggested, it is Merleau's version I have accepted, and will want to rely on here in my further reflections. Sartre, however, is much more celebrated, and Heidegger is by now immensely influential in the strangest variety of places. Virginia Tech's architecture students, for example, are fed him by the carload, I don't know why. If it were just the concept of being-in, that would clearly be pertinent for 'theories' of architecture. But it seems to be the later work, like a much cited essay about a Jug (*ein Krug*) and the Heavenly and Earthly and the rest of the *Geviert* ('Gefourth'?), that people love to brood over. And all that, I am convinced, is really appalling nonsense. The point here, however, is

just that since Heidegger is so much talked about, I had better distinguish the concept of being-in-the-world that I want to take as fundamental from his more widely studied version. Besides, his came first and since I am confessedly an historicist I have a duty to consider beginnings. And then these are recollections as well as reflections, so my contacts over the years with the work of both Heidegger and Sartre also belong to my subject matter.

First then, Heidegger. *Being and Time* was allegedly a first step in the quest for Being; the destiny of the West is that we have abandoned Being for beings; Heidegger—and/or, as it turned out, the German Folk—were to call us back from this fall. Whatever the 'turn' (*Kehre*) that is supposed to divide his early from his later work, that constant aim was never abandoned. What concerns, and concerned me, however, was what for its author was a merely 'ontic' spinoff from his work: the interpretation of human being. ('Human being' is the term by which I used to render his *Dasein;* it is by now accepted usage to call it simply 'Dasein', but I shall take the liberty here of retaining my own rendering.) Heidegger was asking about human being, he explained, as a way into the question of Being itself. Human beings, he pointed out, are the only beings themselves concerned with (their) being, so we were to look at them first before plunging, through a destruction of traditional ontology, into the heart of Being itself.

Human being, Heidegger pronounced, is in its very being Being-in-the-World. I don't want to sketch once again the principal themes of *Being and Time,* in which first everyday and then authentic being-in-the-world are delineated; but I must just mention some features of this account that carry over into others' use of it.

First, in his analysis of the things in the world, Heidegger provides an incisive critique of the Cartesian concept of *res extensae,* of things out there as just spread out in space. In terms of human being, he argues, things are not just *there,* but are 'ready-to-hand', in some context of use. This exposition by itself does not take us much beyond pragmatism. Indeed, there are interpreters of Heidegger who don't see beyond this initial and rather superficial pragmatic theme. But in his argument it serves simply as a first small way into the much more complex ontological unity of *Dasein.*

At the same time, Heidegger is moving in an equally decisive way against the Cartesian concept of *res cogitans,* of mind as a thinking thing over against extended nature. This move is not presented as explicitly anti-Cartesian; yet it is so in a fundamental way. For what Heidegger is doing in his depiction of human being as being-in-the-world is to renounce radically and once for all the attempt to get at our natures through the concept of consciousness. It is a radical move against the *cogito* as the starting point of philosophy. We have to ask who we are, not in terms of 'what it feels like to be a person', or of some secret inner something, to echo once more Wittgenstein's way of putting it, but in terms of where we find ourselves and of what we seek to make of ourselves. The world we are thrown into, the projects we have of preserving, changing, even rejecting it, our addictions to the petty claims of our everyday existence: all that sums up to our way of being (though it's a totality, not a mere sum). From this perspective (as I suggested in passing earlier), the very notion of a 'philosophy of mind' is an anachronism. There isn't stuff spread out there and mind in here; there is what it is to be human, which needs to be looked at straight, without the spectre of 'consciousness' that has till now dominated our thought. In this respect Heidegger's enterprise in *Being and Time* provides a radical new starting point for philosophical reflection. (Merleau-Ponty does in fact retain the term *conscience* (consciousness), but rereads it so radically that it transcends its subjectivistic associations.)

Admittedly, Heidegger's definition of human being, when he has hacked his way to it through a jungle of neologisms, is enough, one would suppose, to frighten the French—recently Heideggerian discourse has fascinated them, but it has certainly frightened most English-speaking philosophers. *Dasein,* Heidegger declares, is "Being-ahead-of-oneself, as already-being-in-a-world, in-being-*bei*-things-within-the-world." (*Bei* means something like 'at home with'; the standard translation is 'alongside', which says nothing; *bei* is equivalent to the French *chez;* we have no corresponding English idiom). This sounds pretty crabbed; but it is straightforward enough, dear reader, compared to the contortions of the text surrounding it. More of that later. For now, let's look just a little at the features of this 'definition', to see what further positive lessons this work has to teach.

"Being-ahead-of-oneself": human being is always in advance of

itself; we project ourselves as what we mean to make of ourselves. For human being(s), the primary tense is future. This feature recedes a little, I must confess, in one's extreme old age: what one has or has not made of oneself is pretty well set by now. But that we do exist as anticipators rather than just as plain beings seems to me an important insight. One could of course put the same point as Wittgenstein did by remarking: a dog can expect his master, but can he expect him tomorrow? But for some the fact that the primacy of the future is here presented as an aspect of a whole view of human being, rather than in a kind of neo-Pascalian aphorism, makes it more impressive (for others, of course, less so).

"As-being-already-in-the-world": we are always already somewhere, not only in a natural world, certainly not just geographically, but always already in a human world, a tradition, a "culture" (though Heidegger would have sneered at that term, as he did at most efforts to make his view intelligible). What he called "thrownness", contingency, historical givenness: that is a fundamental feature of human existence that the major philosophical tradition had ignored or endeavored to escape. Heidegger is here influenced by Dilthey, I suppose, but Dilthey's "philosophy of life" remains, I think, relatively subjective. In any case, Dilthey's account certainly did not burst upon the German-speaking philosophical community as Heidegger's formulation did. For myself, by now I would prefer to draw my sense of contingency from the facts of genetics and evolution, as well as from just plain history. More of that in a later chapter. But for now be it said that Heidegger's concept of thrownness (*Geworfenheit*) does capture pithily an aspect of our way of being that traditional philosophy has neglected or denied.

A corollary of this aspect of being-in-the-world is Heidegger's thesis of the hermeneutical circle. Again, the concept of hermeneutics (the art of interpretation), extended beyond its origin in the interpretation of scripture, comes from a tradition that Heidegger found already established. But his statement of the general principle goes a long way beyond most formulations, both before and after *Being and Time.* In such places as Charles Taylor's influential essay on 'Interpretation in the Human Sciences', for example, or in the much cited *Truth and Method* by Heidegger's follower, Hans-Georg Gadamer, the need for interpretation in history or the social sciences is contrasted with the supposedly pure objectivity of the natural sciences. Now while it is true

of course that any discipline dealing with people demands a level of interpretation different from that of disciplines concerned with inanimate or non-human subjects, what Heidegger stresses in his presentation of the hermeneutical circle is the pervasiveness of this circle, in some form, in *all* discourse. And that is a decisive point. Even a mathematical physicist, even a pure mathematician for that matter, starts pondering problems that have been given him (her) by and in a tradition. (S)he is *somewhere* at the start and grows, whether in acceptance or dissent, from and within the circle established by that historic starting-place. A tag many philosophers of science accept by now is the slogan that 'all observation is theory-laden'. But all theory is history-laden, and that means, laden with the belief structure of a particular community. There has never been a view from nowhere, but neither is there any pure view from 'in-here'. Every human world is already social, a fabric expressing the fundamental beliefs of a particular society, more than individual, even though also parochial. Indeed, the search for pure objectivity that has characterized science and the philosophy of science in our tradition, or in some highly articulate strands of our tradition: that search is itself an expression of one interpretative tradition, one way, if you like, of constructing a world, but of constructing it out of received materials in a place in which the builder happens to find him(her)self. To recognize in some such way that interpretation stretches to all disciplines seems to me a necessary condition for the development of an adequate philosophy of science. And as a matter of fact one can, if one wants to, extract the elements of a sound philosophy of science out of passages in *Being and Time.* I'd rather go to less tainted sources, but the message, I must admit, is there.

Some people would draw a similar moral from Husserl's *Crisis of European Science;* that's as may be. As I remarked earlier, I find, and have always found, Husserl's attempt to establish philosophy as apodictic (necessary) science sadly anachronistic. If one takes *Crisis* as purely historical, his thesis, about the establishment of modern western naturalism as a particular reading of reality, is certainly illuminating. But it is supposed to tie in with the ultimate aims of phenomenology, which, to me, are sadly quaint. What Heidegger learned from Husserl is another question. We all thought in the old days that Heidegger had been Husserl's student. This, however, I have

learned from Ott's biography of Heidegger, was not the case. There were two chairs of philosophy in Freiburg, a Catholic and a non-Catholic one; it was the non-Catholic chair Heidegger had been called to, as Husserl's successor after the great phenomenologist's retirement. Apparently Heidegger had tried and failed to get the Catholic chair and then latched onto Husserl as someone who would forward his career despite that failure. This was something we had no idea of in the early thirties. The story was that Heidegger had run away from his *Klosterschule* (Catholic boarding school) with a copy of Kant's *Critique of Pure Reason* in his pocket, and had studied with Husserl, whom he now renounced (as I heard him do, if not by name, in one of his lectures). We thought of the professor in the other chair, the Catholic one, as just an unimportant functionary whom nobody went to hear. That he actually held the chair Heidegger had failed to get a few years earlier certainly never occurred to us. At any rate, the relation of Husserl to Heidegger was clearly not as early or as straightforward as we thought; whether the argument of *Crisis* influenced Heidegger in the composition of *Being and Time* I have no way of knowing.

That was all parenthetical. I am still noting what seem to me positive contributions of Heidegger's major work before I go on to consider its most striking deficiencies.

The third aspect of being-in-the-world was "being-*bei*-things-in-the-world", in other words, addiction to the petty concerns of everyday. This theme is highlighted in the second part of Heidegger's exposition by the contrast of everyday, inauthentic *Dasein* and the authenticity achieved by the rare existential hero, who has moved through dread to confrontation with his own death, the only event that is wholly his own—though even the resolute be-er-to-death never wholly escapes everydayness either. Be that as it may: in contrast to authentic *Dasein,* the possessor of unfortunate everyday human being is no one in particular: in its addiction to the humdrum, the 'who' of everyday human being is the 'they' (*das Man*). The praise of authenticity, of course, was a conspicuous feature in the vogue for existentialism in the forties and fifties, whether in its Heideggerian or Sartrean form. That topic as such need not concern me here (I shall return to it later), but the characters of 'the They' on the one hand and of the authentic individual on the other do figure conspicuously in the itemization of

the radical deficiencies of Heidegger's account of *Dasein,* to which I now proceed.

I have tried to take due account of the positive features of Heidegger's philosophy in *Being and Time.* Most of these are or can be carried over into a more adequate conception of being-in-the-world. There are three features of Heidegger's version, however, that make it, in my view, fundamentally unacceptable.

First, there is Heidegger's style, which is equalled for arbitrariness and unintelligibility only by Hegel. His peculiar contrast between the ontological and the ontic lies at the foundation of Heidegger's undertaking. The ontological is snatched from who knows what sort of purely Heideggerian profundities—grounded in Being itself, remote from any beings we ever know—and so a Good Thing. The ontic, in contrast, bears some relation to the real world somebody in fact lives in; thus it is a matter of mere beings, and so Bad. What this amounts to is a trick of creating pseudo-apriorisms. Thus, human being is essentially being-to-death (ontological). But you mustn't suppose that this is the case because we all have to die (ontic). Dear me, no; on the contrary, we all have to die because we are being-to-death. Indeed, any reasonable statement is merely 'ontic' and no good; it has to be turned into an *a priori* principle to become ontological and so okay. Kant wanted *a priori* principles, too, but he didn't just decree them in this dictatorial way.

And the language! Heaps on heaps of neologisms, heaps on heaps of puns. For example, in describing how we deal with things ready-to-hand (in his example, for instance, hammering in a nail), Heidegger stresses the future-directedness of everyday human being, in which *Dasein* is said "as understanding" to "project its being toward possibiliities." He distinguishes three aspects of such projection, *Vorhabe, Vorsicht,* and *Vorgriff.* (All such neologisms are printed in bold-face, as are the special pronouncements that constantly punctuate the text.) One can amuse oneself proposing translations for such terms. I have proposed for these three: 'prepossession', 'prospect', and 'preconception'. It's harder in English because of the Latin roots of our abstract nouns; one doesn't get the earthiness of Heidegger's inventions. But when one is deep in explicating this text, as I have done several times, with a group of younger colleagues, this can be an

entertaining game to play. Why on earth, though, should any one take it
seriously? Look at the pronouncement into which these three concepts
are assimilated (still about the ordinary way of handling some tool or
other object in our neighborhood for some everyday purpose; we'll get
to language ["expression"] in a few more tortured pages):

> Sinn ist das durch Vorhabe, Vorsicht und Vorgriff strukturierte Woraufhin des
> Entwurfs, aus dem her etwas als etwas verständlich wird. (*SuZ*, 151)

> Sense is the toward-what of the project structured through prepossession,
> prospect and preconception, out of which something becomes intelligible as
> something.

And that is just one sentence out of four hundred and thirty-eight pages
of similar construction. Unbelievable. Yet I must confess I myself once
took this stuff seriously, witness the notes on the margins of my tattered
copy of the work. Much later, despite my disillusionment with this style
of philosophy, I have worked through the whole text at least semi-
seriously on a number of occasions, chiefly in summer seminars with
college teachers, but also in university courses. And it did seem worth
doing, somehow. Moreover, this passage is part of the tangled process
by which the concept of the hermeneutical circle is going to be
introduced. Did it really have to be like that? One's suspicions are
reinforced, further, by the patent fact that in his later writing Heidegger
is plainly doing nothing but playing with words in a totally unconscion-
able manner. By now I wish on the whole he had said nothing of
importance, even in *Being and Time;* I have, regretfully, to admit that
that is not the case, but I really don't see why sensible people, or any
people, should spend their time and effort in deciphering that crabbed
document, let alone the rest of the *corpus.*

Apart from the way he says it, moreover, *what* Heidegger has to say
now seems to me defective in two fundamental respects, one of which
I have seen for some time, but the other only (relatively) recently
(since the last time I went through the text with a summer seminar
group, in 1979).

First, as I have been stressing since the beginning, the fundamental
counter-Cartesian turn we need in philosophy is to recognize that
there is a living world of which we are part. Being-in-a-(human)-world
is our way of being-in-an environment, as all living things are, and in
particular, as one variant of the way all animals are. And that means that

human being, like any other animate being, must be embodied. But Heideggerian human being, though "in each case mine", as Heidegger says (*je meines*), is as disembodied as any Cartesian mind could be. It isn't sexed, for example. Nor is it anywhere except in its human world; its place is in no living environment, among conspecifics or predators or prey, in heat or cold, drought or downpour. There are a couple of passing references to body, but the problem of *Leiblichkeit* (bodiliness, embodiment) is set aside as irrelevant. Human being takes everything there is as simply ready-to-hand for its purely human concerns. Despite, in one famous passage, its origin out of clay (a myth Heidegger plays on to get to his pronouncement that the essence of *Dasein* is CARE), human being as Heidegger conceives of it is simply the entity that inquires about being. It is not alive, is not embodied— and so, clearly, cannot be individuated. The 'who' of *Dasein* can only be an anonymous 'they', since only a living body, setting itself, in Plessnerian fashion, against and within an environment, could be uniquely this one and not another. Herbert Dreyfus long ago gave an excellent lecture called 'Why Computers Have to Have Bodies in Order to be Intelligent'. He says the argument is contained in his first book, but I don't think it is, really, since there he has already given in to the themes of Heideggerian analysis of everyday human being as if that were the whole story, not only of *Being and Time,* but of humanity. Never mind that; what I want to glean here from that title is the suggestion that not only computers, but *Dasein* too must have a body in order to be intelligent, in order to be at all. And it doesn't; so it isn't really you or really me, it's just 'some one', the they, the non-individuated any old one. If human being isn't understood as one form of being alive, it can't be individuated, so can't have a history, so can't be understood at all.

If the everyday necessarily falls into anonymity, we may ask, what of authenticity? Is human being truly individuated in its ultimate resolve in the face of death? I have long found both the Heideggerian account of the authentic individual (as Being-to-Death) and the Sartrean (as Being-to-Nothingness) too impoverished to carry the meaning that undoubtedly is to be found in the concept of authenticity. But that, I now believe, is not the worst feature of the Heideggerian account. What is truly shocking about it, I am now convinced, is the deep connection between that account and Heidegger's undoubted Naziism

or fanatical German nationalism—even before he joined the Party. If one reads carefully Heidegger's description of the authentic hero, of his relation to destiny and fate, and the account of historicity, as well as the correspondence between Dilthey and the Count Yorck von Wartenburg that he appends to his philosophical pronouncements, one finds, I believe, that the only authentic individual(s) there have been or could be are German soldiers risking their lives for the Fatherland. Heidegger was prevented by less than perfect health from so serving in the First World War, but this special case of Being-to-Death, and the Comradeship that could go with it, seem to me to emerge in Part Two of *Being and Time* as his ideal, as the ringing culmination of his argument. There is all that wretched everyday life, but then there is, sometimes and for the few, the glory of Heroism—Germanic heroism.

Many, I know, would question this reading. My hunch is reinforced, however, by two pieces of evidence. One is the undoubted sick chauvinism of the *Introduction to Metaphysics,* with its account of Germany as the one bearer of the destiny of Being, caught between the two barbarisms of America and Russia. The other, even more striking, comes from the report of a meeting with Heidegger in Rome by his former protegé, Karl Löwith, when Löwith had gone there on the first leg of a long and circuitous journey into exile. He had not only been Heidegger's student, but had written his second thesis, qualifying him as a university teacher (the traditional *Habilitationschrift*), with Heidegger in Marburg. On this occasion, he asked Heidegger whether his membership in the Nazi party was related to his view of history, and Heidegger said, yes, it was. Nor, incidentally, as Ott recounts, did Heidegger remove his Nazi emblem while talking with Löwith. Since I knew both men well enough to remember their appearance, this occasion rises vividly before me as quintessentially representative of Heidegger's humanity. True, this was in 1934, seven years after the publication of *Being and Time;* but there seems to be no evidence of a radical change in Heidegger's position in that period. In 1931–32 it was commonly believed that he held Nazi views, even if he had not yet joined the party, and in the companion piece of the notorious Rectoral Address that I heard him give in 1933 in Heidelberg, on 'The Role of the University in the New *Reich*', he was certainly in full Hitlerian cry.

It has taken me a long time—nine pages or sixty years—to

come to terms with Heidegger. I have had to acknowledge some philosophical lessons of *Being and Time*—and I should also have acknowledged, to be quite candid, the approach to reading Plato that I learned from his proseminar on Plato's *Phaedrus* in the spring semester of 1932. That lesson is confirmed by Herbert Marcuse's comment at a Heidegger conference in San Diego some years ago. For all his vices, Marcuse said, Heidegger made one read texts. That is true. On the debit side, however, the deficiencies even of his one truly significant published work (defects only intensified in his later writing) make his account of being-in-the-world so deeply misleading that one can only regretfully take the themes one must from it, assimilate them to what one finds a more adequate framework, and leave the rest severely alone. Any other course I am afraid I find both intellectually and morally reprehensible.

Sartre I can dismiss more briefly, especially since I have already said at book length all that needs to be said. Sartre is the last great Cartesian: a Cartesian bereft of thinking or extended substance, with simply the sheer activity of the I (not an Ego, which is a cheat, but an instantaneous I) pitted against the total otherness of mere Being (not even the spatialized Being of the Cartesian physical world). The For-itself against the In-Itself, the In-Itself against the For-Itself, with No Exit: that's all there is to it. This is not Being-In at all, but Non-Being over against Being, Being over against Non-Being, endlessly. Oddly enough, *Being and Nothingness* is a great work to teach: its devastating thesis is magnificently put. Like Hume's *Treatise,* it is one of the transcendent works of our philosophical tradition which show how, given inadequate premises, a particular movement of thought works itself into an impassable dead end. On the way to its dismal conclusion, it is brilliant. And Sartre, though strange enough in his abstract and self-defeating demand for an unattainable pure act, is not the same kind of moral monster as Heidegger. Undeniably he is parochial, too. If Heidegger is fanatically Germanic, Sartre is one hundred and fifty percent Parisian. I hope I need not try to specify, even so late in the twentieth century, why such narrowness appears much the lesser of two evils.

Third, then, what of being-in-the-world in its Merleau-Pontyan form? Unfortunately, I have always found it easier to expound a philosophical position I disagree with than to state clearly the chief points of a position I do accept. It is easier to speak from a distance. Besides, Merleau's style, while less pretentious and obstinately thorny than Heidegger's, is by no means clearer. Partly, his best-known work, *The Phenomenology of Perception,* consists at one level of a protracted dialogue with Sartre, Merleau's fellow Normalien and admired associate until their rupture some years after the War. One not only needs to know Sartre, but to know (without his making it explicit) when Merleau is putting a Sartrean position he is refuting and when he is speaking for himself. Worse still, he never stops a sentence and seldom stops a paragraph. For those who are not just captivated by the enterprise, as I was, it is a difficult book to read, and even for such as me, it is a difficult book to talk about. When I have tried to do so in the past, I have found myself infected by his style and while that sometimes makes for an amusing *tour de force,* it does not produce the kind of reasonable exposition I would like to achieve. Yet I have to try again. For in *The Phenomenology of Perception* and in some of his essays Merleau-Ponty has left us, I still believe, the most effective account so far of what it is to be in a world: to be a person living his (her) life in the odd fashion vouchsafed us by the contingencies of global, biological and human history.

The best place to begin is with the early *Structure of Behavior,* in itself a rather dull book (appallingly translated; never try to read the English version!), which does however introduce some fundamental concepts. In the latter part of the work, Merleau-Ponty distinguishes among what he calls the physical, the vital, and the human order. Each of these spheres of reality, so to speak, provides necessary conditions, one might say boundary conditions, for the existence of the next and narrower order. The human order sets further constraints on the vital order: thus our existence is bounded in each case, not only by species-specific requirements like those limiting the possibilities of individuals in other species, but by the demands of the particular culture within which we happen to grow to maturity. At the same time, however, that particular society gives us a home, and, most significantly, it gives us the possibility of remaking it, or even of making, within limits, something new that never was before. This difference in human

sociality: that is, the openness of human being-in to the creation of novel forms of life, is a point that some have made by contrasting other animals' *Umwelt* (environment) with our *Welt* (world). Merleau's formulation makes it specially clear, however, that we are dealing in our case with one version of life on earth, not with some ethereal style of existence detached from earthly concerns, some Cartesian mentality or elusive Heideggerian Being.

So far, so good, or so I hope. The question is, what does Merleau-Ponty do, philosophically, with the human order in his other work, particularly in *The Phenomenology of Perception* and in some of his essays? (I am not concerned here with the unfinished and very strange *Visible and Invisible.*) Perhaps I have been answering that question, indirectly, recurrently throughout these reflections. My stress on perception in Chapter 1 echoes Merleau's thesis of the primacy of perception; I hope to say more about that, also indirectly, when I look in a later chapter at the philosophical implications of Gibson's ecological theory of perception, a theory which a number of people have found to be in some ways convergent with Merleau's. My transposition of Kant into a new key can certainly be paralleled in a number of passages in Merleau-Ponty's book. And my insistence all along on understanding ourselves as living, although I didn't derive it from him, certainly harmonizes well with his stress on the importance of the lived body. To say all that, however, is to give little impression of the power of his work. The best I can do, I am afraid, is to try to summarize its principal themes. I'll try to avoid lapsing, as I have done too often in the past, into quoting purple passages that everyone except for a very small handful of disciples will positively hate. Yet in my own words I can only give a faint idea—to borrow Hume's language—of the impression the work itself can make on a reader with ears to hear.

The Phenomenology of Perception initiates a philosophical method that its author refers to as "radical reflection". Rather than detaching him(her)self from experience either by objectifying it, as empiricism tried to do, or by 'constituting' it through some sort of intellectual activity, in the style of the European idealist tradition, the philosopher is to attempt to catch the essential features of our way of existing in *statu nascendi.* Merleau believed this could best be done by restoring perception, and especially visual perception, to its proper, primary

place in our lives. For vision is not only in fact the primary sense of most of us; it is paradigmatic for the way we are in the world. Vision puts us out there with things and events and at the same time brings them here to us. I am out there with things and things are where they are in relation to a center (a lived, bodily center) that, more intimately than my shadow, moves about with me. Vision by its very nature transcends the subject-object dichotomy that has long distorted our philosophical reflections. By trying to understand perception we can perhaps overcome that disability.

To understand perception, however,—real, living, ongoing perception—we need to understand our *bodily* existence, our birth into, our maturation in, a natural and human world that we both make and are made by each in his(her) own individual, yet more than individual, history. Psychologists in the past, Merleau points out in an introductory section, have reduced perception on the one hand to sensations jumbled together through association and/or to some judgmental activity of a mind. We need to reopen our thoughts to what he calls "the phenomenal field": in effect, to experience as we live it bodily. Part One, therefore, reinstates the living body as the chief actor in our lives. Again, Merleau reviews the vain efforts of both objectivizing and idealizing thinkers to explain our bodily being, and moves to consider in his own terms the spatiality of the body, which is "our anchorage in the world". From bodily spatiality he moves to the synthesis of one's own body, both motor and perceptual, the body as "an ensemble of meanings tending to equilibrium". The next two chapters, 'The Body as Sexual Being' and 'The Body as Expression and Speech', continuing the process of radical reflection, uncover the roots of human sociality and hence of historicity. Sexual experience reveals the inextricable dependence *and* autonomy of each of us. This chapter presents, it seems to me, the core of truth in Freud's generalization of sexuality, without any of the customary Freudian nonsense. Next, language, as refined and generalized gesture, shows how we are always with others, reaching out to them by means that others, in the genesis of our mother tongue, have bestowed on us. The language chapter presents, in my view, the most effective refutation of Cartesian dualism in our literature. Descartes argued that since parrots or monkeys can ape the sounds of speech without understanding, language must be purely mental—whatever that could mean. But language must be

spoken or written, heard or seen (or touched if one is blind). It is a form of gesturing sustained and generalized by the development of natural languages. It exists, as we do, bodily or not at all. "Bodily" here, of course, does not mean 'explicable in terms of the laws of physics', but existing as a living center of action and passion, coming to ourselves, in our case, in a human as well as a natural world.

The reinstatement, or perhaps the instatement, of the body as the ground of our existence prepares us for Part Two of the work, 'The Perceived World'. Two long chapters, on 'Sensing' (*Le Sentir*) and on 'Space', continue the effort of radical reflection to catch my bodily grasping of things and events in the world and the depth of the world into which I probe and out of which things loom up at me. We are trying to articulate the inarticulate, to see coming into being the 'subject' and 'object' poles of an experience that is both originally one and incurably ambiguous. There is much stress here on the 'non-thetic', on those aspects of experience that explicit thought, whether objective or idealist, misses and even denies. (This is of course one of the respects in which Merleau's work is convergent with Polanyi's *Personal Knowledge*.) The chapters on 'The Thing and the Natural World' and on 'Other People and the Human World' complete the account of how we are ourselves out there with things and others. The text, here as throughout, relies heavily on (sometimes questionable) neurological cases and on literary allusions; but the force of its exposition is cumulative and convincing. Heideggerian 'thrownness into a world' is here no a-prioristic abstraction, but the real, historical way we come to ourselves with and among real things and real people. Scepticism about the external world or the so-called problem of other minds can be set aside for the nonsense they are and we can try to reflect on the problems—genuine, goodness knows—generated by our own actual historical condition as living human beings situated so or so in a given natural and social environment.

Part III concludes the work by taking up three philosophical themes from the perspective so far established, the Cogito, Temporality, and Freedom. The title of this part, 'Being for-Itself and Being-in-the-World', reflects Merleau's concern with Sartre's relentless dialectic, but the text goes beyond that attempted dialogue in taking up themes

touched on both at the start and in numerous previous passages in the book. It was established at the very start that the Cartesian *cogito* needs to be rethought and reformed. The 'Cogito' of this chapter has been given thickness: spatiality and duration, a finitude, not of the instant, but of a life history within which I can sometimes come to be aware of myself, though always out there, caught up in what is happening and what confronts and absorbs me, with others who see the same spectacle and are absorbed with me in the world no one of us made but which we all share. Most fundamentally—and this is a theme that shows itself recurrently in earlier chapters, I am a history. Merleau draws heavily in his account of temporality on Heidegger's theme, but with a difference, or several differences. There is no contrast here between an addictive everyday and some mysteriously authentic destiny. Nor is the future stressed as the primary tense; Merleau starts from the present, or from presence, but reads from it the stretch back to the past and toward the future. (Here as elsewhere he draws heavily on Husserlian texts.) The contrast again, however, is with the effort of traditional philosophy, whether empirical-objective or intellectualist-idealist, to deny history: to construct our existence out of instants. But no life is eternal; it is coming-to-be, endurance, and indeed, failure to endure that mark its being, and in our case, not only sheer duration, but history, the coming to be, and dying away, of customary ways of being and doing that make us who and where we are. Finally, the chapter on freedom in a way sums up the tenor of the whole work: it shows us confined by circumstances yet always, if partially and indirectly, transcending those limits when we chose to go, within those circumstances, this way or that. Freedom is qualified, indirect, imperilled but nevertheless given us in our very bodily being-in-the-world. We are always ourselves out there beyond ourselves and, within those limits, making and remaking ourselves in our very limitations.

Merleau-Ponty's attempt to reformulate the problems of philosophy on a post-Cartesian basis parallels other works, such as Plessner's philosophical anthropology, which I mentioned at the start of this chapter, or Polanyi's *Personal Knowledge,* which starts with the problem of accrediting scientific knowledge, but comes in large part to similar conclusions, or Erwin Straus's 1935 work, *Vom Sinn der Sinne,* which Merleau does in fact quote once or twice in his own pondering of the phenomenon of perception, or Kurt Goldstein's now forgotten

Struktur des Organimsus. Perhaps because it is couched in the language of what is sometimes called 'existential phenomenology', a style that so quickly alienates analytical philosophers, it speaks more plainly to my condition than do many other more widely esteemed documents in recent philosophy. I don't know if in this brief summary I have managed to convey something of its richness. What follows will partly hark back to its themes, and draw in lessons from other disciplines to support them.

There is one question I should append to this account, however: why does Merleau-Ponty entitle his major work the 'phenomenology' of perception? The opening pages of the book give an almost unreadable, and not very intelligible account of what 'phenomenology' is, or what he thought it to be. Like many French works of philosophy, it was a thesis, and presumably he was told he must explain the meaning of this key term. The trouble is, as far as I can see from my own rather tangential experience, phenomenology is a movement initiated by Edmund Husserl, in the first instance as an attempt to depsychologize the philosophy of mathematics, but developed eventually as a grandiose effort to survey, and articulate in a super-'scientific' graeco-teutonic language, what one of his disciples was to call "the field of consciousness". And this is, in my view, precisely to deny the realistic bent that is one of the major virtues of Merleau-Ponty's philosophizing. Husserl may have exclaimed "Back to the things themselves!" But what things? What he and his followers practised was allegedly a series of 'reductions' which led ultimately to a purely idealizing, utterly anti-realistic so-called apodictic science—of what? The first step was to execute a 'phenomenological reduction', that is, to *bracket,* or put in abeyance, the existence of whatever we are going to describe—say, the bridge outside the window. This is much like Descartes's technique in the First Meditation, not to deny existence, but to suspend acceptance of it in order to avoid asserting anything not wholly clear and distinct, or, in Husserl's term, evident. In Descartes's case, of course, the goal of such willing suspension of belief was to find one clear and indubitable starting point on which to build a permanent body of knowledge: a body of knowledge of real existent things, minds, bodies (insofar as they are in their nature mathematical, or, strictly speaking, geometri-

cal) and God. In Husserl's case, apparently, however, the aim is not to arrive eventually at some certain and unshakeable knowledge of existence, of real things. The aim of phenomenology is in the first instance to grasp clearly the content—the purely subjective, inner content—of what is before us. This is perhaps a good technique for a painter or a lyric poet, but what good is it to a philosopher? Well, supposedly it leads to the next reduction, which is called *eidetic,* where in turn I bracket, I guess (I can't do it myself, so can only guess!), the particulars of *this* bridge and grasp clearly the very kind 'bridge' itself. This would seem to be reduction to a sort of Aristotelian form or *eidos*—but not, as in Aristotle's case, the form I find in each case of some sort of real individual. Perhaps it is something more like a Platonic form, itself by itself—yet without the metaphysical reality of Plato's really reals. I don't know. But I do know that the eidetic reduction was to be followed by what Husserl called the 'transcendental reduction', where we—or rather he or she: the trained phenomenologist—rose to contemplation of the Transcendental Ego which, at last, was found to constitute the whole series of phenomena, whether particular as in the phenomenological reduction, or generic as in the eidetic. So here is the wretched old Ego constituting everything —and this is supposed to be pure, presuppositionless thought, philosophy as 'apodictic', that is, necessary discourse. Long ago, or relatively long ago, twenty-five or thirty years ago, when I had contracted, vainly, as it turned out, to write one of those blue Penguins on contemporary European philosophy, I read a lot of Husserl. Some of his texts, say the account of perception in *Ideas One,* are beautifully clear and careful. And his famous *Crisis of the European Sciences and Transcendental Phenomenology,* to which I have already referred in passing, usefully illuminates aspects of the 'Scientific Revolution' of the seventeenth century—if only he had omitted the 'And Phenomenology' part. It's like Heidegger's essay, 'The End of Philosophy and the Beginning of Thought': Heidegger's account of modern philosophy's domination by the Inner, the Subjective, is brilliant. And that includes the account of Husserl's philosophy too as insidiously subjective. But when it comes to the 'Beginning of Thought' we are led into pure Heideggerian verbiage. So with Husserl and 'Phenomenology'.

Then why is Merleau's defense of a thorough non-subjective,

indeed, realistic reading of the human condition called 'phenomenol-ogy'? It makes no reductions, and it spends a lot of time presenting and then criticizing work in experimental psychology, as surely Husserl would never have bothered to do. Admittedly, Merleau-Ponty does cite and use heavily Husserl's work on 'Inner Time Consciousness' in his chapter on temporality. Moreover, my European phenomenological colleagues assure me there *is* a school within the phenomenological tradition—the Munich school, as they call it, although most of its adherents seem to be either Polish or Austrian—that is heavily realistic. But again, except for reading some of Ingarden, a Polish writer on aesthetics, I have never studied this work. Nor, I believe, was Merleau influenced by it; and I am here just puzzling over the question why a text as thoroughly realistic in its import as his *magnum opus* should be labelled 'phenomenology'. It does indeed go back to the things themselves, but I don't for a moment believe Husserl ever did. So if the reflections that follow—and precede—are indebted to Merleau-Ponty's major work, they disclaim any kinship with a 'phe-nomenological' tradition.

Darwinian Nature

If the human order is a special case of the vital order, and if understanding who we are entails understanding where we are, it seems obvious that we won't understand much about ourselves, as knowers or in any other way, without understanding something about the character of the living world of which our world forms part. Oddly enough, when I come to think of it, I have never worried much about the physical order; cosmology leaves me cold. The big bang or whatever it was seems too remote from us to need our attention. But organic evolution and its consequences for the kind of nature that surrounds and shapes us are another matter. Not that the 'story of evolution', any more than the story of the universe, answers, as such, our philosophical questions. Or perhaps it answers one question: it tells us that who and where we are and what we can hope to achieve are matters of historical contingency. We will not find graven in some higher reality, Plotinian or Hegelian, a cosmic grounding for our cognitive or moral or aesthetic aspirations. On the other hand, neither will we find in the laws of physics and chemistry principles from which to elicit with necessity our ways of going on. It does not need organic evolution to underline this lesson. Heideggerian *Geworfenheit* would do. But in the sense of stressing contingency in the light of a vast amount of varied evidence, evolution helps. It is an evolved nature, and in the main a Darwinian nature, of which we are one odd expression.

What kind of nature is that, and what difference does it make to our philosophical reflections that it is a Darwinian world? That's what I want to think about now, and to think back about in relation to my own interests, past and present.

I was brought up on Darwinism, the old-fashioned kind, before the days of the modern synthesis. The authoritative, and authoritarian, head of our family, my father's older brother, had a library full of dark

red and brown backed books by Darwin, Haeckel and others in which Natural Selection starred as a major actor. In fact, my uncle was a pretty dogmatic social Darwinist. He had been taught at Yale by William Graham Sumner, who preached an extreme doctrine of the struggle for existence, in which no Charlottes dared weave magic webs for the preservation of the runt that every litter was allegedly destined to contain. I am glad to say that I never could believe in that aspect of the doctrine; I remember sitting on the sofa in my aunt's living room, feet not yet touching the floor, and thinking that the prosperity-forever-for-good-capitalists thesis must have something wrong with it. The great depression proved me right and broke my uncle's heart. And since then I have also learned, from agricultural experience, that if one breeds good sows and feeds them well, few litters contain runts in any case. I don't mean to draw from that observation any wicked eugenicist conclusion; there are all sorts of good reasons why we don't want to breed people the way we do pigs. But it does hammer one more nail into the coffin of social Darwinism.

Nevertheless, if society didn't work exactly as some self-styled Darwinians had thought, it was clear to me that nature had evolved, and ourselves with it. The brief flurries of religiosity I have gone through, and come out of, in my long life were very thin and metaphorical. Certainly no creation story ever competed for a moment, in my mind, with the infinitely more plausible story of evolution. Then, when I took the first year zoology course at Wellesley, not only my belief, but my interest in, evolution was amply confirmed. We had a wonderful teacher named Marian Hubbard, who provided a classic T.H. Huxley syllabus, from amoeba through hydra, earthworm, and lobster, and we learned about the standard arguments against, or feebly for, special creation. It all sounds very primitive now—no genes, no molecules, no nothing—but it did provide an exciting framework within which to think about the natural world and about people as part of it. (Miss Hubbard had never taken her doctorate, because someone had stolen her briefcase with the only copy of her dissertation; in this computer age, always make a backup, and if you have a hard copy, xerox it!)

Miss Hubbard's infectious enthusiasm was sufficient to get me through an undergraduate zoology major, but no further. My incompetence at lab work frightened me off. I always broke more equipment

than anybody else and when I had the control rat in a nutrition experiment it went mad. I did all right in chemistry through qualitative analysis but was afraid to try quantitative, and when I looked in at the physics lab it was full of car batteries and other such boring stuff. So I chickened out. It was partly cowardice and partly laziness—perhaps related vices. As I have told myself and others later, I knew that as a woman I could only aspire to being someone's research assistant and a terribly bad one at that. My father had conveyed to me the advice of a former president of the University of Wisconsin to the effect that in choosing a career one should think, not of the leading ideas or goals of one's work, but of the everyday grind. That was poor advice, obviously. Every job has some dreary routines attached to it; it's what it's all for that makes them worth tolerating. Not that I blame the advice or the advisor; it was my own weakness of will that held me back.

Never mind such speculations. Whatever the reason for my straying, it was twenty years before I returned to thinking, and reading, about evolution. Michael Polanyi, a distinguished physical chemist turned philosopher, had come to lecture at the University of Chicago and though I was marooned on the farm I managed to hear one of his lectures. As I remarked earlier, I found his argument against positivism thoroughly convincing; in fact I thought he had found the very refutation of that movement that I had been unable to articulate twelve years earlier in Carnap's seminar. So when he asked me to help him with the preparation of his Gifford lectures—the work that would be published in 1958 as *Personal Knowledge*—I was delighted to do so. It seemed to me that if I had any talent for philosophy, the best I could do with it in my isolated situation would be to help Polanyi in his struggle, as he called it then, "to articulate the inarticulate". I remember his telling me this as we walked a bare eroded field (it was mostly a horrid clay soil called Clarence Roe or Rowe) on our Cook County farm. One of the jobs he set me soon thereafter was to look up heresies in evolutionary theory, specifically critics of the evolutionary synthesis, which was then, if one takes the centennial year of 1959 as its apotheosis, in its chief period of flowering. And once I started reading that literature I was unable to stop.

The other motive that brought me to philosophy of biology via Polanyi's work was a problem about Aristotle. Polanyi's research had been purely in physical chemistry, for a time in crystallography, then in

reaction rates, and so on. Yet he wanted to look at the processes of science as efforts of living creatures to achieve, as he put it, "contact with reality". In contrast, the one great philosopher who was also a great biologist had presented a model of science that had, in its austere deductive structure, nothing to do with anything alive. It was that paradox that started me reading Aristotle's biological works. But that's irrelevant to my present concern, which is evolution, and my own occasional forays into that endlessly explorable domain. What I want to do here, after looking at some of the heresies Polanyi sent me to investigate, is to consider some of the lessons about Darwinism that I have learned over the years, some when I started working on this literature, some later. The problems I shall be dealing with at varying lengths are: the tension between chance and necessity in Darwinian theory, the place of teleology in evolutionary explanation, the relative emphasis on parts and wholes, and, finally, some of the implications of the fact of evolution for our philosophical reflections on our own nature.

The heresies I tracked down were a strange assortment. Earlier in the century there had been works like Berg's *Nomogenesis,* which sought overall laws of evolutionary development. And of course there were eminent paleontologists who insisted on regular patterns of growth in the fossil record, for instance Osborn, with his 'aristogenesis'. In particular, I studied the work of a German paleontologist named Schindewolf, who talked about 'typogenesis', 'typostrophy', and the like. There were also embryologists, like Lillie or Dalcq, who were sceptical of the power of mutation and natural selection alone to produce the regularities they found in the processes of individual development. The geneticist Richard Goldschmidt should also be counted here. And many taxonomists were also sceptical. Indeed, Vandel, a French specialist in woodlice, announced that the new Darwinism was "destined for total defeat" — "voué à un échec total". Vandel followed a Bergsonian motif, holding that evolution had moved to two "psychic" high points, generic invention in the insects and individual invention in *Homo sapiens.* One of the strangest views was that of J.C. Willis, a botanist who had gone to the Far East with Francis Darwin and been disillusioned about the power of natural

selection when he saw countless different plants flourishing in the same river bed. Since selection depends on differential survival in a given environment, something seemed to him to be very wrong here. He developed as a substitute for Darwinism the theory of the hollow curve, according to which species spread out from a central beginning, scattering like names in a telephone directory, with a few very common ones at the center and the more uncommon scattered at the edges.

What, if anything, did these critics of Darwinian evolution have in common? I don't recall even asking that question at the time; I just looked at the various cases, partly with some sympathy and partly in amazement. None of them was in any way explanatory; they just described phenomena that seemed to resist Darwinian explanation, at least as they understood it, and gave 'technical' names to them. Some of them, like Schindewolf or the embryologists, seemed to miss in orthodox theory a sufficient emphasis on form. Darwin distinguished two great principles in the living world: constancy of form or type and conditions of life. His view was, he said, that the former could be accounted for as effects of the latter. In other words, particular variations of the characters of organisms, together with particular circumstances in their biotic and abiotic environments, will interact in such a way as to produce the constancies of form we see around us: in the different structures assumed through geological time by the pattern of the pentadactyl limb, or the mimetic patterns assumed by certain butterfly wings, and so on and on. Now to say that constancy of form is caused by conditions of life is not to do away with form and its constancy. On the contrary, *b* cannot be caused by *a* if *b* does not exist. Many enthusiastic Darwinians, however, in their disgust with what they call 'typology', seem to deny the very existence of form. There is nothing but particular small variations—not variations from a type, as taxonomists used to think, but just particular tiny differences, and that's that. And indeed, the turn to what Mayr has christened population thinking was certainly one of Darwin's major moves in biological thought. Instead of taking some one perfect 'type' as ideal for each species, or even one type, usually ours, as ideal for nature as such, and others as expressing 'degeneration' from that high ideal, natural historians could now look carefully and lovingly at each minute character of each leaf or daisy or earthworm or mouse or what you will, and consider how each little variant in its own little niche might make a

difference in the history of its 'kind' or of life itself. Yet on the other hand, variations must surely be variations *of* something. There must in each case be some structure, some behavior pattern, to exhibit variation. Indeed, there has been, perhaps inevitably, or at least predictably, a kind of seesaw in evolutionary thought between a stress on shifting particulars and (relatively) constant forms. My paleontological friends like to contrast 'pattern' and 'process'. I'm not always sure what they mean, but perhaps it's the same contrast I'm trying to make here. Embryologists study processes, of course, but processes in which patterns are conspicuous and they don't want to slight those patterns in the story of process they have to tell. That appears to be the case also with an invertebrate paleontologist like Schindewolf, who looked at whole ammonite shells, for example, and saw how they changed over time from one whole pattern to another equally complete. G.G. Simpson, in contrast, the leading paleontologist of the evolutionary synthesis, was a vertebratist, collecting fragmentary equine skeletons and graphing, statistically, the changes over time of whole populations on the basis of very partial data, such as thickness of tooth enamel or the like. Although he did cheat somewhat, I thought, by introducing the concept of 'adaptive type', in the main he found the notion of a 'type' an obstacle to the kind of statistical generalization he was engaged in. Shifting particulars could add up nicely to the story he was telling.

Now although it is true that none of the early objectors to the synthesis was successful in stemming its onward sweep (nor am I more sympathetic to its present-day opponents), it is the case, surely, that every process of change is in fact change *in* some already existent pattern. There is always some pre-existent structure that undergoes change. Hoofed animals can run fast on two toes or one, but if your ancestors were perissodactyls, that is to say, if they had an odd number of toes, you're not going to switch over to the even-toed, or artiodactyl, variety. Such concessions are called by evolutionists historical or developmental constraints. But to those who cherish form they appear to be not mere 'constraints', but contributory causes, not only limitations on, but causal factors in the evolutionary story. In other words, it takes a balance of structure and alteration to produce any episode in evolution, much less the sweep of the whole history of life on earth. There were other themes, too, in the anti-synthesis literature, emphasis

on trends, for example, that seemed to paleontologists to give some kind of temporal ordering to macroevolution. But certainly the stress on form as against its near suppression by Darwinian enthusiasts was one chief *Leitmotif.*

At the same time that I was tracking down heresies, I was also reading the literature of the new 'evolutionary synthesis', or some of it, and wondering, independently of its biological critics, about the structure of the theory. What is the role of chance in evolution, what kind of necessity does it impose, what *is* natural selection when you come right down to it, what has happened, or not happened, to teleology in Darwinian theory? Let me look back a bit from my present vantage point to my earlier acquaintance with this tradition.

It must have been the second, or perhaps even the first, edition of Dobzhansky's *Genetics and the Origin of Species* that I read, for it still included the emphasis on chance and its role in evolution, an emphasis that was repressed by the time of the third edition and the advent of what Gould has christened "the hardened synthesis". In that later phase of the synthesis its adherents found Natural Selection to be all-powerful and tended, some of them sometimes at least, to forget the role of mutation, or chance variation, in their original scheme. Indeed, I once heard two of the leaders of the synthesis, Mayr and Stebbins, congratulate one another on the fact that they could dispense with mutations for half a million years and still have evolution. Of course one needed variation as an indispensable starting point of the selective process, but in the light of the 'balance' rather than the 'classical' theory in population genetics, there was so much variation always available in nature that 'new' mutations, their nature and origin, need be of no concern.

But I'm getting ahead of myself. In 1950, when I returned to the study of evolution, chance was still admitted, even welcomed, as a factor in the evolutionary process. I was struck at the time by the resemblance in this respect between the new evolutionary perspective and that of ancient atomism. For modern evolutionists, as for Democritus or Lucretius, it seemed that when one got down to bedrock one said, it just happened, and that was a sufficient explanation. At the same time, one insisted, in either case, that the story one

was telling was one of natural necessity: given the circumstances, it had to turn out this way. Given that these atoms just happened to collide with those atoms and latch onto them, just these grosser bodies had to result. So one had explained the way things are by chance or necessity or by chance and necessity or by chance as the origin of necessity. It seemed to work in the same way for evolution. Given that this particular fishy amphibian ancestor just happened to have a little air bubble in its throat, and given a drying pond, this lucky fish would leave ancestors with the beginnings of lungs and, except for a few bony relics left for future paleontologists to find, the other poor fishes would disappear from the face of the earth forever. Again, we had chance or necessity or chance plus necessity or chance as the instigator of what would then turn out to be a necessary, or nearly necessary, causal sequence.

How do chance and necessity, which seem to the ordinary onlooker to be contraries, fit so well together? It seems that if one wants to get rid of some kind of cosmic teleology, that is, of the notion of ends in nature, one can either say, it just happened that way, or it had to happen that way. In either case, there is nothing planned or purposive about it.

In contrast to such an explanation, Aristotle objected to Empedocles, for example, that the teeth didn't just happen to come up sharp and useful for biting, nor were they necessitated to do so, but biting or chewing was what they were *for,* their 'final cause' or end. 'That for the sake of which' belongs to natural explanation. Note that, for Aristotle, this emphatically does not mean that natural means-end relations were planned by some Supernatural Somebody. Even where there is a kind of cosmic teleology in Aristotle's account, it does not in any way entail a creator. In this finite, eternal world, things below the moon, and the celestial spheres themselves, imitate, insofar as they are able, the self-contained perfection of the unmoved mover(s). But nobody planned all this and made it so out of some unfathomable purpose of His Own. In the Hebreo-Christian tradition, on the contrary, both the world as a whole and every minutest mechanism within it must have been planned by an all-wise, all-good, all-powerful maker.

I am putting this contrast much too simply; something akin to Aristotelian teleology does seem, for example, to have characterized

nineteenth-century German biology under the influence of Kant.
Although Kant accepted traditional religious belief, he was careful not
to ascribe purposes to the Creator; that was something our limited and
indirect powers of knowing forbade us to do. But he believed that it
was impossible to deal scientifically with the phenomena of life unless
we acknowledged the reciprocal means-end relations characteristic of
organic beings. German biologists followed him in this, as he had in
part followed them. I should confess that I did not recognize any of this
when I was thinking about these matters forty years ago; until recently,
I thought of Kant's reflections on biology, in the *Critique of Judgment,*
as an unfortunate addendum to his work, and as thoroughly
unbiological in its approach. I still find its formulae rather rigid and
unreal, compared to Aristotle's more concrete insights into biological
method; but conversations with Dan Kolb, as well as the reading of
Tim Lenoir's work, *The Strategy of Life,* have taught me to take it more
seriously in the context of the history of biology. That's by the way. I
really want to make a very simple point, which, like most (over)simple
points, keeps complicating itself as I proceed.

It used to puzzle me, I was remarking when Aristotle and Kant
waylaid me, that chance *or* necessity seemed to be equally good, and
almost equivalent, explanatory concepts in atomistic, as in Darwinian,
explanation. And it seemed to me that this obtained because either
concept equally well eliminates end, or final cause, from natural
explanation. Now in nineteenth-century Britain, of course, natural
teleology meant supernatural teleology. Archdeacon Paley made this
crystal clear, and made it clear to Darwin himself, who read Paley with
enthusiasm as an undergraduate at Cambridge. Like Paley's famous
watch, all the particular adaptations of organs to their functions: of the
eye to seeing, the hand to grasping and so on and on, must have been
planned, Paley argued, not only by some maker or other, but by One,
all-good, all-powerful Creator, the one so perspicuously known to
members of the Church of England.

Darwin happily assimilated this adaptationist mode of thought, but
demonstrated, in the "one long argument" of the *Origin,* that initial
circumstances together with the laws of nature obtaining in our world
today could plausibly have combined to produce all the cunning
adaptations natural historians or physiologists might discover. There is
no need whatever to postulate that mysterious Maker of all things;

nature makes herself. Again, it was a question of a peculiar combination of chance and necessity that obviated the need for a cosmic designer. Let's look briefly at each of these as they function in the Darwinian scheme.

First, chance. Herschel accused Darwin of trying to account for natural phenomena by "the law of higgledy-piggledy". Ever since then, people have recurrently reproached Darwinian biologists for ascribing everything to chance. I suppose in the first place they meant that events had been removed from the (allegedly) benign oversight of an all-powerful Providence. But that was a liberation, and not only, as Shaw proclaimed, because mothers no longer had to sit beside the beds of their dying children, saying 'Thy will be done!' It was a liberation, because it allowed us, for the first time in the Christian era, a tolerable position on the metaphysical problem of freedom. An infinite, all-powerful God is the source of all being; my action can have no reality except what He, in his good grace, bestows on it. So what can *I* do? Nothing. There were hot debates about this, for example, in the seventeenth century. Some said, when I perform an action, say, take a step forward, God's 'physical premotion' makes this possible. So then there is really nothing I can do for myself. Others said, yes, you do do it yourself—but then there is a reality, namely, your taking a step forward, that doesn't come from God. But God is the source of all being. Given an all-powerful Deity who makes the world out of nothing, there is no solution to this problem. Leibniz thought he had a solution, but what a sham! Judas was fore-ordained, he argued, to betray Christ *freely;* but to be fore-ordained to perform a given free action, is still to be determined so to act, and so not to be free at all.

How does Darwinism better this desperate situation? First, it removes the One Transcendent Source of All Being and so eliminates the problem in its radical form. But it does better than that: it gives us a reasonable model for a conception of what I have elsewhere called "qualified freedom". All organisms have the abilities they have because their ancestors had long ago acquired them. I can walk on two feet (though now sometimes, as the Sphinx predicted, on three), because my ancestors long ago acquired the strange ability to stand upright, but I find it awkward to walk on four, and I certainly couldn't walk on seven or eight. Insects walk comfortably on six, arachnids on eight, and centipedes on a good many. Some of us human bipeds,

however, can learn to execute elaborate dance steps with our two lower extremities; some can even stand on their hands. Within the limits of our genetic endowment, we can learn a lot from experience. Not that we are the only animals to do so. There is Jane, for example, the macaque who learned to season her sweet potatoes with sea water, and even passed on this knowledge to her fellows and successors. We have no monopoly on either learning or tradition, although we do seem to practise both these skills in a rather exaggerated way. The point is just that, in general, there appear to be among different organisms, and particularly among members of different species, different degrees of flexibility in the modifications of behavior permitted by the genetic program from which they set out each on its unique life history. There is just no way, for example, to teach a sheep, poor dumb brute that it is, how to go out a door: it's just as likely to hedge itself in the angle between door and wall as to go straight out the opening. A donkey, on the other hand—well, admittedly, I don't know much about donkeys and doors, but a donkey can be immensely ingenious about opening gates. Asses are *very* clever animals; how they came to symbolize stupidity I have no idea. Perhaps some fanatical horse lover began it. Be that as it may: it does appear that different organisms differ in the extent to which they can learn from experience. And it is that space for learning, and, where there are traditions, like ours of speaking our strange languages or the macaques' of dipping sweet potatoes in sea water, for example—it is that space for learning or tradition that sets the stage for freedom. I like to quote in this connection the remark of a British zoologist named Pumphrey, who said, in effect (in an article in the first volume of the *British Journal for the Philosophy of Science*), 'there is no wholly bound or wholly free; there are only degrees of freedom.' The notion of total freedom, of a *liberum arbitrium,* was always impossible. The notion of freedom under God is equally inconceivable, unless in the spirit of belief in the absurd. In contrast to either of these positions, we find ourselves, as heirs of Darwin, in a many-faceted, rich, and varied nature, in which some animals are less rigidly programmed than others to follow a relatively stereotyped pattern of behavior, in courtship, in mating, in escaping predators or pursuing prey, or just in enjoying life. And we are fortunate enough to find ourselves at the outer end of this spectrum. Some might say 'unfortunate', since, again within limits, both natural

and cultural, we bear responsibility for what we make, or have made, of ourselves.

Note, please, I am not trying to make any rigid distinction between 'nature' and 'nurture' or instinct and learning, or anything of that sort. For a while, instead of 'instinct' one was taught to refer to 'fixed action patterns', but the last time I dared to utter that phrase, in a class in philosophy of biology in Davis, my students, presumably animal behaviorists, exclaimed with horror that I must call these styles of behavior 'modal action patterns' instead. Nothing is 'fixed'! Never mind; I hope one is allowed some differences of degree, and that is all one needs.

There is also a problem here about how one can talk, as I have been carelessly doing, about members of different species. In strict Darwinian terms, varieties are incipient species and species only more obvious varieties. Or, worse yet, as some modern Darwinians have insisted, since species are not eternal, they must themselves be individuals with parts, not 'classes' with properties. So I can tell this cabbage butterfly from that, or this person from that one for that matter, only as I can tell, say, my head from my foot, or my middle finger nail from my right eye. This is a tangle of questions I hope I may avoid here; let me use expressions like 'member of a species' in an everyday, unreflective way, as indeed Darwin himself continued to do after he had in effect abolished the species concept as his forebears and contemporaries had understood it.

So far I have just been talking about one sense in which Darwinism has been said to invoke chance as an explanatory principle: the sense in which Darwinian nature has been freed from the fetters of a monolithic theocracy. This is really just to emphasize once more, if somewhat more systematically, the contingency that underlies, not only human life, but all there is. Darwinism is in this sense no 'chancier' than is any point of view that accepts the primacy of history.

There are, however, two areas in which 'chance' does enter into a Darwinian view of nature. The first has to do with the nature or source of the variation available for selection to act on. Darwinian explanation is often said to involve two steps: random variation and natural selection. It is in the first of these two steps that the architects of the synthesis assigned a role to 'chance', and it is there that Darwin too had placed a 'chance' factor. Darwinian evolution sets out from slight

variations among organisms, variations that just happen to be available, rather than being called forth, as neo-Lamarckians have supposed, by the needs of the organism. The latter notion now seems quaint and nearly forgotten. Yet when, at the nadir of my career, I was visiting British grammar schools as senior research fellow in the Institute of Education at Leeds, I actually encountered a 'Lamarckian' biology teacher. Using that same old piscine example, she asked her pupils how amphibians began, and the answer was, some fishes tried harder than others to breathe out of water. She even had a visual aid: a poster showing eager fishes jumping merrily out of the water and gasping for air. The trouble is that no one has thought of a mechanism by which such strivings could be passed on to the next generation—and nothing matters in evolution, obviously, except what can be passed on. Only heritable variations count. Admittedly, Darwin wasn't always sure that there couldn't be inheritance of acquired characters. Since the rise of modern genetics, however, so much emphasis has been placed on the accepted mechanisms of heredity that any alternative to Mendelian inheritance, presided over, also, by Weismann's principle of the separation of the germplasm, has seemed, to put it mildly, extremely unlikely. New and subtler models, like Leo Buss's account of *The Evolution of Individuality,* suggest some modification of Weismann's principle, but I think it's fair to say that any one who accepts a theory of natural selection, as Buss surely does, also accepts the two-step notion in some form. There just must be some heritable variations available for selection to work on if there is to be evolution at all, and those variations are not called forth by the needs of the organism. In this sense they are random. That doesn't mean, of course, that they are uncaused. As the techniques of molecular biology proliferate, more and more is known about the genes that trigger particular mutations, and some day it may be possible to explain why any or all such variations arise when they do. But however thoroughly accounted for in physico-chemical terms, they will still be 'random' in the sense of evolutionary theory. They arise or have arisen through causes irrelevant to the biological needs of their bearers. Again, that's why the theory of natural selection is described as a two-step theory. First, before any kind of evolution can take place, some slight (heritable) variations beneficial to their possessors must just happen to be available.

The second step, of course, is the causal nexus summarized under the heading of 'natural selection'. Some slight variations turn out to be of some slight advantage over available alternatives, and if they are heritable, they will prove more numerous in the next generation. 'Natural selection' as a principle has no particular content; the term is shorthand for an indefinite number of cause and effect relations between particular features of particular organisms and particular features of their particular environments. (Robert Brandon put this with exemplary clarity in an article in 1981, and the same point is made in a fuller context in his book, *Adaptation and Evolution,* published in 1990.) Enthusiastic evolutionists have sometimes spoken as if selection were some natural 'force' or special creative power. 'Whatever we see,' they used to say, 'we can be sure that selection sees much more.' Or, as Dobzhansky put it, selection is fully creative, like a composer or a poet. Nonsense. Evolutionary processes described, or explained, in terms of natural selection are ordinary when-then cause and effect processes that have to be examined in each case in terms of the circumstances of the particular episode involved. You just look at the conditions that obtain at time t_1—call them A—and then at those obtaining at time t_2—call these B—and if the former appear to provide necessary and sufficient conditions for the occurrence of the latter, you say that what happened first is the cause of what happened next, or A caused B.. This kind of causal sequence was analyzed classically by Hume and then Kant, and given its most common formulation for philosophy of science by Mill. It is the kind of causal explanation we use in ordinary life—what caused the accident? Ice on the road—and it works perfectly well for the kind of case amenable to explanation by natural selection.

In such causal processes, further, we may find, in addition to historical contingency and random variation, a third kind of chance of a harmless and unproblematic kind. The cause and effect relations involved in a particular evolutionary case often involve large numbers, and so a stochastic element must be introduced into the causal generalizations characteristic of evolutionary narratives. But the causality involved is still classical when-then causality. It is necessity (if probabilistic necessity) supplementing the 'chanciness' of random variation. So far, so good. There is a more intractable philosophical problem involved here, to be sure, and that is the problem of causality

as such: what do we mean by that concept and how do we suppose causality works? Since Hume and Kant, as I have just been pointing out, the cause of an event has been understood to be a set of necessary and sufficient conditions reduced to a temporal sequence. Metaphysically, that appears by now a thoroughly inadequate conception: the regularities of nature are not *just* one darned thing after another. But so far as I know nobody has yet produced a more satisfactory analysis of this indispensable concept. One can only say that evolutionary cause and effect relations are in the same boat as any others. As far as the tension between chance and necessity goes, that seems to me just an expression of the way things are, and we have to live with it. Nobody promised us a rose garden.

The question of the role of chance in a Darwinian nature has led me rather far afield. There was another feature of Darwinian evolutionary biology that puzzled me when I thought about it forty years ago, and that was, not the relation between chance and necessity, but the relation between causal necessity and teleology. Darwinism began, or so it seemed to many, as a rebellion against cosmic teleology. Yet Darwinian discourse is thoroughly, some would say incurably, teleological. In fact some writers still accuse Darwinian theory of being too thoroughly 'purposive'. Natural selection works only for features of organisms that are 'good for something' in terms of differential survival and, ultimately, differential reproduction. And if one applies the principle of natural selection everywhere, one finds adaptations, traits that are useful to their bearers, everywhere. I used to characterize this feature of Darwinian thought by speaking of an "axiom of adaptivity": every feature of every organism one investigates must be there because it had some function that it performed a little better than some competitor. Thanks to some particular slightly improved bit of natural technology, it evaded predators better, or seized its prey faster, or got a mate more readily, or digested its food better, or what you will. Organisms appear to be adaptation machines, each little trait of which has been so-to-speak engineered to do some particular job. At a colloquium in Manchester, the great cotton geneticist Harland boasted that there were thirteen different genetic loci that could produce a particular orange spot on the petal of the cotton flower. Someone

asked, what was the function of the spot. He didn't know, he said, but it must have some function or it wouldn't be there. It was this kind of thorough-going adaptationism that would be attacked by Gould and Lewontin in 1979 in their famous paper on 'The Spandrels of San Marco and the Panglossian Paradigm'.

By now I see that there are two pairs of contrary conceptions involved in this kind of thinking: teleology versus causal necessity and part versus whole. The problem of the place of teleological discourse in evolutionary biology is not, as such, hard to sort out. Robert Brandon did the job definitively, in my view, in the 1981 paper I have already referred to (and again, the argument is repeated in his book). Darwinism explains the origin of means-end phenomena by old-fashioned when-then causality. The teleological language belongs to the phenomenon to be explained, not to its explanation. To paraphrase Richard Dawkins's catchy title, natural watches are made blindly, not by anybody's foresight.

True, there are complications even here. A more cosmic teleology did creep back into the new Darwinism for a time in the guise of 'evolutionary progress'. "Evolution," the great R.A. Fisher declared in 1932, "is progressive adaptation and consists in nothing else." Similar pronouncements were made by Julian Huxley and other leading evolutionists. There are at least two difficulties with this conception. For one thing, progressive adaptation is in the long run what leads to extinction: very specialized adaptations, like that of the beak of the huia bird, for example, where the male's beak is absolutely precisely constructed so as to feed the female with a beak equally exquisitely designed for being fed—such utterly precise structures can prove readily maladaptive when circumstances change a little. I hope I am right in remembering that the huia bird has indeed gone extinct. And of course every kind of critter goes extinct eventually; ninety-some percent of species there have been on this planet are extinct already. How did 'natural selection', seeing so much more than we do, permit this? On the other hand, if one generalizes the adaptations referred to in Fisher's maxim, and says, not that each particular adaptation keeps getting better and better, but that adaptations have on the whole got better through evolutionary time, so that the precise adaptations of the past are bettered by those of the present, then one has the problem of measuring such 'improvement', and, what's worse, one seems to be

reintroducing just the kind of cosmic teleology we thought we had banished for good. In fact, the notion of progress in evolution, as it was touted in the heyday of the synthesis, appears to contradict the equally cherished maxim that evolution is opportunistic, and has no fore-or-dained direction. Indeed, the concept of progressive evolution has since been severely criticized, notably by G.C. Williams in his by now classic *Adaptation and Natural Selection* (1966), and has, fortunately, receded from view.

What produced the kind of hyperadaptationism attacked in 'Sprandrels', however, was not just confusion about evolutionary teleology, but, as I remarked earlier, the entanglement of two pairs of tensions in Darwinian discourse: the tension between cause and end, and the tension between part and whole. The first of these two tensions, as I hope I have just indicated, can be dealt with readily enough. The trouble is that, thanks perhaps to the nature of 'popula-tion thinking', and also perhaps to the rise of biochemistry and then of molecular biology, there is also a tendency in some evolutionary writers to think only in terms of least parts of organisms, and to find means-end relations in every little recognizable character of every organism studied. As I said earlier, organisms turn into adaptation machines, like Harland's cotton plant, where each little part must inevitably be accounted for as doing something for survival and reproduction. This is the position Niles Eldredge calls "ultradarwinism" (a term in fact already used by Weismann, and recoined by Eldredge, and adopted by myself, in ignorance of its earlier use. See J. Gayon, *Darwin et l'après-Darwin*, 1992, for the original meaning of the term.) Ultradarwinism, as Eldredge thinks of it, not only looks at cases of 'adaptedness', as any selective explanation has to do; it looks for such cases in every nook and cranny, until organisms are reduced to an assembly of gadgets, if possible at the molecular level. The selfish gene prevails. If the older admission of chance as a factor in evolution reminded me of ancient atomism, this ultradarwinian thought style, though assimilating chance to the power of natural selection, appears more substantively atomistic. It provides one more instance of the recurrent tendency in our tradition to find phenomena explained only when they are taken apart into bits.

There is no need, however, to combine the more plausible features of Darwinism with such an atomizing tendency. On the contrary, there

is every reason not to do so. Traits, the characters or behaviors of phenotypes that need to be explained, do not come singly, and neither do genes. Even genes function in context, and even whole genomes have to belong to organisms acting and interacting in their particular environments if they are to play a role in evolutionary history. Wholes at a number of levels matter: whole genomes, whole organisms, whole ecosystems. We can retain, I should hope, sufficient pluralism to stop short of the whole of nature—which, as a whole, lies, I believe, beyond our understanding: things just are very complicated, and however much we come to understand, there is always more. But at the same time, our understanding can, and must, reach, so to speak, to partial wholes. From this perspective we can see a certain justification in the complaint by critics of Darwinism that evolutionary theory suffers from a neglect of form. Wholes are more than aggregates because they are structured. We can investigate their organizing principles as well as their ingredients. That is not to deny for a moment Darwin's insight that it is conditions of life that have produced constancy of form. But it is forms that are so altered, and the conditions themselves, if by that we mean environments, are themselves informed. As I said earlier, patterns and processes, structure and history, are equally features of an evolved and evolving nature.

This has been a very crude and overabstract run at what we might mean by 'Darwinian nature' as our habitat. I have caught myself talking a lot about 'evolutionary literature' or 'Darwinian discourse' or the like. But let me stress as firmly as I can that I am *not* talking about 'Darwin's plots' or 'Darwinian rhetoric', or anything of that sort, as post-post moderns nowadays talk of such things. I am trying to describe how in a particular tradition, *which I accept,* the phenomena of nature are described; and accepting that description, I put, as Polanyi would have said, an assertion sign in front of my statements. That's not just how some people talk; with such qualifications as I have been recommending, it's how I talk, not because I like the sound of it, but because *that's how I believe the world is.* And I have good reasons so to believe. They're not 'foundationist' reasons, whatever that might mean, but they are, from where I stand, reasonable reasons, and that's the best anybody can do.

Other fashionable ways of talking nowadays, I should perhaps also add, ways which I accept only very partially, would forbid me to speak,

as I have been doing, of 'Darwinism' or 'Darwinian evolution' or the like. There is, they say, no 'essence' of Darwinism—*a fortiori,* since there are no essences at all. That is what population thinking—Darwinism???—has decreed. So how dare I speak of such a non-existent entity? Now of course I know that any historical thought style is far from constant: we don't go, with a hop, skip and jump, from one Foucaultian *episteme* to another. 'Darwinism' has meant very different things to different people, to me and my Sumnerian uncle, for example. But that doesn't mean it doesn't mean anything, as distinct, say, from a belief in special creation or in Bergsonian creative evolution. And something of what it means to me, as well as, so I believe, to a number of others whose knowledge and judgment I respect, is what I have been trying to convey. (Gayon's book, which I mentioned above, puts with exemplary clarity the relation—the true relation, I believe—between historical context and philosophical analysis or reconstruction. Each demands the other.)

So here we are: natural beings who have come into being, like all our nearer and remoter cousins, in largely Darwinian fashion. What difference does this placement of ourselves in an evolving nature make to our reflections about our own capacities? Going back, once more, in my old age, to my Kantian beginnings, I have put this lately in terms of what Kant said were the four questions asked by philosophy. These are: What can I know? What ought I to do? What may I hope? And, summing up the others, what is a human being? Though with an emphasis on the first, it is the fourth question that my reflections chiefly concern, and the chapters of Part Three will do so more particularly. To put it for now in a nutshell (in a formulation I have used on other occasions): a human being is a biological individual capable of becoming a responsible person through participation in (or as one unique expression of) a culture. What about the three particular questions, which, in Kant's view, summed up to the fourth? Our question here is: what difference does our acceptance of the fact of evolution make to the way we answer them?

As to the first: there is by now a whole industry called 'evolutionary epistemology', which began, so far as I recall, with the circulation in mimeographed form of an article by Konrad Lorenz; I mentioned this

earlier in connection with my (rather different) rereading of Kant. Lorenz argued that Kant's a priori categories of the mind were now understood to be ways of coping with our environment written in our genes. We think alike because natural selection has forced us to do so. G.C. Williams gives a nice example of this view of the origin and nature of intelligence. There were two brothers, he says, Hans and Fritz Faustkeil, who went down to play on the seashore. (We'll assume they were not identical twins, though Williams doesn't say.) Their mother said, 'Don't go out too far in the water!' Hans was a good, clever boy and did as mother said; so he grew up and found a mate and left numerous progeny unto this very day. Fritz, on the other hand, was bad (or stupid) and disobeyed; he was drowned and left no descendants. Now while of course I would be delighted to suppose that intelligence consists in doing what mother said, I find the example rather trivial. I hope there's more to intelligence than that. But what more that is, I find it hard to say. I am myself given to remarking that all knowledge is orientation. Maybe orientation isn't just obeying orders, but knowing one's own way about. Again, it's perhaps a matter of accepting a less reductive version of Darwinism. Orientation in an environment can be a pretty subtle and complicated matter. And of course in the human case it is all sorts of social subworlds, practical skills, games, sciences, in which we learn to find our way. More of that later.

The point here is that as giving us boundary conditions for knowledge, the acknowledgement of the fact of evolution is both sound and indispensable: our biological natures set limits to what we can achieve as knowers and to the ways in which we can achieve it. 'Reason' has been demoted from any transcendent and eternal locus to a firmly terrestrial site. But there are at least two difficulties with the Lorenz-Williams formula. First, to ask how something arose is not the same as to ask what it is or how it works. I know, I know, essentialism is wicked and nothing is just-so eternally and out of all relation to its history. But surely even changing things have characters—"properties across instances", as Ernst Mayr puts it—in this case, instances over stretches of time. That our capacities for knowledge evolved, like other capacities, makes a difference (an essential difference?) to our attitude toward them: we can't claim for them separateness from nature or exemption from change. At the same time, it seems to me, such an acknowledgement of our historicity should also increase, not diminish,

our confidence in developing and using such capacities. As I said much earlier, in my rereading of the Kantian Analytic, we are real animals trying to find our way about in a real world, not idle noise-makers 'conversing' about nothing (or about nothing but besting our interlocutors). But I'll harp sufficiently on realism in my next chapter; let that be for now. The point here is just that insofar as 'evolutionary epistemology' consists simply in stressing the phylogenetic background of our cognitive powers, so be it. True, even of this milder variety of the doctrine, there are proponents who claim to have 'solved' the problem of knowledge, a claim that they make in particularly solemn and long-winded form. But as a necessary rather than a sufficient condition for an account of human knowledge, we may readily grant that so-called 'evolutionary epistemology' has a sound enough core.

Unfortunately, however, there is a more virulent form of the doctrine that has produced a dismal enough literature: a kind of cognitive sociobiology, I suppose. (I should perhaps remark that I use the term 'cognitive' as equivalent to 'pertaining-to-knowledge'. More widespread even than evolutionary epistemology, there exists nowadays a large and widespread form of grantsmanship called 'cognitive science'. I know little about it and wish I knew less; but it seems to use these Latinate terms in some special senses of its own, distinct from what laymen call 'knowledge'. I hope I may be permitted to retain the older usage.) In this version, evolutionary epistemology claims that 'knowledge', since it is a behavior of certain animals, who have evolved by natural selection, is thought to *be* a form of selection: ideas function like genes, more or less, and are selected in a competitive arena analogous to, if not identical with, good old nature-red-in-tooth-and-claw. This is but one version of what is called in general 'naturalized epistemology', in effect a theory of knowledge that eliminates any theory about knowledge and makes it, like nature in ultradarwinian perspective, just one darned thing after another: or, perhaps, in terms of the traditional struggle for existence, some darned things after some others. Philosophically, one wants to ask what it is to make a knowledge claim, what is it to bring evidence to bear on such a claim, and so on. So-called evolutionary epistemology in its radical form eliminates all such questions. It springs from a reductive and impoverished Darwinism and an equally reductive and impoverished concep-

tion of philosophical reflection. Alas, I have not the Duchess's power to order: 'Off with its head!' I can only ignore it and advise my readers to do so, too. So far as I can tell, the fact that we are products of evolution trying to orient ourselves in a largely Darwinian nature sets a new and fruitful background for our epistemological questions but does not as such either raise or answer them.

The same holds, more or less, for Kant's second and third questions. Although I have concerned myself minimally with ethics or the philosophy of religion, I may venture to say a little about these matters here before I go on to what seems to me the most significant epistemological consequence of an evolutionary metaphysic: an unwavering and unrepentant realism. Kant put his second question in the terms: 'What ought I to do?' because he believed in an ethic, not of a highest good we seek or ought to seek, but in terms of duty: the only moral good for him was a good will. But let us take the liberty of putting his question in a more general form. On what grounds ought I to decide what I ought to do? We can be thinking then either in terms of goods, ends of action, or of obligation, the rightness of actions. In either case, what difference does the acceptance of the fact of evolution make to our answer?

The relation of evolution and ethics has been a rich field for debate ever since Darwin. Darwin's bulldog, T.H. Huxley, argued in his Romanes lecture that evolution was irrelevant to ethics. In contrast, his grandson Julian argued in turn in his Romanes lecture that an adequate ethic could be derived from evolution, progressive and forward moving as he believed it to be. Others, like C.H. Waddington in his book *The Ethical Animal,* joined the chorus in praise of an evolutionary ethic. Nowadays both these doctrines appear to have reached new extremes. G.C. Williams, in a reissue of T.H. Huxley's essay, insists that what the older Huxley meant was that nature is positively evil and morality must be raised up in opposition to it. A thoroughly reductive sociobiological evolutionist like Michael Ruse, however, insists just as emphatically that 'ethics' does flow from evolution, not in the benign form advocated by Julian Huxley or C.H. Waddington, but in the sense that, as he puts it, "morality is an illusion foisted on us by our genes." What is one to make of such disputes?

The answer, as I see it, is simple. As in the case of our reflections about knowledge, the fact of evolution sets conditions for our ethical

speculations, but in itself neither raises nor answers ethical questions. In fact, come to think of it, evolution does bear somewhat more directly on the problem of knowledge than it does on ethics. If all knowledge is orientation, it follows that all knowing-that, as Ryle called it, entails an element of knowing-how. (They are not identical; there is a great deal of knowledge that is sought, and acquired, for the sake of understanding, rather than for the sake of getting something done; but even the most theoretical knowledge must still be skill-ful.) So there is a special bearing of our evolutionary situation on the nature of knowledge. I don't see even that much connection in the case of ethics. Again, evolution sets limits to ethical thought: moral principles are not God-given or totally unrelated to our natural situation. If they were, there would be no reasonable way, for example, to argue that we ought not to confer pain on other animals. Yet the principles of evolutionary biology cannot on their own dictate an ethic. Each of us must do that within his/her own cultural-historical situation within nature (within nature, not against nature, as Williams claims to follow T.H. Huxley in insisting). I'm not sure about "ethics without biology", as Tom Nagel calls it, but ethics as permitted within the conditions set by biology seems a reasonable enterprise, not ethics dictated by biology nor yet conducting a war to the death against it.

What about Kant's third question, in effect, evolution and religion? What he intended by asking "What may I hope?" was to vindicate the hope of personal immortality. That sort of anthropocentric mythology Darwin and Darwinism ought surely to have done away with. But what about a more general question concerning evolution and religion? I have been moved in recent years to put this question (as I have to my reflections about freedom) by Will Provine's insistence that once Darwin had spoken, one must "leave one's brains at the church door" (and also one's freedom, which he seems to think an all-good all-powerful maker guaranteed and Darwin abolished). Did Darwin leave his brains at the church door in Downe, one wonders. Perhaps so; he may just have been wanting not to trouble Emma—though a recent account of his position in the parish makes it appear that he was a singularly active and beneficent member of that Anglican community. Admittedly, once we find ourselves as natural beings at home in a Darwinian nature, fundamentalist Christianity or any other literal and dogmatic belief in a Transcendent, All-Powerful Maker and Lawgiver

with a Mind somehow analogous to ours (or to which ours is somehow analogous) must wither away. But are wilful ignorance and superstition identical to reverence and the impulse to worship something greater than ourselves? There is grandeur in this view of life, Darwin wrote at the close of the *Origin*. Again, perhaps this was only meant to placate his readers as well as his wife; but I doubt it. A sense of the vastness and the vast variety of nature must have impelled the work of natural historians like Darwin and still drives the efforts of many working biologists in many different fields. Such an attitude is not wholly alien, I should think, to religiosity at its best. Given the manifold self-delusions and fanaticisms supported by organized religions, I am no longer sure the game is worth the candle, but at least one can deny the crude Provinian thesis: Darwin in, religion out. It ain't necessarily so, though at this juncture I wouldn't like to say what is so in this context. By now, the Philo of Hume's *Dialogues* seems to me the safest guide in the philosophy of religion.

The Primacy of the Real

R ealism is dead!' That is the announcement of a respected philosopher of science, Arthur Fine, in his much-quoted essay, 'The Natural Ontological Attitude' (reprinted in his book, *The Shaky Game*). Fine is a former president of the Philosophy of Science Association and an authoritative writer on both Einstein and quantum mechanics. 'Realism is dead', says he. 'Long live realism', I want to reply. But it's not obvious, to begin with, just who is the monarch happily deceased, nor is it easy to describe accurately and clearly in this case the person and character of the successor to the throne—especially when one must make oneself heard against a chorus of social constructivists, deconstructionists, post-post-deconstructionists, pragmatists and other nonsense-mongers in their legions. All the same, if this book is to make any sense at all, something like that is what I have to do.

It's a tough job for several reasons. To begin with, I distrust 'isms' in philosophy and wish I could do without them. Philosophers, in their aspiration to be superprofessional, to have a lingo of their own as medical or scientific specialists do, are inclined to wrap themselves in protective coats of 'isms'. When I confessed to a young colleague recently that I found a manuscript of his hard reading, he exclaimed, "But aren't you a contextualist, too?" Ugh! I did, for my sins, write a paper called 'Historical Realism and Contextual Objectivity . . .', in which I was trying to say, I suppose, more or less what I want to say here, but leaning more explicitly than I usually do on some recent work in theory of knowledge. I'm afraid most of the time I neglect this literature. Although some of it may for all I know contain excellent insights, reading it gives me the sensation of living in a padded cell, thoroughly insulated from reality. If anything allegedly concrete is referred to, it's usually science-fiction counter-examples, like a famous one of supposing you're a brain in a vat. Indeed, many of my colleagues teach introductory philosophy through science fiction. Alas, I can't read the stuff, let alone teach it. It may be an (un)earthly paradise

they've all discovered, but I'm left grubbing down here alone, like the little lame boy left behind in Hamlin, but without even a glimpse of that lovely land.

This disability puts me, in at least two ways, in an awkward position. For one thing, although I am, so to speak, a professional 'philosopher' in that I possess advanced degrees in that strange discipline and have studied and taught the subject, if subject it be, on and off for nearly sixty years, I feel myself in general cut off from the thought-style of my colleagues. For another, if, as I said, I want to avoid the proliferation of isms that afflicts them—or perhaps serves to protect them from an unfortunate self-knowledge—still I find myself joining in their ism talk, like it or not. I've already written a chapter with 'empiricism' in its title and empiricism as its principal subject-matter, and here comes another 'ism', realism, that I find it hard to avoid.

For a few years, in fact, I used to refer to the position I take in philosophy as 'comprehensive realism'. But this is not only an ism, it's an ambiguous one and I'd now like to avoid it. The trouble is that 'comprehensive' might mean all-inclusive. But of course I didn't intend to suggest that *everything* is real, including for example the concoctions of science-fictionists. I meant two things, which I have already said often enough in these chapters: 1. that we exist *within* a real world, are surrounded by it and indeed shaped by it; and 2. that we ourselves are real. In other words, like many others (though not in the main those now in fashion), I am trying to overcome the subject-object dichotomy that has plagued most of Western philosophy since Descartes. There is no fundamental contrast between me-in-here and everything-else-out-there. And that is not because 'I' am everything or nothing and 'it' (or 'they') nothing or everything, but because the radical split between in-here and out-there makes nonsense of a world that is living, complicated, messy as you like, but real. I am myself one instantiation of that world's character, one expression of it, able also, in an infinitesimal way, to shape and alter it. By now I find the adjective 'comprehensive' inadequate to convey this notion and I can't think of a better one. Sometimes I exclaim crossly that I want to call myself a 'naive' realist, but my colleagues say that won't do at all because that term has, in our modern tradition, a certain meaning which I surely wouldn't want to endorse. (I'll return to that point shortly.) Perhaps I should embrace what my colleague Joe Pitt calls 'Sicilian realism', or

realism with a vengeance! But meantime I have taken refuge in calling this chapter 'the primacy of the real' rather than 'realism' of this, that or the other kind.

What I am looking for is something like what Merleau-Ponty expressed in his thesis of "the primacy of perception". Things and events impinge on us one way or another through our senses, and that includes, of course, cerebral mediation of incoming information as well as our social-linguistic reading of it. From the beginning—even prenatally, it now appears—human individuals constantly, or recurrently, notice and interpret impacts from things and events both outside and inside their own bodies. Seventeenth-century writers used to speak of 'reading the book of the world'. In a way that is a good metaphor. Yet the world is not a text in the sense of an artefact, either God's or ours, let alone mine. It is what obtrudes, fascinates, concerns me from the start and, so far, to the end, and it is also what has made and continues to make me who I am. This is neither arbitrary 'world-making', as one contemporary philosopher sees it, nor the abolition of the very notion of a world, as in some other fashionable views. It is, to say it yet once more, to recognize where we are and therefore who we are as human animals. This seems so obvious, and yet it is what philosophers, almost with one voice, seem to want to deny. How did this strange situation come about?

Fine's celebration of the death of realism opens an essay called 'The Natural Ontological Attitude', the name he gives to a stance that is supposed to be non- or anti-realist. How can our 'natural attitude'—which, like that of any animal, consists of efforts to orient ourselves in our environments—be opposed to realism? Perhaps Fine is thinking of debates about 'scientific realism' which focussed on the question whether the unobservable entities postulated by scientists 'really' existed. In the early decades of this century there were still distinguished chemists who insisted that we shouldn't consider atoms anything but artefacts because we couldn't see them—and the same went in early days for genes. Science was supposed to be tied down safely to observation, as distinct, of course, from the unbridled speculation of philosophers. And observation meant the 'raw' givens of sensation. You had to have seen it with your eyes, heard it with your

ears, or had a piece of it fall on your tail. So Gute Mahlzeit, Foxy Loxy! But seriously, this was for positivistically inclined scientists and philosophers of science a pressing problem. Science was supposed to go from observation to hypothesis (or theory), then through deduction to more observation and so on and on. And anything not amenable to observation, at least indirectly, was taboo. This is still a position taken, if in more sophisticated form, by some eminent philosophers of science and their disciples. (They call themselves 'empiricists'; their view has a fair bit in common with the Humean empiricism I tried to come to terms with earlier). If everything must be tied down to observation, however, there does seem to be a problem about the 'reality' of 'unobservables', and much ink and energy have been expended in wrestling with it.

Positivists in their heyday used to refer to the traditional problems of philosophy as 'pseudo-problems'. When we talked, for example, about universals, they said, we were just talking nonsense. Our words and sentences were simply meaningless. It seems to me that in the controversy about 'scientific realism' in the limited sense I've been alluding to, positivists, or logical empiricists as they came to call themselves, were struggling with a pseudo-problem of their own. Not that their discourse was, strictly, meaningless, but it was based on such badly mistaken premises that it could only be trivial: an 'angels on the point of a pin' sort of thing. And the same objection holds to the controversy about whether the 'laws and theories', as distinct from the 'entities', of science have real referents; Fine may be thinking of that kind of 'scientific realism', too, for all I know; but it doesn't matter. Both controversies arise within the universe of discourse created by positivism, or as it came to be called, logical empiricism. And that is, in my view, a near to empty universe. For it is glaringly false that scientists are always chasing observations only. In different disciplines, to different degrees and by different techniques, they do of course check their hypotheses experimentally, and experimental results are at some level 'observable', though often only remotely, *via* highly artifactual instrumentalization. But what all these busy people are doing is trying, through experiment, to find out how something in the real world really works. And in that context there is (in most cases) no sharp separation between 'observation' and its contrary, be it 'logic', 'hypothesis', or 'theory'. Of course people sometimes think they have found entities

that don't in fact exist—like phlogiston in Priestley's time or like M- or N-Rays after the discovery of X-rays. But quite often they discover relatively hidden realities that do exist, like atoms or genes. Of course, again, their evidence for such existences is in part experimental and so in part involves 'observation'—that is, checkable data. But it's not just data that science is *about.* On the contrary, strictly speaking, any statement made by any scientist beyond 'this pointer reading here such and such', or strictly, 'this black dot here now', goes beyond the data. It's usually attempting, as Cartwright has recently argued, to get at the cause of some effect. But causes don't lie there on the surface waiting to be collected. One can probe wrongly, one can probe rightly, but probe one must. What's wrong with that? We know we're fallible but that's no reason not to try to find out. We can certainly give up realism in that narrow, and rather silly sense, of claiming that the entities postulated must be real, or, for that matter, that the laws and theories formulated by scientists always refer to real regularities in nature, without denying that scientists are really trying to make real discoveries about real events—and entities—in a real nature, which exists, as goal and challenge, independently of their efforts to understand it.

Granted, there have been eminent scientists who have insisted that their enterprise had nothing to do with an independent reality. The positivist school of Vienna, from which logical empiricism derives, stems directly from the philosophy of the physicist Ernst Mach. And E.P. Wigner, a Nobel prize winner in physics, professed to find it odd that psychologists (of behaviorist bent) were so physicalist in their leanings, when physicists knew that they were only trying to under-stand their own subjective impressions. Biologists seem to me in general to have a more wholesome—and 'natural'—attitude toward their subject matter. But even there, I knew a pathologist, of all things, who when the U.S. president met the Russian leader of the moment, remarked how strange it was that people should think they were discussing the world's affairs when really each one was only looking at the electrons dashing about in his own brain. When I asked him what he thought he was doing in his lab, he said, that's just work, but the other is what I really believe! And if you look at Sewall Wright's article on evolution in the fourteenth edition of the *Encyclopedia Britannica,* you will find him insisting that really there are only ideas or expres-sions of mentality of some kind; all that work he reports in population

genetics is relatively illusory. But I think, or hope, such attitudes are rare among biologists. If they use techniques so esoteric as to produce artefacts, they know they have failed. It's processes that go on in real organisms and in the molecules of which organisms are composed that they are trying to explain (and not, unless they are neurologists, just buzzings in their own brains). Struggling with this chapter, I have been comforted to notice that Niles Eldredge, by profession an invertebrate paleontologist, says in an essay about the intractable problem of what a species is: "I am only sure of one thing; it is nature, not my own vacillation, nor the collective inability of biologists over the ages to agree, that lies at the root of our difficulties in deciding what species actually are" (in a manuscript entitled 'What, if Anything, is a Species?'). If there continues to be disagreement over this question, it is because nature is complicated, not because taxonomists just happen to prefer one lingo or another. There is a reality out there—or not just out there, since we are part of it—so rich that our best efforts to understand its regularities will never exhaust it.

Fine seems to think that because most scientific hypotheses have broken down there can be none with any claim to truth, that is, with any claim to tell us something about the way things really work. That's like saying that because most species that have ever lived are extinct there's nothing living now. That there are many failures doesn't mean there are no successes. Indeed, although a belief in 'scientific progress' is now unfashionable, there does appear, if one is not blinded by fashion, to be a striking accumulation of those rare successes leading to a much broader and deeper knowledge of many natural processes than anyone has ever had before. There is so much of it, in fact, and in so many complexly related and unrelated special areas, that no one person can possibly possess more than a tiny corner of it. And I don't see how one can reasonably explain this phenomenon except by taking a realistic view of what scientists are trying to do and have to a striking degree succeeded in doing. There was a paper some years ago about Aristotle's view of the heart, in which the author argued that since Aristotle had good reason in terms of his observations (often on abandoned neonates or spontaneously aborted foetuses) to think the human heart had three chambers, he was just as 'good' a scientist as a modern physiologist who finds it has four. But I'm afraid that if I

develop chest pains I will look, not for a follower of Aristotle, but for a modern cardiologist to consult. The knowledge of nature available, with proper training and aptitude, to our contemporaries is simply vastly greater than that available to the best intellects (and observers!) in the fourth century B.C.

Fine has an answer to that statement which I'll come to shortly, but I still want to ask, how did the 'natural ontological attitude' come to be allegedly opposed to realism? In the seventeenth century, where our attitude to nature has its roots, it was believed that ordinary people foolishly supposed that things 'out there' were 'like' their images or 'ideas' of them. They thought roses were red and violets were blue and sugar was sweet. But in fact, so the new view went, nature is what can be understood mathematically, in particular through geometry, and all those other seeming 'givens' of our senses were just inner feelings responding to the motions of a dead, spread-out mass of matter. So the natural ontological attitude was the 'realistic' one, the view still sneeringly referred to as naive realism. And that's why, of course, since I don't believe my sight of a red rose or taste of sweet sugar is a sort of picture of something out there that I've somehow copied in my head, I can't rightly call myself a naive realist. I do in fact believe the rose *is* red—I know it from a tea-rose color, for example, by looking—and sugar sweet—I know that by tasting. But I certainly don't hold that kind of simple copy view—if anybody ever did. I'll have more to say about perception in the next chapter; but meantime I'm trying to see what, in our tradition, it has been thought 'natural' to believe about the things around us and our relation to them. And we are told, initially by Descartes, and afterward by others, that the natural, unsophisticated way people see this matter is in terms of 'naive realism'. When we become more 'scientific', we may say with Galileo that color, sound, taste, and smell would be but mere names if the living creature were removed. We may even remind ourselves of Eddington's two tables: the seeming, 'perceived' one that's hard and can hold dinner ware or a computer and the 'real' one that's a gassy almost-void with atoms and smaller particles dashing madly 'round in it. But it's the educated rather than the 'natural' attitude that's anti-realistic. Believing in atoms and electrons surely isn't as natural as believing in red roses and sweet sugar. My pathologist colleague was being sophisticated, or so he

thought, in denying reality to anything more tangible, visible, or ordinarily obtrusive than electrons.

Granted, acknowledging the reality of the unobservable entities postulated by the sciences may feel pretty natural, too. As Hume has told us, custom is second nature, and we are accustomed to accepting the authority of scientists; so we also believe in the existence of atoms and electrons and genes and viruses and all sorts of such things. In short, we are realists to our bootstraps unless Fine and others persuade us otherwise. Why ever not?

Well, here, in effect, is what Fine tells us. If we are to justify scientific realism, he says, we must have a method of argument *more* accurate and more exact than the methods by which the conclusions of science are elicited. Scientists work by what Peirce called abduction, going, within a given context of presuppositions and previous knowledge, through some less than deductive kind of inference, to a (tentative) conclusion that our premises alone would never logically justify. Now that may work, practically, for scientific research—in fact, despite Fine's quantitative gloom, it seems to have worked on the whole rather well in many cases. But if we want to rise to a higher level and justify this procedure, we must do it, Fine insists, by some (unknown) method more explicit, more precise than the method we seek to justify. He adduces other, sometimes very ingenious reasons for his view, chiefly critical analyses of the arguments of 'scientific realists'; but that is the chief relatively formal argument he invokes.

Well, what's wrong with it? What's wrong with it is, first, that it still reflects a deep belief in the positivist, or logical empiricist, image of science, insofar as that view entailed a strict separation between the processes of scientific discovery and their subsequent justification. The kind of superstructure of laws and theories erected on an experiential base that logical empiricism envisaged was to provide a 'logical reconstruction' of science; but that reconstruction was possible only through the device of separating sharply what was called the context of justification from the context of discovery. There is something unsettling, to logical minds, about the way(s) discovery works: it depends too much on situation, interests, even (God forbid) personalities. So the philosopher of science must look only at the results of science, at the way finished bodies of knowledge—ideally, nicely axiomatizable

theories—can be justified, that is, arranged in neat logical structures, once they exist. That is, obviously, to give an account of the cognitive claims of the sciences without any account of scientific research. *Hamlet* without the Prince of Denmark, in fact.

The advantage of this strange procedure, however—or its apparent advantage—was that everything we had to say about science, and everything we thought science itself had to say, could be made entirely explicit, just as Fine thinks a defense of realism should be. We had a neat arrangement of basic reports of 'observation'—'protocol sentences'—and laws consisting of generalizations of these and grander sets of sentences (or formulae) called theories from which the lower-level statements could be deduced. And, wonder of wonders, further observation statements could be predicted from the superstructure. It was all there for those who run to read. Now in that situation of course if you want a further justification at a yet higher level—a reason why all this rigmarole should be thought to be about something beyond its own contrivances—you would need an equally precise and explicit series of meta-statements rising above the others. In Fine's view, indeed, you need a *more* precise statement over and above the lower level justification you already have.

Yet an image of science that omits research, omits the practices of science, is a will-o'-the-wisp. Some such airy image did, indeed, dominate official philosophy of science for a half century or more. But, as Arthur Fine knows better than most people, philosophy of science needs to be pursued through careful study of the concrete, historical practices of some, or several, scientific disciplines. And when it is so practised—when the artificial separation between discovery and justification is abandoned—the demand for total explicitness, for more and more exact and literal justification, fades away into thin air where it belongs. The rigmarole of constructing ever more exact justifications gives way to studies of the ways (there is no single way) in which, in many, partly overlapping areas, the search for knowledge, and the claim to have knowledge, come into being and maintain themselves.

The scientist turned philosopher who made this point central to his account of scientific knowledge, and of knowledge generally, was Michael Polanyi. It is his insistence on the tacit foundation of knowledge, in contrast to the impossible search for total explicitness, that is

needed, I believe, if we are to acknowledge the real immersion in reality of the processes of science. All knowledge, he argued, necessarily includes a tacit component on which it relies subsidiarily in order to focus on its goal, whether of theoretical discovery and formulation or of practical activity. All knowledge has a 'from-to' structure: it is the groping *of* embodied beings *toward* the understanding of something in the world that surrounds them. Sometimes, admittedly, that something, the focus of our search, may be something in ourselves; but the primary drive is outward. Indeed, it is through that from-to relation that knowledge is rooted in the reality of the knower and his(her) world.

The acknowledgement of the tacit component of knowledge, with its from-to structure, obviates in one move both the difficulties I mentioned in Fine's argument. If all knowledge, however exact and explicit, rests on a tacit component: on understanding rather than just the manipulation of symbols, then we cannot reasonably separate the practices of knowledge, questioning, search, discovery, from the logical reconstruction of such knowledge when achieved. And if we do not separate the 'two contexts', we are always engaged with the tacit as well as the explicit: with knowledge claims, procedures, fundamental beliefs implicit in our scientific practices, as well as with the surface formulations and reformulations of our knowledge claims.

Polanyi expounded his platform in a number of ways through many years. One of the clearest statements of it he made in an address to a philosophy of science congress in the 1960s. "The original intention of logical positivism", he said,

> was to establish all knowledge in terms of explicit relations between sensory data. In the course of the last twenty years this programme has been gradually relaxed
>
> I suggest that we transform this retreat into a triumph, by the simple device of changing camp. Let us recognize that tacit knowing is the fundamental power of the mind, which creates explicit knowing, lends meaning to it, and controls its uses.

That is not to say that explicit procedures and exact formulations achieve nothing; far from it. But if, as he continues,

> [f]ormalization of tacit knowing immensely expands the powers of the mind, by creating a machinery of precise thought, . . . it also opens up new paths of intuition.

Therefore, he declares,

> any attempt to gain [total] control of thought by explicit rules is self-contradictory, systematically misleading and culturally destructive.

It is self-contradictory, since the claim to total explicitness must be tacitly understood, thus denying its own claim. It is systematically misleading because it distorts reflection on the significance and the techniques of any scientific practice by presuming that the enumeration of explicit criteria for its exercise tells us all we need to know about it. It is culturally destructive, since it claims to reduce the subtle and manifold richness of a tradition to items analogous to parts of a machine. Therefore, he continues, formalization must be grounded in tacit knowing, in other words:

> The pursuit of formalization will find its true place in a tacit framework.

"In this light", he concludes:

> there is no justification for separate approaches to scientific explanation, scientific discovery, learning and meaning. They ultimately rest on the same tacit process of understanding. The true *meaning* of Kepler's Third Law was *discovered* by Newton when he *explained* it as an outcome of general gravitation: and *learning* by insight has the same three aspects on a minor scale. (Reprinted in *Knowing and Being*, Chicago, 1969, 156)

The move Polanyi called for seems to me indispensable if we are to escape the to-and-fro of realism-anti-realism arguments. Admittedly, an 'empiricist' or operationalist (who believes science consists in carrying out certain techniques successfully, with no further object of understanding anything)—could admit a tacit component and still hold his(her) own view of scientists skating on a glassy surface of meaningless phenomena. So by itself, the admission of a tacit dimension is not sufficient to establish realism. But it is a necessary condition, indeed, *the* necessary condition that has to be met if we are to reflect to some purpose on the sciences as historical practices rather than trying to elaborate arbitrary 'reconstructions' of what science neither was, is, nor could be.

Fine, too, wants to let science be what it is, instead of some philosopher's pipe-dream. And even he speaks, in another essay, of "the scientist's hope that a good theory will penetrate into nature more

deeply than its predecessors." But that's all a realistic view demands. Why shouldn't the Natural Ontological Attitude (NOA for short) admit the primacy of the real, our rootedness in the real, as it always has done? Fine says 'realism' only adds to his NOA a kind of screaming fit, saying it's *REAL, REAL, REAL!*

Maybe so. But in the current state of affairs in philosophy of science and related fields—sociology of science and various spillovers from such unlovely areas as literary theory—in the current situation, some such screaming seems to me wholly appropriate. For beyond the bounds of standard, professional philosophy of science, where debates about 'scientific realism' and other such topics still to some extent persist, there are all the fashionable folk who boast of being social constructivists, or deconstructionists or pragmatists, or even all of those at once. Sciences are social structures, they cry; society is competitive; therefore sciences are competitions. Of course there are scientists whose chief aim in life is to get a Nobel prize. But that doesn't mean science is nothing but a cut-throat competition for prizes. There was a questionnaire sent out by Sigma Xi a few years ago about the motivations of scientists. Many replied, 'curiosity', or just love of a particular subject-matter. Some of these may have been lying, of course; there are hypocrites in every field. But there is such a human drive as wanting to know and in some people it is all-absorbing. Others, in the deconstructionist camp, point out that everything scientists, like other people, say they have to *say:* to express through language or other man-made symbols. But languages and other symbol systems are artefacts, cut off from 'reality'. Scientists, like the rest of us, are trapped in that second, surrogate reality that we have made for ourselves. So they might as well be constructing ships in bottles as so-called explanations of allegedly natural processes. (Another current version of this 'argument' tells us, nothing can be accomplished without persuasion; therefore everything is rhetoric.) And pragmatists say, it's all just a question of what works. The traditional correspondence theory of truth insisted that true statements somehow correspond to or mirror the structure of reality. But we can't get outside our skins to some purely objective height and check what 'reality' is. So, pragmatists say, there's no 'truth' to be found, only success or failure.

All these 'arguments' seem to me to illustrate a single fallacy, although I have not been able to put a name to it. They all resemble a

person who, because he has to use a hammer to hammer in a nail, says there is only a hammer, no nail, or because he has to use a nail to hang a picture says, there is no picture, only a nail, or because he has to look at a picture to recall what its object looks like, says there never was an object, only a picture. (Because I have to see a photograph of my mother, long since dead, in order to recall what she looked like, I never had a mother.) This seems to consist in taking the means for the end, or the technique for what it's concerned with. Whatever it is, it's obviously very silly, but in all its varieties—and doubtless many more—it's also extremely fashionable. And when one is, as one is nowadays in universities, nearly surrounded by it, one feels a bit of screaming is in order.

And I hope one can do a little better than scream. It should be possible to point out, for example, that if society is competitive, it is also sometimes actually social. If scientists compete, they also co-operate, as other people sometimes do. Indeed, they have to do so: that's the way, for the most part, the enterprise of science works. To begin with, the practices of the sciences rest on teaching—which in every area, but especially in the sciences, works as much by example as by precept. Polanyi used to say, if you want to know about the presuppositions of a given field, spend five years in the laboratory of one of its leaders. In the course of such a process, the very person is altered, not, however, in a 'subjective' way, but by entering into a community that shares interests in, and techniques for finding out more about, a given subject-matter. And once the learner has assimilated the knowledge and the know-how that characterize his (her) discipline, a similar give and take has to continue among peers. The sociality of science is not wholly selfish.

Nor is the submersion in language necessarily, or even usually, a process of detachment from reality: it is our road of access to it. A recent collection of lyric verse by an eminent Irish poet is called *Seeing Things*. And rightly so. Language, even poetic language, is not turned in on itself: it intensifies seeing, the obtrusiveness of things, to which, through words and phrases, we can turn more vividly, and of course more permanently, than we could do without them. Language provides perspective, and although perspectives are limiting—we can't see from everywhere at once, let alone from nowhere—they are not blinding. Spotlights show more, or more exactly, than a more diffuse lighting

would do. (Of course, Heaney's title may also suggest 'seeing things' as Lady Macbeth does in the sleepwalking scene; but it surely includes, and for me evokes most vividly, the primary, 'realistic' sense of seeing.)

Pragmatism, I fear, doesn't merit even so brief a refutation. Sure, nothing succeeds like success; but successes are successes *in* something or other, and if they are successes in scientific knowledge, or any other cognitive activity, they are successes in coming, in Polanyi's phrase, into contact with reality: successes in knowing something about something. Never, of course, infallibly, and never in such a way that the knowledge in question cannot be refined and improved—or even overturned. There is no one set path or direction to such practices. But they do exist, and exist, in the big picture, cumulatively. They should be respected for what they are, not cried up, or down, for what they are not, or for what, emphatically, they are not 'nothing but'.

I started this chapter by asking what realism it is that's supposed to be dead and what its successor is. I hope I have suggested, if not established, that the dead realism is a rather dreary in-house debate about what 'scientific realism' amounts to. What the realism is that ought to take its place, I have been trying to establish since my first chapter—and since my recovery from a brief attack of positivism in the thirties. One important move in its direction, I have argued here, is the adoption of Polanyi's recognition of the from-to character of knowledge. That effort has been hampered, not only in the positivistic tradition, but in philosophy as a whole, by a badly mistaken theory of perception. Merleau's "primacy of perception" was an effort to correct this mistaken conception; but a much more substantive correction of it is fortunately available by now and I hope a layman's account of that new view will help to add weight to my own rather rambling reflections. The anthropological relativism I knew in my youth, revived with bells on by the fads and fashions I have just been referring to, can also be corrected, I believe, by consideration of some more thoughtful work in social anthropology. In the next two chapters, I want to call on both these disciplines to help me in my search for an adequate conception of persons as embodied beings seeking to understand in some respects the very real and demanding environment(s) in which they find themselves.

PART 3

COPING

Perception Reclaimed: The Lessons of the Ecological Approach

B ack in Chapter 1 I talked about the role of perception in knowledge. When I wrote that lecture, about fifteen years ago, I was relying heavily on the Merleau-Pontyan view of the primacy of perception, and I think that both the realism of Polanyi's account of science and my own long-time weakness for realism-wherever-possible contributed to my enthusiasm for Merleau's work. At the time, however, there was, so far as I knew, no adequate account of perception to back up such a point of view. I did try to use Aristotle's account, but I now see that his exposition, with its insistence (in spots, anyway) on the incorrigibility of perception (which has to mean the incorrigibility of *sensation* as a pretty subjective and private process) doesn't really help, and certainly no modern account I know of transcends or undercuts the purely subjective, and so anti-realist, foundation of orthodox empiricism. Everybody who talked about perception at all concurred in holding it to be some sort of process that took off from meaningless, inadequate, subjective data and from them constructed by some kind of 'unconscious inference' conjectures about what might be there in the real world. And this wasn't just philosophers. My father taught English at the University of Wisconsin; he was not in the least inclined to philosophical reflection. But I remember walking down University Avenue with him while he commented on the strange fact that I couldn't tell at all what he was seeing—for instance, when we were passing the pink or orangish brick building that housed the Forest Products Lab—nor could he tell what I was seeing. Seeing, hearing, smelling, tasting, touching were purely private matters that might for all we know be totally idiosyncratic to every individual. We just had our own peculiar sensations and knew nothing of anybody else's. But if that's where we start, and if that's what we stress about the senses, it's hard to see how we get from there to any relatively direct knowledge of the world around us. When I was working with Polanyi, I

recall his being impressed by an account of sense perception by the British neurologist Sir Russell Brain, in which he interpreted sensation as symbolic, as signs for the entities or events we might indirectly reach out to with their assistance. It never occurred to either of us that sense perception might be interpreted in a radically different, and more realistic, way.

Such a view is now available; indeed, it was partly available at the time, although I didn't know it. What I am referring to is the subdiscipline now entitled ecological psychology, which owes its existence largely to the work of James J. and Eleanor J. Gibson. In 1969 Bert Dreyfus and I organized a meeting at Berkeley—one of those large amorphous, or polymorphic, meetings, that don't, I think by now, do anyone much good—on the topic 'Concepts of Mind'. Bert has a long-term love-hate relationship with the philosophical aspects of work in Artificial Intelligence, and I was concerned, chiefly in connection with philosophical questions about biology, with the problem of reductionism as it was then debated: is biology reducible to physics and chemistry, are minds reducible to nervous systems, and so on. One of our speakers was the eminent perceptionist J.J. Gibson. To tell the truth, I don't remember just what he spoke about, nor do I recall whether I had yet read his 1966 work, *The Senses Considered as Perceptual Systems,* or whether I read it shortly thereafter. He was an impressive speaker—even though I don't recall the content of his talk!—and I did read the book some time around then and used it as an example in one of my reductionism papers. I also got to know both the Gibsons when they visited Davis for a quarter some time in the seventies, and saw them again in Ithaca when I visited my daughter there later in that decade. It was always challenging to talk with Jimmy Gibson, and his widow has since become a close friend, whose work I try to follow insofar as the alien world of experimentation is open to me. But I must confess that I didn't at the time come close to understanding what they were up to. It was only when I read J.J. Gibson's last book, published in 1979, the year he died, that I began to see the really fundamental importance of the Gibsons' work for the philosophical problems that interest me. Like some other philosophical readers of his work, I found in Gibson a striking convergence with Merleau's views, and in 1981 I taught a month-long seminar on the two writers at the University of Waterloo. Since then, partly because of the

difficulty of Merleau's rhetoric (which I alluded to in Chapter 4), and partly because he needed a theory of perception that didn't then exist and now does, I have concentrated rather on trying to understand and expound Gibson than on trying to bring the American and the French thinker together. In any case, what I want to do here is to say, if I can, how I think that the Gibsons' work, and especially his *Ecological Approach to Visual Perception,* can contribute to a more adequate conception of the way we cope with the world around us through the perceptual systems conferred on us by our evolutionary history.

Let me recall the traditional view of perception on which till recently all of us were raised, and to which, alas, many philosophers and psychologists still cling. In a famous passage in the Second Meditation, to which I referred earlier in another context, Descartes comments on the error, as he sees it, involved in saying that we see things with our eyes. On the contrary, as he has just demonstrated, it is (on his view) only by an act of mind, rather than through our sense organs, that we 'perceive' even a particular body present before us, like the piece of beeswax he has just been examining. Supposing men were passing by his window, he remarks, he would at first be inclined to say he 'saw' them. "Yet what do I see", he asks, "but hats and clothes, under which automata might be hiding?" It can plausibly be argued that the standard modern theory of perception stems from this Cartesian distinction. In terms of the theory that eventuated, however, he should have said, strictly speaking: 'What do I see but colored patches of various shapes and sizes which I judge to be hats and clothes, which in turn I judge to cover men?' Earlier he had been looking at a piece of wax, which, heated, changed its every sensible property, yet remained the same piece of wax. So he had grasped its presence, he argues, not by his senses (all whose presentations had been wholly altered), but by an act of mind, in which he *understood* this wax to be something extended, flexible and mutable. The same goes for every 'sensible' object. To see a hat or other item of clothing, let alone a human being, is to receive visual data, meaningless in themselves, and to infer from these the judgment that such and such—a hat or my granddaughter Hannah—a coat or a colleague—is over there. The data themselves are simply *sensations,* pure givens

private to me and in themselves indicative of nothing beyond themselves. *Perceptions,* in contrast, are the result of, if not identical with, judgments that I make on the inadequate evidence of my sensations combined with experience. Or more accurately, they are judgments based on repeated inferences from this visual or auditory datum here now to those tactile or visual or auditory data to come, inferences made over and over in the past, so often as to become routine. Thus Berkeley, following, and helping to perpetuate, this tradition, stressed that we never *see* distance. Creeping about as babies, we have learned to associate certain shapes and sizes with the (successful) anticipation of certain other, 'corresponding' feelings of hardness, softness, and the like. The floor to be got over, the chair I can hold onto when I get there: these have been inferred from early relations between 'vision' and touch experienced in infancy and toddlerhood. So I *infer* distance from a repetition of correlated visual and tactile sensations. In other words, babies start with a chaos of disparate sensations that they gradually learn to collect and categorize into the judgments that we call 'perceptions'. So they can figure out eventually, despite the grave inadequacy of sensory data, what's 'really' there.

This distinction, between meaningless sensations, carrying little or no information about the world, and full-bodied perceptions, based on association and judgment, was reinforced in philosophy and psychology (which were not in those days separate disciplines) by the study of optics: by the discovery of the retinal image at the back of the eye. It seemed that vision—our most prominent sense—must be based on this flat upside down pointillist image, which we somehow use to calculate, in some esoteric way, what it is that has so affected the surface deep in the eye of the ox or frog or human being in the case. Sensation, 'stimulation' at some point in the body, is what is really happening; perception is the result of complicated and devious processes by which we have calculated what is probably the cause of the sensation in question. As I said, this view is still widely accepted. Recently I noticed on our library shelves a psychology text dated, I think, 1987, in which the author started, yet once more, from the "blooming buzz of confusion" babies allegedly begin with and showed how from that inadequate starting point we build up an inferred model of a world. Indeed, the notion that perception has to be constructed, by devious and highly indirect means, from the extremely inadequate data

of pure sensations: this notion has been assimilated over the centuries into the 'common sense' of all of us, or almost all of us, as my father's comments walking down University Avenue illustrate. One of the most eloquent defenders of the still standard view, Richard Gregory, not only argues, with many others, that perceptions are 'hypotheses' from which we infer predictions of what we cannot really sense; he goes so far as to call perceptions "fictions", inventions for getting around, blindly, in a world we can never directly apprehend.

Yet the theory of perception developed on the basis of the sensation/perception distinction gives rise to all kinds of puzzles. Berkeley worried about how it could be that from inverted retinal images we so readily judge things to be right-side up. The celebrated Stratton and Kohler experiments on seeing with inverting spectacles took off from this problem. Although their results can easily be fitted into a revised account of sense-perception, their procedures still rested on the traditional view.

That view was given its classic formulation by Helmholtz in the nineteenth century. He seems to have intended his theory as a support of realism against the idealism rampant in Germany in his day. Yet the sensation/perception dichotomy, and the inferential theory of perception associated with it, lend themselves at least as well to an idealist as to a realistic reading. Indeed, Fichte, half a century before Helmholtz, had given German idealism its start by relying on Hume's sensationalist reading of our experience. If my sensations are just little bits of feeling here 'in' me, then it is I, the almighty Ego, who, all alone, builds up experience. Such a perspective was supported, also, by the sceptical tradition in philosophy. (It seems odd that Hume's scepticism, directed as it was against theistic speculation, and the wildest speculative idealism should rest on the same foundation. But as a matter of fact, Berkeley's epistemology, too, came to serve in his later writings as the substructure of a pretty wild metaphysical idealism—or so they tell me.) And oddly enough, the belief that the senses tell us little about the external world was also supported up to a point by the development of neurology: by the discovery of specific nerve endings and the like—as well as by the optical investigations on which it had relied since the seventeenth century. At the same time, of course, the esoteric methods of experimental psychology, directed to the study of 'pure' sensations, isolated by ingenious experimental design, strengthened

the belief in the importance—and the poverty—of sensation as the foundation on which we must somehow construct a model of things and events 'out there'. That's how it was; that was the situation we had to deal with. Mach lying on his Viennese sofa counting his sensations was the beginning of thought.

But is the distinction between sensation and perception really necessary? Must we stress 'pure' sensation as the building block of our experience—sensation taken on its own in contrast with the complex constructs of perception? How much does pure sensation matter in our lives? In moments of intense pain I have recalled Keats's exclamation: "Oh, for a life of sensation rather than thought!" For pure pain is pure sensation, and it cancels not only thought, but all the perceptual contact with things and events around us that we usually live by. Pure sensation, exemplified by pain, seems marginal to the lives we ordinarily lead, and rather undermines than facilitates them. Is pure pleasure (if it exists) also so peripheral, or even destructive? Psychologists used to talk about 'hedonic tone', a phrase that suggests a kind of marginality. Something is happening, and its 'tone', its aura, is pleasant rather than painful. Admittedly, what hedonic tone was allegedly marginal to was itself sensation, not full-blown perception: little bits of feelings like this-here-now-this-special-shade-of-red, not the perception of a red folder on my desk. But the phrase 'hedonic tone' transferred to a less 'technical' context may suggest the point I want to make, which is that experience does not appear to be constructed out of little bits, whether pleasures, pains or bits of this-hue-(or taste or smell or sound)-exactly-here-exactly-now. Berkeley, and Hume after him, did honestly believe, it seems, that experience is built up of such little mental atoms, and their belief has lingered in later theories of perception, both in philosophy and psychology. Yet surely it is arbitrary and unnecessary to dissect experience in this abstract way. If I consider my sensed apprehension of what surrounds me, I don't find minimal sensibles of the kind Berkeley or Hume were after, and least of all do I ever *see* those upside-down tattered flat images at the back of my retina from which I am supposedly building up some complicated story of 'a woman outside the window walking her dogs'. This has always seemed to me an unlikely story. Unfortunately, it has become even more firmly

entrenched in philosophical argument through the fashion for artificial intelligence and computer models of mind: the more calculation the better, and poor old everyday perception can continue to pass unnoticed, or continue to be torn to bits for the sake of some high-tech contrivance.

Let me return for a moment to my question about pleasure. Is it a pure sensation or even the 'tone' of such a sensation? I find it pleasant to lift up my eyes to the hills from my computer; I believe I work better when I have a view to look at. The 'pleasure' comes partly, as Aristotle would have it, as relaxation, as a brief change of rhythm. Perhaps at the moment, with fall colors at their height, it is contrasting hues that please, and those would seem to be 'pure sensations'. Yet even they delight by contrast and shape and proportion. There is one round bright red tree, for instance, with still-green neighbors, and the hills behind it, and there are cattle grazing in the foreground. What such a view gives me, I think, is an awareness of spatiality, not of bare Cartesian extension, to be sure, but of the spatiality of *things*. And in turn, the pleasure of seeing all this is marginal to what I am working at: trying to write this chapter. Don't even the most intense pleasures play their role as aspects of an episode that is more than *just* bits of sensed particulars? Like Hobbes in the *Leviathan,* I must leave it to my reader to see "if he also find not the same in himself. For this kind of doctrine admitteth no other demonstration." But when it comes to sensation in general and its distinction from perception, I can now call on help from an empirical discipline, ecological psychology, to support my case.

Long before the publication of his last book, James Gibson had come to see that sensation is unimportant in, and even irrelevant to, everyday perception. That is a really radical insight and still hard to put over. The work of ecological psychologists depends on its acceptance, and it seems to me that any fruitful account of knowledge ought to do so, too. What matters is not little inner bits of feeling, but the way in which, relying on their perceptual systems, different kinds of organisms cope with their environments. 'Ecology' is, literally, the study of home, and ecological psychology investigates animals in their homes, that is, their habitats. More particularly, it investigates animals in their

efforts to find out what things, happenings, conspecifics and other animals have to offer them. What is primary is not inner bits of sensation, but the grasp by an animal, through its perceptual systems, of what matters to it in its environment. This change in starting point and in interest constitutes a truly radical break in the psychology, and I would hope, the philosophy of perception.

Of course this new approach to psychology did not spring full born from the head of its authors. Indeed, some already find in Gestalt psychology the turn that was needed to liberate philosophy from the old sensationalist epistemology. But Gestalt thinking was still tied pretty closely to the old retinal-image approach to vision: witness Köhler's celebrated retinal-size/brain-size experiments, and to the effort to reduce 'mind-states' to 'brain-states'. Gibsonians are by no means Cartesian dualists, who separate mind from brain, but neither are they reductionists, who want to take animals apart into whatever physical components they turn out to be made of. They are concerned with the cognitive (in the first instance perceptual) activities of whole animals in organized environments. If the sensation/perception dichotomy is irrelevant to their concerns, so is the old mind-body or mind-brain problem. Besides, the units in terms of which the Gibsons analyze perception are not passive presentations or images, whether atomistic, as in the Berkeley-Hume tradition, or more 'holistic' as in Gestalt psychology.

Gibson's theory, insofar as he had developed it up to his death, was presented in his last book, *The Ecological Approach to Visual Perception,* in 1979. The phylogenetic background for his view, as applied also to the other senses, is explored in his 1966 *The Senses Considered as Perceptual Systems.* An in-between position, in which he had not yet escaped the sensationalist-retinal-image tradition, is represented by his 1950 work, *The Perception of the Visual World.* Some of the concepts used there are still accepted by psychologists who have not yet recognized the revolutionary significance—and seminal importance— of the later discoveries. For a newcomer to these ideas, it is useful to read *Ecological Approach,* then turn back to *Senses Considered* and forward again to 1979 with, it is to be hoped, enriched understanding. Ed Reed's biography, *J.J. Gibson and the Psychology of Perception,* published by Yale in 1988, also gives a most illuminating account of

Gibson's career and interests. Another important contribution to the history of the ecological approach is Eleanor Gibson's recent book collecting and recalling her own work over the decades, which both contributed substantively to the ecological theory and served to instantiate and develop it in new directions.

This is not the place, nor am I the person, to go into detail in these matters. Here I just want to record my debt to the Gibsons and indicate by a very sketchy summary of their theory of perception what I believe they can contribute to a new and more fruitful account of animals, and particularly human animals', knowledge of their world. Some years ago, a former student of Eleanor Gibson's, Nancy Rader, suggested to me that a good source for introducing the Gibsons' view, in contrast to the older sort of theory, would be an exchange between the Gibsons and Richard Gregory in the *Times Literary Supplement* in 1972 (707–712), an exchange which puts clearly and succinctly the gist of both theories. In fact, Eleanor Gibson has included that exchange in her recent *Odyssey in Perception and Learning* (M.I.T. Press), so that it is now easily available.

So let me try to clarify the Gibsons' approach to perception by contrasting it with Gregory's very traditional theory.

Both theories share the premise I have tried to state in my biological rereading of the Kantian analytic, back in Chapter 2. They assume that human reality, like the reality of other Animalia, is rooted somehow or other in the contact with our environments mediated by our perceptual systems, and in our case as in some others also by 'higher' cognitive systems grounded in perception, both of these being products of our phylogeny. Perception, it is agreed, is our path to information about the world. But how is such information acquired: from what source and by what means? There the ways part.

On the older view, as we have seen, the stimuli from which perception must be initiated are meaningless sensory signals which will have to be worked up, indirectly, into perceptions. The distinction between sensation and perception is fundamental and sensations are the necessary material from which perceptions are built. Sensations, moreover, are atomistic and momentary; for vision they are, if not identical, at least closely associated, with the famous upside down flat retinal images that provide the impoverished 'pictures' out of which we

have somehow to construct perceptions. Gregory writes: "information given by eyes is only of indirect use to living creatures. To make use of it, a good deal of computing is required."

For Gibson (or better, the Gibsons), the situation is quite different. From their point of view, sensation is unimportant. Indeed, J.J. Gibson has argued, it was in asserting that point sensations are necessary to perception, "are the basis of perception", that Berkeley went wrong and so led astray the major tradition of experimental psychology to this day. On the contrary, as Gibson sees it, the information necessary to perception is conveyed in structures and deformations picked up by perceptual systems: in the case of vision, by the eye, hand, brain, body system. As Eleanor and James Gibson put it in the exchange I am relying on here:

> In life, the sea of stimulus energy in which an observer is immersed is always an array and always a flow. The stimuli as such, the pin-pricks of light or sound or touch, do not carry information about their sources. *But the invariant properties of the flowing array of stimulation do carry information. They specify the objects of the world and the layout of its surfaces. They are invariants under transformation, non-change underlying change.* (my italics) Note that these invariant properties are not in any sense pictures or images of objects and of layouts as so many psychologists have been tempted to think. Nor are they signals from the objects and surfaces of the environment like dots and dashes in a code. They are mathematical relations in a flowing array: nothing less.

What is presented, therefore, is relational: spatially, an array, temporally, a flow. Images are irrelevant in such presentations, nor is it a question of *re*presentation, but of a direct being-with of organism and external reality. (I shall return shortly to the concept of *invariant* introduced in the passage I just quoted, and also to another fundamental concept of Gibsonian theory not mentioned in the confrontation of 1972 that I am relying on for now. But for the present let me stick to this elementary comparison.)

In the traditional model, further, the bits we start from have to be pulled together by association. Hume has given the classic account of this alleged process. On the ecological view, in contrast, the primary process involved in perceptual activity is *discrimination* or *differentiation*. E.J. Gibson's work on perceptual development may be taken as definitive here; her book of 1969 is a classic text and she and her co-workers have produced, and are still producing, a whole literature that substantiates and extends this view. The myth that association is

the necessary forerunner of perception can at long last be forgotten: the idea that animals from butterflies to babies have built up associations from many instances before they perceive anything can be dismissed for the nonsense it patently is. Out of the infinite complexity of available information, organisms can discriminate information that is species-specifically relevant to their survival in their environments. Cats sense the presence of mice, and vice versa, beavers see the right kind of spot, and the right kind of wood, for building a dam, and so on and on. Some of this information pick-up may take place relatively spontaneously, but in many cases much is also learned, *perceptually* learned, through the organism's own active exploration.

What emerges out of this contrast, unfortunately, is information in two different senses. Much of the misunderstanding of J.J. Gibson by his critics, and even by some of his alleged supporters, springs from this semantic difference. For Gregory and the majority of theoretical and experimental psychologists, information in perception is identified with the calculations of information theory and, even worse, with work in artificial intelligence. But perception is an activity of *animals,* which are natural entities, not artifacts, and however cunningly machines may simulate such processes, they miss, on principle, the bodily reality indispensable to it. Gibson's 'information', in contrast, is much more biological: it is what is available to particular real organisms, squirrels, bluebirds, eels, or people, in the particular real environments which permit them to be, and even define them as, the particular sorts of real organisms they are. In acorns, a squirrel sees food for the winter, not conceptualized as with us in laying in supplies under threat of a blizzard, for example, but in its squirreline way it sees something we formulate as future-food-supply. A bluejay might see food in my feeder, or might flit off seeing danger if I were to move suddenly nearby. Perceptual systems have developed through evolutionary time precisely because they worked effectively to pick up such information essential to the lives of the animals in question.

What, then, is perception on these two views? For Gregory—and although he puts the case more extremely than some, he is echoing the standard view—perceptions, as I pointed out earlier, are hypotheses, or even fictions. Thus he declares that

> perceptions are constructed, by complex brain processes, from fleeting fragmentary scraps of data signalled by the senses and drawn from the brain's memory

banks—themselves constructions from snippets from the past. On this view, normal everyday perceptions are not selections of reality but are rather imaginative constructions—fictions—based (as indeed is science fiction also) more on the stored past than on the present. On this view all perceptions are essentially fictions: fictions based on past experience selected by present sensory data.

For the Gibsons, on the other hand, as they write in the same exchange I have been quoting:

> Perception therefore does not have to be conceived as the interpreting of messages or the learning of the so-called 'sensory code'. It is the exploring of an array, the extracting of available information, and the optimizing of its pickup. The eyes, for example, look around, focus their lenses on details of the world, and modulate the intensity of the light when the illumination is too high or too low. For listening, the head turns to equalize intensity of input to the two ears so as to point the head towards the source of sound.

A number of crucial differences are contained in, or follow from, these contrasting definitions. On the traditional view, perception has to be mediated; for Gibson, it is direct. For the tradition, perception is sensation plus judgment, or some form of cognitive activity. There is a sharp break, therefore, as I have been stressing all along, between sensation and perception. Hamlyn, for instance, a well-known British historian of perceptual theories, failing to understand the existence of any other possible view, lamented that poor Aristotle had only one word, *aisthesis,* for the two processes. Gibsonians like the present writer might, at first glance anyway, think him fortunate. True, there are sensations, fleeting bits that can be captured perhaps by drug addicts, perhaps by experimental psychologists, perhaps by sufferers from toothache or gastric ulcers. But, as I suggested earlier, it is the full-blooded process of perception that chiefly matters in the life of organisms and its distinction from sensation, in drawing attention away from what ought to be the central subject matter of perceptual psychology, has done more harm than good. Witness the fact that perceptionists like Gregory spend infinite time in the study of illusions: the hollow face, impossible objects and such, and little in the examination of real, everyday perceptions. Gibson and his school, in contrast, are concerned with the analysis of real-life situations: driving a car, crossing a street, jumping a long jump, the early perceptions of infants, and the like. (They can also do subtle analyses of illusions, like the Escher drawings, and so on, but illusion is not their primary concern, as it often seems to be with older-style perceptionists.)

Gregory, and other traditionalists, celebrate their theory as active, since passive sensations must be used as data for the active computation of the fictions that count as perceptions, and they condemn Gibson's theory as passive because it takes perception to be direct. This is a crass misunderstanding, since, as I have already insisted, the Gibsons' theory stresses from the start the exploratory activity of the perceiver. It is every bit as 'active' a theory as the other, only it places the cut between direct and indirect perceptual awareness at a different place, and therefore reads differently the place of cognition in perception and the difference between different kinds of cognition. For Gregory and others, sensation (on which perception has to be built) is passive and non-cognitive, while perception (based on unconscious inference) is distinctively cognitive. For Gibson, the primary perceptual process is already cognitive—and I think one could argue further that all cognition is, in the last analysis, at least in part perceptual. (I shall return later to this conjecture.) For Gibson, at any rate, the break between the direct and indirect (though not between passive and active) comes at the juncture, in human perception, where tools, words, and pictures come to mediate perception.

Another contrast which I shall touch on only fleetingly here, but which deserves more careful exposition, especially in connection with the bearing of either theory on epistemology, is the difference in the evolutionary premises of the two theories. As I noticed at the start of my comparison, both theories take perception to be the product of natural selection, through which organisms have 'learned', so to speak, phylogenetically, to adapt to the demands and opportunities of their environments. And both theories have abandoned Cartesian mind-body dualism. But for the traditional perceptionist it is machinery that now substitutes for mind as the organizer of experience. Gregory in particular loves gadgets, and he is happy to see us as congeries of gadgets making their way deviously if inventively through a hostile environment. This kind of evolutionary perspective can be given popular support, for example, by alliance with Richard Dawkins's *Blind Watchmaker.* Dawkins loves gadgets, too, and his argument illustrates well the way one can rely on computers or supercomputers to support a stubbornly reductionistic view of evolution and its outcome. In other words, the evolutionary basis for the traditional theory is externalistic and mechanistic, stressing the machine model of

the organism that has always been one feature (though by no means the whole) of selection theory. And in line with its machine-minded stance, it explains the origin of sense organs and their activities in terms of classical linear causality. One might say that the standard view picks up the Newtonian theme in Darwin's method and ontology. Gibson's theory, on the other hand, follows the richer and biologically more appropriate ecological aspect of the Darwinian tradition. This is made especially clear in the argument of *Senses Considered.* In this kind of evolutionary perspective, what Darwin called "conditions of life" are taken to be of primary importance; animals are viewed *in* their environments, and their phylogenetic as well as developmental histories are interpreted in interrelational, thoroughly functional terms.

'Functional': that adjective demands, parenthetically, clarification of another ambiguity, like the 'information' one. Unfortunately, just as there are two meanings of 'information' in the psychological literature, so, chiefly in philosophy versus psychology, there is functionalism and functionalism in it. 'Functionalism' in its contemporary philosophical guise, of course, is machine-minded with bells on; but this has less than nothing to do with real biological functions. It's the name given in philosophy and so-called 'cognitive science' to a variety of computational, often AI-oriented, speculations. According to Eleanor Gibson, however, 'functionalism' is the view of ecological psychology, which, she insists, echoes the position taken by William James in his *Principles of Psychology.* I am not enough of a James scholar to be able to corroborate that statement; but I can assure you that if I say 'functional' in a Gibsonian context, I certainly am *not* referring to any aspect of any view of such folk as Fodor, Dennett et al.

But to return to Gibson: the exchange between Gregory and the Gibsons that I have used to describe Gibson's theory antedates by several years some further developments not only in his terminology, but in the basic concepts on which the theory rests. The concept of 'invariant' was already in place in 1972, when our exchange took place, but a few years later Gibson coined the term 'affordance' to refer to what is, in his view, the object of perception. Let me amplify my introduction to the Gibsons' view by saying a little more both about affordances and invariants.

According to a recent exposition by Eleanor Gibson, all perception involves three components: first, the things and events in the organ-

ism's environment; second, the information available for pickup by the organism, usually in the form of invariants: constant mathematical ratios within a flowing array, and third, *what* the organism uses its information pickup to perceive: the *affordances* that the environment offers it. Thus the rabbit offers the hunter a meal, while the hunter offers the rabbit danger. Not that the rabbit *says* to itself, 'my father was put in a pie by Mrs. McGregor and the same might happen to me'; but through smell, sound, moving silhouette—through its perceptual systems, in short, it senses what we would call danger. 'Meaning' is not something superadded to the environment by human linguistic or other conventions; the worlds of animals are full of meanings which are perceived as such through the pickup of invariants. Note, however, it is not invariants as such that are perceived; they are the regularities that specify the objects and events whose affordances are directly perceived, whether as predator, as prey, as plaything, as potential mate, or whatever the biological situation in question demands. Invariants have been, and are being, studied, experimentally and analytically, by psychologists of the ecological school: for example, by David Lee of Edinburgh in his investigation of the long jump, by Gibson himself in his classic study of automobile driving, or by Eleanor Gibson and her co-workers in the famous studies of the visual cliff. The question there is: what information specifies crawlability or walkability as against falling-off-the-edge? The investigator studies, by varying experimental conditions, the characters of surfaces that the infant perceives as crawlable-on or walkable-on or: no, fall-off! To put it in Wittgensteinian terms, all seeing is seeing-as, not through some trick of visual illusion, but because perception is always the engagement of an active, exploring organism with the affordances of things and events that are happening, within reach of its perceptual systems, in its real ongoing world.

What has interested me in all this, of course, is the bearing of perception on knowledge. How does knowledge fare on the two theories I have been comparing? Basically, the traditional view suggests a phenomenalist position. We are not in a real world, but construct one out of disconnected bits and pieces. A Humean propensity to feign supports, not only human, but all animal experience. We

have only fragmentary bits of sensation, experienced or remembered, and only the gentle force of association holds these meaningless bits together to make the custom that guides our lives. When it comes to our particular case, moreover, our artefacts, languages, and other products of culture, can only add a further dimension of artificiality to an already unreal scene. Not so much a Humean vision is suggested here as a Hobbesian one: where the pure conventions of language and society are added, arbitrarily, to the blind impulses of nature.

For Gibson (or the Gibsons), on the contrary, as human reality is one version of animal reality, so human knowledge is one species-specific version of the ways that animals possess to find their way around their environments. Granted, our modes of orientation in our surroundings are peculiarly dependent on the artefacts of culture. Culture mediates between ourselves and nature, and given the multiplicity of cultures, we appear, so far as we can tell, to possess, or to be able to acquire, a very much greater variety of paths of access to reality than can members of other species. Now culture, and the artefacts of culture, are of course of our own making and in the last analysis we accept their authority only on our own recognizances. But culture, rather than being a mere addendum to nature, a fiction supervenient on the naturally induced fictions of perception—culture, on our reading, while expressing a need inherent in our nature, is itself a part of nature. There is no culture, and therefore no human reality, and *a fortiori* no human knowledge, not dependent on the use of natural materials and itself contained in nature, in the natural environment of mother earth, on whose existence we all depend. And our efforts, however disciplined and esoteric, to use language, instruments and pictorial representations to find our way in our human environments (including such environments as libraries, laboratories, space ships and what not) are analogues of other animals' devices for finding their way in their less arbitrarily contrived environments. As J.J. Gibson writes (in *Ecological Approach*), the human environment

> is not a *new* environment—an artificial environment distinct from the natural environment—but the same old environment modified by man. It is a mistake to separate the natural from the artificial as if there were two environments: artifacts have to be manufactured from natural substances. It is also a mistake to separate the cultural environment from the natural environment, as if there were a world of mental products distinct from the world of material products. There is only one world, however diverse, and all animals live in it, although we human animals

have altered it to suit ourselves. We have done so wastefully, thoughtlessly, and, if we do not mend our ways, fatally. The fundamentals of the environment—the substances, the medium and the surfaces—are the same for all animals. No matter how powerful men become they are not going to alter the fact of earth, air and water—the lithosphere, the atmosphere and the hydrosphere, together with the interfaces that separate them. For terrestrial animals like us, the earth and the sky are a basic structure on which all lesser structures depend. We all fit into the substructures of the environment in various ways, for we were all, in fact, formed by them. We were created by the world we live in. (*Ecological Approach*, 130)

Again, this is a thoroughly realistic view; it contradicts the phenomenalism or constructivism of the traditional theories of perception and, consequently, of knowledge, while at the same time leaving room for us to ask, within culture, and *via* its mediation, within nature, reflective questions about the character and import of cognitive claims. The vaunted 'naturalization' of epistemology, whether on physicalistic, psychologistic, or evolutionary grounds, evades precisely the conceptual and reflective questions that we, as the culture-dwelling animals we are, are inclined to ask. Granted, there can be, nowadays, no reasonable theory of knowledge that opposes assent to our phylogeny. Yet *within* our being-in-the-world as the kinds of beings we are, we do have room to speculate, critically and philosophically, on the kinds and varieties of orientations-to-environments that constitute, not only the perceptual learning of pre-language-using infants, but also even the most 'intellectual', but still analogous, explorations by scientists, including psychologists, and humanists, including philosophers, of the physiognomies and structures of the particular subworlds that characterize their special disciplines.

Now after that very general proclamation—or battle-cry, if you like—I want to focus on two particular questions that a Gibsonian approach to the problem of knowledge would suggest. As I have already pointed out, Gibson contrasts perception, which is direct but already cognitive, though tacitly so, with the indirect avenues to contact with reality mediated by human tools, languages, and pictorial representations. What if any is the role of perception in these indirect, or mediated, cases? And where the knowledge sought and acquired is, if you will, more cerebral and less directly perceptual (although of course perception itself is effected by higher centers as well as by the

sense organs themselves: it is always the sense-organ-brain-body system that is involved; but let me put the contrast very crudely as I have just done)—in these, so to speak, more cerebral cases, is the threefold structure of perception: objects, information through invariants, and affordances still maintained? In other words, where knowledge goes beyond the perceptual is it nevertheless analogous to perception in its structure?

On the first question: I believe that perception is often deeply involved even in cognitive activities far removed from everyday perceptual activity. Take the three forms of indirect 'awareness' of things that Gibson lists. Tools are often used simply to facilitate perception; this is true even of classical microscopy. We are talking here of perception aided by instruments; the indirectness lies in our construction of facilitating instruments and techniques, not in perception itself. Generally, the cognitive use of instruments has been to improve perception; it hasn't left it behind as a 'primitive', let alone impoverished, springboard to knowledge.

What about language? Doesn't that remove us from our perceptual to a radically 'mental' sphere? Certainly not. As Merleau-Ponty has argued so persuasively, even speech has to be realized in sound or in visible or tangible units. Language is itself perceived. And what is more, the child from the moment he or she becomes a language user enters into a richly developing feedback process from words to things and events and back again. The exploration of its world by the human infant is, in normal circumstances, complexified from early on by the linguistic as well as the other bodily expressions that surround and help to guide it. If language mediates our cognitive orientations in a way, so far as we can tell, radically different from the seemingly more straightforward perceptions of non-language users—or, so I believe, of invertebrate language-users like the bees—still it is often, at any rate, our very percepts that are enriched by such interventions. And our developing perceptions in turn inform and enrich linguistic expression. With classical X-ray techniques, for example, the beginning student sees a muddle of black and white shapes; with practice and further learning he (she) comes to *see* pathologies (or their absence) that had before been invisible. (Polanyi used to recount this experience from his days as a medical student.) The same holds of the reading of an electronmicrograph, which involves subtle theoretical as

well as perceptual skills. Perceptual discrimination, I would argue, stretches further even into the more 'abstract' disciplines than is often admitted.

At the same time, of course, there are language-mediated disciplines that seem to be pretty far removed from everyday perceptual apprehension, or from everyday language-perception feedback. When a physicist discovers a new particle, is he doing something in any way akin to the perceiver's information pickup with its attendant perception of an affordance? Does the structure of what Gibson called explicit (conceptual) as distinct from tacit (perceptual) knowledge, rest on a structure analogous to the threefold structure of perception? I think we can hazard a guess, at least, that something akin to the structure of perception holds even for sophisticated research remote from everyday perceptual situations. There is something in the real world that the scientist wants to understand; in his highly disciplined, artefactual environment, which includes not only his laboratory and its equipment, but the language of his discipline, the experimental techniques developed by his own group and by others he has met or read of: in that environment he has learned to pick up the information that in turn allows him (her) to 'see' what is going on: to pick up the evidence for the existence of something previously suspected perhaps, but not before substantiated. What the scientist is doing, I would conjecture, is to make *explicit* invariants that are not brought to the level of consciousness in the everyday perception of affordances. In Michael Polanyi's terminology, he (she) is bringing to focal awareness what is ordinarily subsidiary. Take some of Tinbergen's early work on nesting behavior: herring gulls will brood eggs of certain shapes and sizes, but not others. Here the experimenter is learning, by manipulation of dummy eggs, the affordances perceived by nesting females of that species, and he is doing it by changing the invariants that would normally supply the necessary information. Here of course the subject as well as the experimenter is a perceiver. But I have a hunch—as yet no more than that, perhaps—that even if one is investigating, say, damage by cold as against ozone to the growth of spruce trees, it is the experimenter's control of the invariants involved that makes his (her) data more significant than the 'observations' of someone who just looks at trees and sees that some are sick and others not. It has been often said that the experimental sciences, rather than just 'looking', set the

right questions to nature. They do so, in Gibsonian terms, by bringing, through 'arbitrary' but systematic techniques, invariants to a level at which they become the experimenter's affordances. Or again, in Polanyian terms, they make focal what is normally subsidiary. This is not just a case of 'seeing' more, but of promoting, so to speak, invariants to the status of affordances. To do this takes the discourse of the discipline in question, its experimental traditions and its theoretical presuppositions. It takes the right subworld within the natural world and the people who are encultured by interest and training to know how to behave in it. The most general application that I know of of the theory of affordances, indeed, is much more detached from ordinary perception than either of the instances I have suggested: namely, Philip Kitcher's view that mathematics is the study of universal affordances. In terms of the view of explicit knowledge I have just suggested, one would want to amend his formulation slightly and say that mathematics is the attempt to investigate the invariants on which universal affordances are based. Although unfortunately Kitcher based his account of Gibson's concept on an inferior secondary source, the theory is an attractive one and merits further thought.

So far I have been talking only about two of the three indirect forms of knowledge Gibson lists, but I'll take the risk of saying a little about his third sort of indirect knowledge: knowledge obtained through pictures. What about them? Here we have another case of perception, in particular of vision, but, on Gibson's account, peculiarly indirect, and more limited than real-life perception. What is characteristic of picture perception is that (except for some trompe-l'oeil cases) we are always aware of the frame, and hence of the real background, as well as of the scene or person or pattern that we see 'through' the flat surface of the picture itself. It is this doubleness, of picture *and* frame, that makes picture perception unique. Picture perception, too, of course, can mediate and influence claims to knowledge: this holds not only of children's learning through pictures but of the craft of biological illustration, and even, as I have suggested in passing earlier, of such subtle, theory-laden techniques as the production and reading of electromicrographs. What is most illuminating about Gibson's theory of picture perception, however, it seems to me, is the dazzling new

light it sheds on the nature of painting, especially of 'representational' art. The painter (as Merleau-Ponty has so eloquently argued in several essays, including the last published in his lifetime: *The Eye and the Mind*)—the painter reconstructs the act of perception more explicitly than does the naive perceiver. He (she) like the scientist—and also of course the trained art historian or art critic—seems to be elevating certain invariants to the level of affordances, so that he (she) purposefully uses and brings directly to view relations that in everyday life would be subordinated to perception of the opportunities or dangers afforded by the events and objects around us. This theme is tangential to the lessons about our cognitive orientation in the world that I have been trying to elicit from the ecological approach to perception, and I won't try to pursue it further—though I wish someone else would. But I hope it makes sense to suggest a comparison on the one hand between everyday perception in its threefold structure and the same threefold structure altered in the practice of either science or art by the turning back, so to speak, of the affordance aspect to the invariant one: of bringing the otherwise submerged, or subsidiary, to focal attention. In the case of the sciences, it may be some aspect of reality very remote indeed from our ordinary perceptions that is being thus revealed—if always within the appropriate cultural subworld—while in the case of painting, whether representational or abstract, it seems to be the vividness of perception itself that is being brought explicitly to our attention by the painter's command of his technique.

This is all very sketchy, but let me try to sum up the main points I have been trying to make. First, it seems to me emphatically the case that, on philosophical as well as experimental grounds (insofar as I know from reading, and from talking and listening to some of the psychologists concerned), the new, but by now very impressively developed, and developing, ecological approach to perception ought to replace, once and for all, the abstract and improbable traditional theory. Descartes thought the commonsense view of perception a prejudice of infancy (reinforced by the scholastic education of his time). Let us admit that *his* prejudice (and Berkeley's and even, alas, Hume's) against common sense—and infancy!—have misled both psychologists and philosophers for several centuries. Let us start again

and see how far both science and philosophical reflection can take us from a more commonsensical starting point.

Second, I hope the little I have said about tools, language and picture perception in particular and about the culture-nature relation in general have suggested some ways in which this new and more adequate theory of perception can be applied to the problem of knowledge. Perception, on this view, *is* already knowledge, not because it adds 'unconscious inference' to atoms of sensation themselves without meaning or coherence, but because the fashion in which our perceptual systems permit us to find our way around already affords a substantial body of tacit knowledge of the real world (or worlds) that we inhabit: worlds both natural, and, within nature, cultural. Further, perceptual learning, I suggested, reaches much farther into developed cognitive disciplines than the traditional theory would allow us to believe. And finally, there is a significant analogy between the threefold structure of perception: things or events; invariants, which are the source of information; and affordances— between that threefold structure and the structure of what we may call more 'cerebral' disciplines, which involve the mediation of tools, language or pictures. I have suggested, if very tentatively, that in such cases, or at least in some such cases, invariants, whose pickup usually points to the affordances the organism directly perceives, are promoted, so to speak, to the role of affordances. Thus experimental, observational, or theoretical techniques often bring into view, as novel and artifact-induced affordances, invariants that would normally serve only as means to the perception of those more common affordances evoked in everyday life. Picture perception, or picture making, finally, seems to perform, for the artist or the informed viewer, a similar service for perception itself.

This is only the barest starting point for what might be accomplished, philosophically, on the foundation of the ecological approach to perception. It's as far as I have got in a dozen years of thinking about the question—on and off. I used to believe there were three young philosophers who might pursue the matter further with more imagination and more youthful energy than I can boast. By now one of them has left the profession and a second has betrayed the cause by constructing, laboriously, an account of Gibson's theory as a theory of *re*presentation—just what it emphatically is not. It was the traditional

view that insisted on those secret inner somethings as somehow representing, 'standing for', quite different things out there. And it is one of the great virtues of ecological psychology that it abandons that misconception. The third of my promising three, Ed Reed, whose biography of Gibson I mentioned, is now deep in psychology, both academic and clinical; but if he finds time for philosophy, he may yet fulfill that promise. And of course others as yet unknown may possibly see how the new light on seeing can illuminate philosophical problems about the way we orient ourselves in our world and claim, with some good reason, to know something about it. Meantime, I hope that, even in this very slight beginning, I have provided some inkling of the philosophical insights that might be built on this truly original and, in my view, profoundly convincing psychological account of the way our perceptual systems, like those of other animals, but also differently, make contact with the world. It is the peculiar difference initiated by our reliance on culture that I shall think about next, especially in relation to the work of so-called symbolic anthropologists.

Our Way of Coping: Symbols and Symboling

Ecological psychology stems from, and rests on, a revolutionary account of perception. But perception is common to all animals; so much is evident to every one but Descartes and his most fanatical followers. To most perceptionists and to many Darwinians, too, it would seem, then, that we are 'just like' any old animal. Yet, as I have recurrently been stressing, we are also rather odd animals. We cope with the world around us, as all animals do, by reliance on our perceptual systems. Yet, all the same, there also seems to be something rather different about us compared to our fellows in other animal populations. And certainly the way we make knowledge claims, while it is rooted in our animate being and our animate situation, also differs significantly from the way other critters manage.

What's the difference? Merleau-Ponty's distinction among the physical, vital and human orders may give us the locale for an answer, reminding us that we are not to be placed in sharp dichotomy over against other animals, but that we exhibit a different life style among others. Still, we need more than that. How shall we characterize what used to be called 'the uniqueness of man'? Like many practitioners of philosophy (though, surprisingly, by no means all of them), I have tried from time to time to express some thoughts about this issue, back in 1947 in a paper in *Ethics,* (quaintly entitled 'On Some Distinctions between Men and Brutes'), in my Davis research lecture of 1971, 'People and Other Animals', in discussions of some European writers, and most recently in a book written with Niles Eldredge on the biological basis of social systems (Columbia, 1992). For some years, indeed, as I mentioned earlier, I hoped to formulate a version of what is called in Europe philosophical anthropology, a philosophy of human nature that makes more use of apposite empirical knowledge than most philosophers in the Anglo-American tradition are inclined to do. Nothing came of this project; the present chapter is yet another attempt

to indicate the direction in which, as I see it, one might reflect to some purpose on this question.

What is plain from the start is that, so far, no simple answer has worked. 'We have reason, other animals have none': it is clear that many animals make inferences. 'We use tools, other animals don't': Köhler's apes, even before Goodall's, plainly gave the lie to such a claim. 'We recognize our mirror images': a famous experiment by Gallup showed that chimps do, too. 'We have traditions': so do the macaques who follow their pioneering ancestress in salting their sweet potatoes in sea water. 'We speak, others do not, or not in the same syntax-governed way we do': here controversy still rages. Looking at some of the issues raised, or positions taken here, may guide us in the right direction for a more promising answer.

To begin with, we may take the question as twofold. Is there something different about human language, and how does human language, if it is different from other forms of animal 'speech', relate to our special way of coping? Our language may be different, without its being *the* difference that makes us different.

First, then, is human language in any way unique? There are people who call themselves cognitive ethologists, and who claim that all animal communication is of the same order, from amoebae, or certainly from social invertebrates, to human beings. The language of the bees, so thoroughly studied in this century, is said to be language in the same sense as dolphin or elephant or primate communication. Bees not only dance to tell one another where the food is; they can even be made to tell lies. And what can be more cunningly or triumphantly linguistic than lying? This attitude reminds one of seventeenth-century controversies about the so-called beast-machine. Honey bees were at issue that time, too: to make such precisely hexagonal cells, it was argued, they had to possess, if not knowledge of Euclidean geometry, at least the kind of knowledge artisans have who build nice regular structures. Opposing such opinions, Descartes thought he was making our souls safe for God and immortality by denying any thought whatsoever to members of other species. Modern defenders of our allegedly unique linguistic competence are not necessarily concerned with such quasi-theological issues; but as in the

time of Descartes, their opponents, or some of their opponents, want to include 'intelligent' invertebrates in their claims for non-human speakers. So are the bees just like us?

I am still with the first part of my two-part question, and here my answer in turn comes in two parts. The first part is evolutionary: surely the vertebrate central nervous system has a cognitive function that enables us to distinguish, in general, between invertebrate and vertebrate life styles. People and bees, to begin with, see the world differently. Granted, octopuses are invertebrates, too, and their eyes are built, on principle, like ours; that's another story. But insects find themselves in a visual world structured on principles wholly different from ours. And what they do with their visual information, given the difference in their nervous apparatus, has got to be different, too. Not that I subscribe for a moment to the currently fashionable 'neurophilosophy'. But surely the central nervous system provides necessary, though not sufficient, conditions for the means by which vertebrates find their way around in their environments—and that includes, of course, the devices by which they make contact with their conspecifics in meeting their shared concerns with food, shelter and reproduction. Short of such an appeal to Darwinian principles, moreover, it seems to me that the existence of some thousands of human 'natural' languages over against one honey bee language suggests a pretty deep difference in the processes involved. To this, honey-bee language enthusiasts reply that there are many different dialects in this one language. A weak reply, I should think. But in any case the Darwinian answer appears to be sufficient: the evolution of the CNS had to be 'for' something. There are of course characters or behaviors of many organisms that have no adaptationist explanation. But structures as complex and intricately co-ordinated as the vertebrate, or the primate, or the human central nervous system don't look like mere spinoffs from some more important aspect of the animal's life history. They may be in large part what the paleontologists Gould and Vrba have christened 'exaptations', systems used for purposes other than those for which they were originally selected. But they are not therefore wholly non-adaptive in origin. And when we grant that much, the extreme cognitive ethology thesis certainly looks pretty silly.

Second, there is a more basic, and perhaps more philosophical, reason why it is mistaken to generalize over all kinds of animal

communication and to include human language in that one category. That reason is: that the primary function of human language is not communication, but the construction of a cultural world. Of course we use language to communicate: 'Come here!' 'Don't do that!' 'Elect me President!' And equally of course, in this respect our communication is only quantitatively different from that of others, especially of our very near kin the great apes. Maybe we signal more efficiently than other animals the presence of predators, prey or possible mates, or maybe we don't. That's not what matters. What matters is the system of a natural language within which, or from within which, we both make and experience our world. A child, in becoming a language-user, enters into a new world, in one sense continuous with, but in another sense sharply distinct from, the array of signals with which it has already been communicating with its caretakers. I have already quoted von Humboldt's saying, to the effect that a language is a true world that a human being places between itself and things. But it is not a barrier that cuts off our existence from the 'real' world. It is the home from within which, to revert once more to seventeenth-century idiom, we read the book of nature.

The anthropologist Marshall Sahlins made this point, or something close to it, in his attack on E.O. Wilson's *Sociobiology,* the year after its publication (*The Use and Abuse of Biology,* Michigan, 1976). For Wilson, he writes:

> the theoretical importance of human speech lies in its *function of communication* rather than in its *structure of signification,* so it is primarily understood to convey information rather than to generate meaning. As communication, language is not distinguishable from the class of animal signaling, it only adds (quantitatively) to the capacity to signal. What is signaled is information, which may be measured, as in classic theory, by the practical alteration in the behavior of the recipient from some otherwise probable course of action . . . This functional view of language . . . is particularly appropriate to a biological standpoint, for by it human speech is automatically subsumed in the adaptive action of responding to the natural or given world. What is lost by it is the creative action of constructing a human world . . . So far as its concept or meaning is concerned, a word is not simply referrable to external stimuli but first of all to its place in the system of language and culture, in brief to its own environment of related words. By its contrast with these is constructed its own valuation of the object, and the totality of such valuations is a cultural constitution of 'reality'. (61–62)

I don't know why 'reality' here is in quotation marks. Granted, the living order, to paraphrase Merleau, is wider than, and includes, the

human. But human constructs are not therefore less real than the natural world within which, or the natural materials out of which, they are built. Sahlins continues, correctly, as I believe: "What is here at stake is the understanding that each human group orders the objectivity of its experience, including the biological 'fact' of relatedness, and so makes of human perception and social organization a historic conception" (62). In the course of his exposition he quotes a passage from Ernst Cassirer that I want in turn to quote here, since it seems to remove the quotation marks from the reality constituted by human language. Cassirer writes:

> An 'objective' representation—it is this which I wish to explain—is not the point of departure for the formation of language, but the end to which this process conducts; it is not its *terminus a quo* but its *terminus ad quem*. Language does not enter into a world of objective perceptions already achieved in advance, simply to add to given individual objects signs that would be purely exterior and arbitrary. It is itself a mediator in the formation of objects; it is in one sense the mediator par excellence, the most important and valuable instrument for the conquest and construction of a true world of objects. (Cassirer 1933, quoted in Sahlins, 63)

Cassirer was a neo-Kantian and his statement echoes the Kantian conception of human cognitive activity as constitutive, on the formal side, of the objectivity of our experience. It is in its contribution to the categorial constitution of reality that human language shows its true power—unique, so far as we can tell, in the animal world.

In answer to the first half of my question, then, we may indeed claim that human language fulfils a function different from that of animal communication in general. And to many that has long seemed to be an adequate answer to the question as a whole. That we speak, or how we speak, is what distinguishes us even from our nearest kin. It seems to me important, however, to take our question one step further. Is it language itself, or something not itself linguistic that language exemplifies, that marks off our life style from others? Human language, in its constitutive function, may turn out to be but the most massive or the most obvious expression of a more fundamental capacity: what Sahlins calls the symbolic function, or another anthropologist, Peter Wilson, simply symboling. If "each human group orders the objectivity of its experience", it is not only through the structures of its language, and the products of its language (myth, science, poetry) that it does so, but through its behavior, its rituals, even its etiquette. In all such behaviors, a given society, a given historic group, is enacting and

enforcing the system of symbols and of symbolic activities that makes it the group it is.

When I have tried in the past to explicate the preceding thesis, I have usually met with total deafness or at best misunderstanding. For some years I was in the habit of relying on A.J.P. Kenny's definition of mind to give me a starting point. Although, as I've remarked earlier, I find the category of mind, with its Cartesian associations, misleading and irrelevant, Kenny's formulation seemed to me to fit well what I wanted to say about persons, or about the kind of responsible persons we take ourselves to be. As he put it, "To have a mind is to have the capacity to acquire the ability to operate with symbols in such a way that it is one's own activity that makes them symbols and confers meaning upon them" (in his contribution to the 1973 Gifford Lectures, *The Development of Mind,* Kenny et al., Edinburgh, 1973). Excellent, it seemed to me. But when I tried to rely on this statement in a conference on sociobiology some years ago, I was congratulated on finding just the formula to fit the behavior of those dear little bees! And on another occasion I found that my philosophical audience thought that by 'symbols' I must mean something like algebraic symbols, or at most things like flags or crucifixes. Besides, Kenny himself has since so qualified his definition that it has become rather a statement of the situation I want to elucidate than a clarifying summary that I could use to begin my own argument. In the later version he said: "The mind itself can be defined as the capacity to acquire the abilities to behave in the complicated and symbolic ways which constitute the linguistic, social, moral, cultural, economic, scientific and other characteristically human activities of men in society" (*Freedom, Will and Responsibility,* London, 1978, 12). That's become rather a hodge-podge, which one would need to sort out before trying to do anything with it. So that resource is out.

Where to turn? I had been searching for some years, in a desultory way, in the literature of social anthropology when I happened on Peter Wilson's *Man the Promising Primate* (Yale, 1980) — promising, as we'll see, in two senses. That little book gave what seemed to me a thoroughly lucid and in large part convincing account of our odd way of coping. It is Wilson who introduces the term 'symboling', and while in general I dislike our habit of making verbs of common nouns (like

'processing' or 'formatting' or—ugh!—'critiquing'), I find in this case that the neologism is useful. So I want now to indicate some of the features of Wilson's exposition that seem to me specially telling. The argument is an intricate one, and I cannot reproduce it here in detail, nor do I want to focus here on what seem to me some weaknesses in it. But I hope that by indicating some of its chief components I can convey its general purport.

The Promising Primate rests on (at least) two major presuppositions. The first is, as I, too, have argued in Chapter 5, that we have come into being in a Darwinian world and by Darwinian principles. The second is that, within such a world, we have an unusual place in virtue of a kind of contradictoriness in our way of living, and especially of living together. Wilson sees in Enlightenment political philosophy, from Hobbes to Kant, the development, with variations, of this principal theme. Though there was never in fact a Hobbesian war of all against all, there is in our form of social existence—in every human form of social existence—a tension between the separateness of individuals and the constitution of social bonds. Or as Kant saw it, we are characterized by an 'unsocial sociability': "we cannot do without associating peacefully and yet cannot avoid constantly offending one another" (quoted on page 8). This is scarcely a logical contradiction, but it is a tension characteristic of the social structures on which human lives depend. It may be suggested that a similar tension characterizes some non-human social groups as well; as with the case of our peculiar linguistic structures, we have of course no direct way of knowing that members of other species do not share what appear to be our oddities, but the Kant-Wilson conjecture seems a reasonable one.

Moreover, this tension rests on, or is one expression of, a more fundamental opposition which Wilson makes explicit in his concluding chapter. Primate evolution, he argues, has gone in the direction of 'generalization', the emergence of more and more flexible structures and behaviors, allowing adaptation to a variety of environments. "But generalization", he writes,

> in principle allowing the most flexible individuals to take advantage of any (or most) contingent environmental situations, contradicts the very principle of natural selection, which concerns *variations* that can only be of a specific nature. Since the environment comprises multitudes of species selected on the basis of

> such differences, it is itself specialized. Yet the primate order in general, and the human species in particular, show no specific variants that can be selected to fit the organism to a setting . . .
>
> It is from this real contradiction and the need for its resolution at its various levels, by every human population and every individual, that the sense of purpose has evolved. For only when an organism of general abilities confronts a contextual situation as a problem is it presented with any idea of a purpose. The organism cannot guarantee that what it does to produce and reproduce will succeed, since it must guess at the best way to achieve these ends. Such reasoning entails the separation of the goal from the means of attaining it and brings a corresponding doubt about the goodness of fit. It must hardly occur to a giraffe during the normal course of its life that there is any difference between reaching up to the higher branches and getting leaves to eat. But for humans there is always a discrepancy between setting off on a hunt and coming back with meat; between planting seeds and harvesting grain; between looking for berries and fruits and finding them. (152)

This passage expresses, of course, the first sense in which as primates we are 'promising'. We have wide possibilities of adapting ourselves to various particular situations, even though, or just because, we are so poorly endowed with special devices to find very specialized environmental demands. As Herder put it, we are invalids of our higher powers. Hence the gappiness, the negativity if you will, characteristic of our life style. This is what Plessner called "eccentric positionality": the fact that we can stand to one side of ourselves and consider the duality yet unity of ourselves and our bodily being. And such a 'divided self', according to Wilson, expresses the "phylogenetic contradiction of the human species in its world situation" (153).

I have rashly conjoined here Peter Wilson's introductory remarks and his conclusion. Let me try to sketch very roughly how he has come from the one to the other.

Our 'phylogenetic contradiction', adaptive generalization contrasted with the need to solve particular day-to-day problems, is expressed in our life-histories in the way in which the human neonate faces the world prematurely, relying on the first year of life to bring it into the particular social world in which it will become the responsible person it has the capacity to become. The relation between nature and artefact characteristic of such a life history Wilson analyzes in two contexts: the contexts of reproduction and of production (of food), or, as Eldredge (or Eldredge and Grene) would put it, the contexts of genealogy and of economics. It is the former, reproductive, context

that is essential to the point I want to make here, and I shall limit my summary to that (major) portion of Wilson's argument.

The primary bond on which our life history rests is that between mother and infant. But then there is also the pair bond between male and female. The female finds herself divided between these two relations; the male has, immediately, only the one. What mediates between the two, Wilson alleges, is the invention of the father. The male has no immediate visible relation to his offspring; indeed, there have been, and perhaps still are, human societies in which biological paternity is denied or unknown or at least unimportant. What matters in human societies is the social institution of kinship, which is made possible by the (social) acknowledgement of fatherhood.

It is the division of the female's loyalties to child and to mate that make possible, or, indeed, necessary the invention of the father. But we must now take another step: "the emphasis shifts from the primary and pair bonds to the kinship bond of father/child" (95). In the end it is the child through whom kinship is established. And the child itself develops as a divided self, united to its primary kinsmen, father and mother. How is such a set of divisions to be maintained?

Social identities are created in human societies by the activities known as rituals: certain performances make the person who he or she is in a given social order. Ritual, however, Wilson, points out, retains a certain substantive material existence in the bodies manipulated under its rule. But what one must do in one's special social identity, as husband or chief or in-law, for example, has yet to be specified. And that is where our 'promising' nature in the second and more fundamental sense has to be considered. "All that is made possible by the realisation of kinship in the human animal, the promise of society and culture as adaptive dimensions", Wilson declares, "rests upon the development of the ability of individuals of the species to commit themselves in this way" (101). It is the promise that stabilizes the precarious relations on which our social life is founded. For in promising, the human person constitutes his (her) divided character by pledging in the present a future that is not yet. But how can this be done? I cannot in fact do now what I promise to do tomorrow. I must rely on a form of words, and that means, as Wilson puts it, on "some form of symboling" (106). Promises, however, are fragile. They are

given public sanction and support through the sanction of the taboo, which is just as paradoxical in nature: instead of avowing what is not yet, taboos focus on what is not and what ought not to be. But that can't be done literally either. Wilson writes:

> In the promise, that which is not but will be has to be transformed into the 'now'. But I cannot promise to do something by doing it now. I must therefore give some indication in the present that is independent of the future action but can stand for whatever I promise. I must symbol. Similarly, I cannot establish what must not be by doing what must not be done: I cannot impose the incest taboo by committing incest and then negating it. How am I to negate it? I must somehow indicate what must not be by showing it not literally but figuratively, by symbols and myths. (107)

Kinship systems, rituals, and language all belong together as human devices for dealing with our species-specific problem (of a generalized endowment coping with specialized needs), but it is in the last analysis the power of symboling, most evident in language, that makes such solutions possible.

For Wilson, as we have seen, language is *the* form of symboling. Ritual, since it works with the bodies of the actors and with material objects, does not plainly "make something out of nothing" as the explicit act of promising does. Other versions of the same general thesis, or related theses, about the role of symboling, or of the symbolic function, in our societies draw more heavily on the study of ritual for their account of human behavior and the constitution of human societies. True, language is clearly essential for the establishment and maintenance even of such largely tacit behaviors—witness the fact that anthropologists describing their subjects' customs rely heavily on the vocabulary of the indigenous language in the case. (Once long ago in Ireland I translated a German work on African and West Indian customs. My children figured out that I was being paid sixpence a word for the job, and so I got half a crown for translating: "Nur ein Papaloa hat einen Badgigan"—"Only a Papaloa has a badgigan." Nice work if you can get it!) Yet language, I believe, while necessary to the activity of symboling, is not identical with it. So I want to refer here to a coupleof studies that go behind the linguistic level to the very act of symboling and its role in the constitution of a human person and of a human society. Again, I shall report these studies very skimpily, but I hope I can give some indication of what they suggest for our problem.

In *The Fame of Gawa* (Cambridge, 1986) Nancy Munn reports her work on the people of Gawa, in Papua New Guinea. Her aim is to support through a single case study a general model of practice as symbolic process. While making little of the theme of language that is central to Wilson's argument, she considers the ways in which a people constructs itself, so to speak, through its own practices. (She is following, with due acknowledgement, the method of other anthropologists and sociologists in the symbolic mode; but since I have no hope of mastering that literature, and could not in any case report it all here, I am taking her work as illustrative of its genre.) Her book is subtitled: "A Symbolic Study of Value Transformation in a Massim (Papua New Guinea) society". Unfortunately, 'value' is a term difficult for philosophers to cash out. I confess to have written, thirty years ago, a chapter on "facts and values" and I still believe what I (tried to) say there, but I admit it's a blurry sort of subject and I'd rather avoid the term. What is more significant, for me, is the conception of a spacetime in terms of which human beings bodily develop and assert—or deny?—themselves. This is not only an individual spacetime, but an intersubjective medium characteristic of a society which both molds and is molded by those who participate in it.

It may be objected that in speaking of spacetime I have left the symbolic for the literal: Gawans live in houses (as we do) and depend for their life style on sailing by canoe to other islands and back home again. There they are, there are their canoes, there is the sea, there are the 'kula' shells they give and receive on their journeys. All these are material things that exist. Where are the symbols, and especially why should the 'spacetime' of an actor or of the community be said to be 'symbolic' of anything? Let me take just two examples from Munn's account to illustrate the way in which such material entities are imbued with symbolic character.

First, the house: this is, Munn says,

the primary protective and controlled physical space in connection with a person's kariewaga [= authority], with the pre- and postnatal care for a woman and her newborn baby, and with death. Just as the house is the regulated interior space into which one is born, and which provides a mediating location between the interiority of the mother's body and the exterior world outside the house (a world into which the baby and its mother move only in carefully regulated stages), so also it is the location of the last phases of life—the domain of dying, the final repose of the deceased before burial, and of the secluded mourners who represent

the dead after burial. Both of these transitional stages are phases of weakness when mobility is constrained or the body inert. In general, the house is the domain of physical space that marks the least extension of the person in spatial control and that in a number of contexts is associated with the body in a prone or otherwise in an immobile position. (75–76)

Contrast with this the ritual of canoe building and canoe ornamentation. Canoe building entails not only collection of the appropriate materials and the labor of building, but ritual decoration both of the owner and of the canoe itself. In this process the canoe is anthropomorphized, decorated as an extension of its owner, who in it will spread the fame of Gawa. Bodily and intersubjective spacetime are here wedded in a positive sense: the person takes on expanding significance, and so does the object made and embellished to signify his social role.

When I heard Nancy Munn describe the Gawan canoe building ceremonies fifteen years ago, I found her account luminously clear because it reflected my own Merleau-Pontyan approach to the study of the human order. My impression at the time was that no one else in the audience understood what she was saying. I hope that my present readers, whom I have prepared for such oddities, will be more receptive. Other animals of course have 'houses' and territories; other animals of course assume various social roles. Ants, for example, build whole cities, and act as foragers, guardians or garbage collectors, as the case may be. But we systematically construct such places and such roles, and are constructed by them, through the activities of symboling that make our particular society—and thereby our particular selves— the societies and the selves that they historically proclaim themselves to be. Admittedly, we couldn't do any of this without our peculiar form of language. Indeed, Munn's account of Gawan practices is saturated with seemingly untranslateable Gawan terms. The power of linguistic expression is necessary to, and the most conspicuous instance of, symbolic activity. But it's the capacity for symbolling, whether tacit or explicit, that enables us to create and to maintain our societies and ourselves as the fragile sort of social beings that we are.

One more example may reinforce the point I am trying to make. The Karavarans are a Melanesian people described by F.K. Errington (*Karavar,* Cornell, 1974). If we look at them from our reflective point of view, we find them following a remarkably Hobbesian view of

human nature—or a view that corresponds to the most common account of a Hobbesian view. They believe, in other words—or so the anthropologist interprets their beliefs—in a war of all against all inherent in our very natures, a war that is overcome through social practices that manage to institute an uneasy peace. These beliefs are implicit only; no one in the community formulates them. But they are *realized*—enacted and so given reality—in the community's rituals, which, indeed, through such realization create that community. The most important ritual, according to Errington, is the mortuary ceremony called the matamatam, in which the wild (female!) spirit or tubuan is tamed. Errington concludes that

> the matamatam is not a blueprint or a model of society in action—rather it *is* society in action. To put it a different way, the ritual is not just a statement of order, it is an ordering. At the moment that the tubuan is domesticated, society itself is domesticated: the tubuan peace is the immediate consequence of the adept's controlling the tubuan spirit. . . . Through domesticating the tubuan, the Karavarans domesticate themselves. (248)

Thus, Errington continues, "the symbol does not stand apart from what it symbolizes. It is effective because it can only be understood in action. The symbol . . . creates that which it depicts" (249). The promise, it seems to me, makes explicit the creation of a new reality that is here enacted, enacted, indeed, with the help of language, but not in verbal form. It is such systematic self-creation, in kinship systems, rituals and languages, that most clearly distinguishes our life-style, in its many self-constituted forms, from the life forms of other kinds of organisms, even of our nearest kin.

Maybe, with the help of snippets from a few writers chosen from a vast literature I have managed to say what I wanted to more clearly than I have in the past. Nevertheless, there are still two matters I must, unwillingly, raise.

The first concerns the relation of language to symbolic activity. Peter Wilson considers the form of words identified with promising to be the instance *par excellence* of symboling. I have tried to suggest that the activity of symboling itself is prior to language—not temporally, of course, but in terms of necessary presuppositions. Recall

Cassirer's Kantian argument here: symboling is the necessary presup-
position for the kind of language we in fact have. But if language
depends on symboling, then symbolizing language—metaphor,
poetry—is more fundamental in our language-bound lives than is
literal speech. That is in effect what Sahlins was after in the passage I
quoted earlier, contrasting the systematic function of language with the
(merely) communicative. I am sure that is correct, but find it a difficult
truth to explicate—partly because it runs easily into deconstructionist
corners where I do not want to find myself, partly because I am myself
excessively literal-minded and don't feel at home amid the light that
never was on land or sea. Be that as it may, I shall make one more stab
at it by contrasting the position I want to defend with one diametrically
opposed to it. Dan Sperber, in his *Rethinking Symbolism* (Cambridge,
1977), argues that "the symbolic mechanism has as its input the
defective output of the conceptual mechanism" (141). In other words,
in our rational, potentially scientific moments we rely on unambigu-
ous, precise, explicit codes: we communicate, as the bees do, only
better. When we can't do that, we invent symbols to get by. We use
symbols where words fail. Now this seems to me exactly backwards.
According to Sperber:

> It is . . . not a question of discovering the meaning of symbolic representations
> but, on the contrary, of inventing a relevance and a place in memory for them
> despite the failure in this respect of the conceptual categories of meaning. A
> representation is symbolic precisely to the extent that it is not entirely explicable,
> that is to say, expressible by semantic means. (113)

I would say, on the contrary, 'a representation is literal precisely to the
extent that it is, for practical purposes, entirely explicable'. There is of
course, I would insist with Polanyi, *some* tacit dimension to every
expression. Totally precise language would say nothing. But there are
diminishing degrees of tacit participation, and diminishing degrees of
metaphoricity, in linguistic expression as it runs—downhill—from the
poetic to the literal. And it is the power of symboling—of bringing
together what is and what is not—that makes the whole game possible.
Once when I read a paper on this general line at U.C. Berkeley, John
Searle produced one of his genial putdowns with the cry: "Metaphor?
When I say I want onions on my hamburger, I *want* onions on my
hamburger!" Of course he does—and the bee wants its sugar source,
too. That's what we and the bees have in common. They want that

sweet something over there, Searle wants the macho taste of onions right here. But he says so differently (and therewith assumes his charmingly aggressive *persona* differently), thanks to the creation of a human reality through systematizing, ordering symbolic activity. As Diotima explained to Socrates in the *Symposium,* we are all poets, that's to say (*literally*—!!—in Greek) makers, creators of a human world; but we are so just insofar as we are poets, people who live by symboling.

That's the best I can do for now on the relation of symboling to language. Finally, and again reluctantly, since I have been alluding to the construction of different human worlds by different social groups, I must face yet another ugly ism that rears its head: this time, cultural relativism. Ethical relativism, an issue treated in many introductory philosophical courses, I take to be included under that rubric. As I remarked earlier, I have always avoided professional ethics in its contemporary form. So I'd rather approach the problem as an anthropological layman than as an uninformed and dissatisfied 'philosopher'. In any event, ethical relativism, I should have thought, is one example of cultural relativism: if you and I differ in our moralities, it is probably because we live in different subworlds within our common world. The question is: whether there is one shared, species-specific world constituted by one common set of principles, to which we all belong, and if not, how we can venture, from within one particular world among many, to criticize the beliefs or behaviors characteristic of another.

At the end of Part II I said that I wanted to speak of the anthropologists whose work seemed to me to 'correct' the glib relativism I remember from my youth. But surely Gawan society is different from Kararavan society and both differ from ours, which differs, in turn, from other Western societies and even more strikingly from those of the East. So how 'corrected'? Isn't this the same relativism as ever—the same, indeed, that we can find in Herodotus, who remarks that the Indians burn their fathers while the Greeks bury theirs? Yes and no. Given the plurality and the diversity of human cultures, I do find it unlikely that there is one great system of standards adherence to which defines humanity. But when I read the reports

from which I have been quoting only snippets, especially when they are put in terms of the symbolic activities that constitute a certain society, I believe I can enter into those practices, in imagination, in a way in which older descriptions did not allow one to do. Thinking back, superficially and too generally, perhaps, to the cultural relativism of the twenties and thirties, I have a hunch that it took one of two forms. Either we just looked curiously at the quaint behaviors of everybody, including ourselves, and thus adopted a kind of cynical non-belief. Or we took it that our own standards, as we understood them, were 'the fact-truth', as an Irish neighbor puts it, and those who disagreed with us were the ones who quaintly adopted some posture or other. On a smaller scale, the same contrast obtained in the discussion classes I taught in Northern Ireland (much later, in the sixties). Ten or a dozen first-year students—all Protestant, of course—ranged themselves on two sides of a long table in my office, and, regularly, I found on one side a group disillusioned with the fanaticism on which they had been raised, who insisted that no one believed anything, and on the other side a cluster of unquestioning yea-sayers, who accepted as obviously the case everything they'd ever been told in Sunday school —without knowing there was anything to accept: it was just so. The more thoughtful literature of symbolic anthropology, it seems to me, permits one to escape between the horns of this dilemma. Or it does so, I should say, when assimilated to the concept of commitment as Polanyi developed it in *Personal Knowledge,* especially in the chapter on implicit beliefs.

Polanyi, too, uses an anthropological example in that chapter, the case of the Azande, studied by Evans-Pritchard. The Azande believe that death is always due to witchcraft (as do the Gawans, except for the death of the very old). We know they are mistaken. But if some one dies of a burst appendix, there's no use explaining that to the grieving family; they know it was a witch! Then aren't we just re-adopting the careless relativism of earlier decades? No; this is different. And the difference is that we know that we hold our beliefs, as, indeed, the Azande do theirs, responsibly and with universal intent. Given such self-knowledge, further, we can school ourselves to approach other cultures with understanding while recognizing our own allegiance to our own. From within our own system of ritual, myth, and language we can describe and appraise the practices of others. Indeed, it is one of

the characteristics of our particular tradition that, within limits, we are able to do this—as well as to appraise and amend some features of the tradition in which we ourselves were reared. It is our own self-constitution as a society—or a sub-society—capable of criticizing and amending our own fundamental beliefs that makes possible the development of disciplines like anthropology or history. Literary genres like the novel or any major style in painting or sculpture also depend, I should think, on the same capacity for self-distancing—but always from within the nexus of standards or beliefs to which, as members of this society, we stand committed.

Admittedly, such a position does not entail a total escape from the relativist dilemma. We have not found some wholly stable, eternal cluster of self-evident truths to which we know, and know that we know, that every human being, on pain of damnation, must subscribe. There is a parallel here, perhaps—though with a difference—to the tension between chance and necessity that we found to characterize a Darwinian attitude to nature. We happen to have grown up in this society, not in another. Then are we just 'determined' to follow its symbol systems? Do we just add cultural to natural determinism and forego freedom and, with it, responsibility? I think not. In an earlier chapter, I spoke of the way in which a Darwinian nature allows room for varying degrees of freedom in the life histories of various organisms. There is the same kind of range in the freedom allowed by various cultures. And we are fortunate in inhabiting a world where for many at least that range is relatively ample—and where to some at least it is clear that such amplitude is what ought to exist where it does not.

So far, then, we seem to find a parallel between nature and culture. But we must also notice that what we assume in performing the symbolic activities that constitute our particular society or subsociety is a new necessity. We enter into obligations which compel us—not biologically or physically, but personally and morally—to act as we do. The intellectual passions that drive the life of science, the aspirations that compel the artist to paint or write or carve or build or compose: all these strivings express commitments, obligations to fulfil demands made on us by something that both defines and transcends our particular selves. I'll say more about this in my final chapter; for now the point is to recognize what Polanyi called the paradox of self-set standards. We accept with universal intent principles or patterns of

behavior that we have at one and the same time both happened to develop and enacted as responsibly our own. Socrates grew up as an Athenian who by so growing implicitly made a contract with his state to obey its laws. That is paradoxical enough. And to recognize that members of other societies both act and submit in the same paradoxical way adds to the paradox. But as long as we see that we are truly acting our way, affirming our standards with universal intent, we may both understand others, up to a point, and look at their practices critically from the position that we do in all honesty accept. This seems to me, as in the Darwinian case, a tension in our way of being that, being who and where we are, we simply have to accept. We find ourselves in a more precarious situation than were the founding fathers with their budget of self-evident truths. But when a dogmatism is overcome, can we really want it back? Our case is uncomfortable, if you like, but it seems to me neither as frivolous nor as naive as the relativisms of the recent past.

Before leaving this topic, however, I must admit, sadly, that Polanyi in part undercut the position he had developed in the account of implicit beliefs. In 1991, when I was asked to contribute to a Polanyi centennial conference, I went through the argument of *Personal Knowledge* again, after an absence of twenty years, to try to clarify the distinction between the subjective and the personal, on which the concept of commitment rests. The "fiduciary programme", with its accompanying concepts of commitment and of personal knowledge (as distinctive from subjective whim), is developed in Part Three. Part Four is to give it its ontological underpinning through a study of the nature of living things and of our knowledge of them. Polanyi there elaborates and refines the distinction between the subjective and the personal, and counts as 'subjective' commitments made to a mistaken system, so that Zande practices now turn up (in a footnote which I had not previously noticed) as subjective rather than personal. We, the heirs of a modern European liberal tradition, turn out to be the only human beings who make commitments with universal intent. Everybody else is following a mere subjective impulse. This seems to me a sad betrayal of Polanyi's fundamental insight. On the other hand, at the very close of Part Four he does refer to all the traditions of all societies, to what he calls "social lore"—and that includes science, religion, the arts—as "everything in which we may be totally mistaken." I have

always cherished that expression, and cling to it still in the face of the treacherous footnote, whose existence, however, I cannot in all honesty deny. Indeed, there are other problems with Part Four also, for example, in Polanyi's gross misunderstanding of evolutionary theory. So I had better just take the chapter from Part Three as the best authority for the rather uneasy position I have been trying to describe.

In the last two chapters I have been talking about two disciplines outside philosophy, ecological psychology and symbolic anthropology, which have seemed to me to shed some light on philosophical problems—not by solving them, but giving us a good starting point for our reflections. The ecological approach to perception puts the natural foundation of our search for knowledge in a new and much more promising light. And the work of symbolic anthropologists allows us to look with new insight at the way we institute and maintain the human networks of actions and beliefs on which our lives as human beings depend. All along I have been circling round the same problem: the problem of what it is to be the kind of responsible person who can make a knowledge claim. I'll see if, in conclusion, I can add anything to what I've been trying to say by circling yet once more over that same terrain.

On Our Own Recognizances

This part of my reflections is called 'Coping'. After some musings about how we know and about who we are, I wanted to ask, or to look back at my earlier efforts to ask, how we manage. As natural beings made what, or who, we are by the givens of a culture, how does each of us, as a responsible person, cope with the world around us, including, of course, our peers of the human world? In the last two chapters I tried to give some clue to the biological and cultural aspects of an answer, as I have found them offered to us in the disciplines of ecological psychology or of symbolic anthropology. Now I have to face the question, how each of us responsibly takes up the burden of shaping those natural and cultural parameters into a particular life history.

Indeed, that is the question I had in mind when I started drafting this memoir. When I first thought of writing this book, in fact, I meant to call it *Persons*. But then it turned out to be about a cluster of other topics, focussed especially on matters related to the problem of knowledge, and bringing in a lot of what professional philosophers call necessary conditions for our ways of knowing, or claiming to know, but not very directly about the concept of the person as such. Still, 'Persons' is the title I thought of for this concluding chapter. Now I'm not sure why. I've rambled on about evolution, and reality, and perception, and symbolling and heaven knows what. True, I did talk in my Kant chapter about the importance of agency in knowing. And, in a way, I suppose talking about being-in-the-world is, in effect, talking about persons, only in a different philosophical language from the usual English-language one. But the talk is so different, one isn't sure it's the same topic. Heidegger would have sneered at the concept of 'the person'; the term is corrupt and Latinate, isn't it? Indeed, etymologically it means mask, a player's mask—so the very word entails concealment of what it *really* is to be whatever it is we are. That message would be even more emphatic in a Sartrean response: a person *as* a person is already in bad faith, just as an *ego* inevitably is. We

try to reify, to make into some *thing,* the nothingness that is all we can honestly be. Both Sartre's brilliant early essay, *The Transcendence of the Ego,* and his dramatization of the actor's wretched destiny in the person (!) of Edmund Kean exemplify this theme. Neither does Merleau-Ponty consider the question, what it is to be a person. True, he is not concerned, as Heidegger and Sartre were in their different ways, with the obsessive search for authenticity, which seems in either of their formulations to condemn most if not all of us to some kind of less than personal status. But 'person' just isn't a concept in his discourse. I find his chapter on freedom, and some of his essays, like the one on Cézanne's doubt, telling for such reflections, but there certainly is no direct discussion in Merleau's work of the question I had wanted to raise. So it might appear that my chapter on Being-in-the-World evades the problem of persons, too.

Now I'm left with it, head on, and wonder why I thought it so central to this cluster of reflections and recollections that I first wanted to give the whole collection the name 'Persons', and then thought of that title for my concluding, and, presumably, culminating, chapter. It seems that not much of my checkered career has been spent in thinking about persons, rather than about particular questions in the history of philosophy—about Descartes or Kant or Hume or Aristotle or Sartre or some others more easily forgotten—or about the philosophy of science—especially the philosophy of biology, and there especially evolutionary theory, or, for a while, the question of 'reductionism'. Yet somehow the problem of the person has been haunting me through all these wanderings, and I need, in conclusion, to ask about it less indirectly.

Musing on this question, I received my copy of Annette Baier's presidential address to the Eastern Division of the American Philosophical Association in 1991, 'A Naturalistic View of Persons'. Perhaps, I thought, my problem is solved. I hoped she might be saying just what I wanted to say and couldn't find words for. But, alas, as often happens in philosophical argument, she chiefly criticized those who approach the question from a less than naturalistic point of view. Impatient as I am of what is written in the name of 'philosophy of mind', I don't even know the literature she is criticizing. And on the 'naturalistic' side, she

mostly makes a bow in the direction of Darwin, as I have also done, and of Freud, as I am not inclined to do. She wants to get rid of 'subjectivistic' views of the person or the self—and so do I, of course—but she doesn't say much about what we are to substitute for those misguided doctrines. We are to think about communication, she says, presumably about ourselves as social, not solipsistic beings: as blessed with Humean sympathy, not just Hobbesean egoism. I have followed Sahlins in stressing the distinction between communication as such and the more systematic ordering principles that characterize our form of language. Nevertheless, in a very general way, I suspect that what Baier is saying is what I, too, have been stressing all along: we are social animals, and what makes us peculiar animals is our peculiar form of sociality. But to say we are not alone is not to say who, within the biological and social boundary conditions that order our existence, each of us is. That's more difficult. So let's make another try.

Perhaps it will help at this juncture to go back to the little I said about freedom in my Darwin chapter. There I quoted Pumphrey's saying: there is no wholly bound or wholly free, there are only degrees of freedom. Even though, as Spinoza argued, most of us are in bondage, while some few achieve the kind of freedom he envisaged, we are all, on principle—or once were, on principle—capable of acting freely. And in a lesser or more general sense, we do each act freely. We have the good luck, or the heavy burden, of belonging to a species whose members possess, within the limits of their genetic endowment and their early assimilation to a particular culture, a wide range of opportunities to choose, to go this way or that. Each time I make such a choice, it is *my* doing. For all the sheer contingency of my genetic makeup and of the chances of where and with whom my growth to maturity took place—for all that, it is I alone who do what I do. In those discussion groups in the First Arts course in philosophy in Belfast, which I recalled in the previous chapter, where half the group claimed confidently that they knew God wrote the Bible and the other half claimed to know that everything they had been taught in Sunday school was rubbish, each student was claiming knowledge, claiming to assert what, on good authority, he or she believed to be the truth. Do you accept what your teachers taught you? Do you reject it? In either case, it's *you* who do it, and no one else. One writer speaks of

'epistemic responsibility'. That's a good phrase, I think. Indeed, it is 'responsibility' I am concerned with here. To be a person, in the sense in which we human beings consider ourselves persons, is to be the center of actions, in such a way that we are accountable for what we do. Even if we are not accountable, as Augustine was, to God, or, as every actor is in a public context, to the law, we are accountable to ourselves. What does that mean?

There is, goodness knows, a veritable ocean of philosophical literature on this and related questions. As I said at the outset of these reflections, I tried many years ago to read some of it, and failed. In my experience, the professionalization of fundamental questions so often leads to triviality, that I hasten to neglect what, as a kind of professional, I suppose (or others suppose) I ought to read. John Searle has devised a famous parable about a Chinese room, in which only Chinese is spoken and a mere English speaker is cut off from the normal intentional dimension of a life in language. Most philosophers, I have found, live in a philosopher's room, where all apertures have been hermetically sealed against reality and only recent copies of a few fashionable philosophical journals are furnished to the inhabitants.

In any case, I *am* impatient. Perhaps it's all very well not to suffer fools gladly, but if one doesn't suffer bores gladly either, one's society is limited. Yet here I am, like it or not, facing a question that many of my peers have dealt with at length and perhaps with great subtlety, though I have only the vaguest notion of what they've said. Still, let me take a run at two common directions I'm avoiding and see if that helps me, briefly and in conclusion, to hint at what I believe needs to be said. (Here, of course, I'm doing just what Baier did, and trying to get at what I want to say by pointing to some things I don't want to say.)

I noticed, in passing, that whatever I choose, it is *my* doing. Aristotle, speaking of what he called "deliberative desire", remarked: "That kind of origin of action is a human being." That sounds good. Although human beings may seem to be driven this way or that by circumstances, it *is* each time—even with those who habitually run away from their own responsibility—as Sartre would put it, who have built guard rails against anguish—it is each time the person herself who chooses to do, or to be, so and so or such and such. Alan Donagan called his essay on action or agency, *Choice: The Essential Element in Human Action* (Routledge, 1989). To say what it is to be a responsible

person, is to say what it is to choose. Since Donagan was one of the few thoroughly academic philosophers whom I deeply admired and respected, I hope I may take that work of his as representing one characteristic sort of answer to our question.

Donagan first set up carefully—with the meticulous attention to the current philosophical literature that he always managed and I can't—the concrete, embodied character of the individual agent. That emphasis, I admit, surprised me, since Donagan was an unrepentant dualist. Once when we were both participating in a summer institute, called, I believe, 'Biological and Social Perspectives on Human Nature', and I was defending, as usual, our kinship with other animals, he exclaimed with some disdain, "Well, if you want all those little woolly things, I suppose you can have them!" Now, it seems, the fact that we are also animals, though chiefly naked, not woolly, did later seem to matter in his account. But the point here is that, granting the concrete, historical wholeness of the person, Donagan did then go on to characterize our uniqueness—over against those little woolly things—as consisting simply in our ability to choose. And to choose means to do what one might not have done, or not to do what one might have done. The determining phrase is: I could have done otherwise. He gives the example of someone considering buying a house. The prospective buyer wants such and such features, and can afford just so much expenditure. So he weighs features against costs and comes to a decision. He might go a little deeper into debt in order to keep a second fireplace, or he might save money and abandon a family room, and so on. His deliberative choice makes him a human home-buyer as distinct from a swallow making its nest in a barn or a beaver damming a stream. Like Aristotle's slogan, that sounds pretty good. It takes in the 'otherwise' that Spinozistic determinism doesn't allow. If, as Spinoza insists, everything flows from the nature of the whole, I never choose. But I *do* choose. So all is well. But is it?

There are at least two problems here. First, it's all very well to say 'I could have done otherwise'. But how does one check out the 'otherwise'? After all, I *did* do what I did do, not something else. I *did* buy this house, not the cheaper or dearer one I might have chosen. The 'otherwise' characterization of choice becomes a mere formality. Further, it seems to me, in the most important choices of our lives, choices of a vocation, of a mate, of a political cause, there is often little

back and forth deliberation between this and that course of action. It is just overwhelmingly plain what one *has* to do—not as driven, not with a metaphorical pistol to one's head—but in the clear vision of what it is *right* to choose. I'll return to that consideration shortly, but meantime just recognizing the compelling character of our most significant decisions leads me to question the adequacy of the 'could-have-done-otherwise' formula to capture the peculiarity of human agency or action.

Another direction in the consideration of free action, or of 'autonomy', stresses consciousness, self-consciousness, or in some sense an inward direction in dealing with the responsible individual. For example, John Christman, a colleague at Virginia Tech, has published a collection about the problem of autonomy which he calls *The Inner Citadel* (Oxford, 1989). Much of this material is pertinent and interesting, but the "inner" in his title worries me. Like Baier, I want to avoid the inward turn of reading agency, or responsible personhood, in terms of consciousness, or, to cite Wittgenstein again, in terms of "secret inner somethings". What I want to stress even in the individual is not anything inward, but something like an ordering principle, a center of responsibility to principles, or ends, or causes, something beyond myself to which I *owe* allegiance.

Such a statement calls to mind two traditional concepts in philosophy: the Kantian ethic, which, I have confessed, entirely passed me by in my callow youth, and, even more alarming to some, myself included, the so-called positive concept of liberty. Recent interpretations of these traditions may well demand that they be thought through anew and with a different outcome. That seems to hold especially of the Kantian critical philosophy, which is given a radical rereading in the essays of Onora O'Neill (*Constructions of Reason,* Cambridge, 1989). However, since these are my recollections of what I and others thought of these matters, before such refreshing reinterpretations were available, I venture to say a little about those earlier conventional readings and my own, doubtless inadequate, responses to them.

The only truly free entity, Kant argued, is a free will. And a free will, as Kant understood it, is characterized, not by some arbitrary liberty of choice, unrestrained by anything or any one, but by responsible action in the light of obedience to the moral law. As Kierkegaard put it in his

usual dramatizing way, "Though heaven and earth should fall, thou shalt." The quintessence of freedom, of doing what *you* would do, as *your*self, is your giving of yourself freely to the moral law that you recognize as binding. Kant expressed this thought with a Puritanical dislike of pleasure, of benevolence, of happiness, of anything *but* doing what you ought. If you give to help the homeless, for example, because you feel for them, and wouldn't yourself want to spend winter nights sleeping on a filthy city grating, that's not a moral action. On the other hand, if you have no sympathy for such people, and consider them so many bums who just won't work, then your aiding them is a moral act. In other words, if your feelings enter at all into the performance of your duty, Kant seems to be saying, then it's not a duty, not worthy of praise as stemming from a pure good will. (A Kantian good will is not a good will as in "Good will toward men", but an intention to act that stems purely from duty, in contrast to any kind of 'inclination' or desire.) This Puritanical aspect of Kantian ethic makes one loath to agree with him. Why can't doing what one ought harmonize, rather than conflicting, with what one wants? Surely a human life should be capable of the kind of fulfillment in which aspiration and obligation are at one.

Nor is that the only difficulty in adopting Kant's view of autonomy. Kant formulated his chief ethical principle in terms of a "categorical imperative" that has been much derided, with some justice, I think, by moral philosophers. The principle 'Act so that the maxim of your will can at the same time serve as a universal law' appears too formal, and hence empty, to help much in the concrete, messy ethical dilemmas that we in fact confront in our particular lives. Nevertheless, there *is* something right about making obligation fundamental not only to ethical choice, but also to the search for knowledge. Responsible action in any area—cognitive, moral, aesthetic—is possible only as the response of the individual to a legitimate demand on him or her. Maybe one could play a continental-type word game here and point out that responsibility is a kind of answering, or responding. I act responsibly when I am answering to a principle that makes a claim on me, a claim I freely acknowledge as binding. Go back to Augustine: this is my freedom, that I am subject to this truth.

Can one retain this insight and avoid the apparent sterility of the

Kantian formula? Onora O'Neill argues that one can. As she under-
stands it, the categorical imperative is not a formula to be literally
followed in each decision of one's life, but something more like what
Kant calls a regulative principle, which guides conduct as an ideal, an
ideal possibly unfulfillable for finite beings, who do have to act within
particular circumstances and from less than 'pure' motivations. Indeed,
in her essay on 'Reason and Politics in the Kantian Enterprise', she
considers in particular the enterprise of the First Critique (which is
concerned with our theoretical powers), and insists that the categorical
imperative governs the self-critical inquiry of theoretical as well as
practical reason.

Kant himself has said this explicitly in a number of places. For
example, O'Neill quotes the little essay on orientation in thought (Was
heisst, sich im Denken Orientieren?) to the effect that to reason ("to
use one's own *Vernunft*") is "to ask oneself, with regard to everything
that is to be assumed, whether he finds it practicable to make the
ground of the assumption . . . a universal principle of the use of his
reason." (O'Neill, 59; Kant, Akad. Ausg., XI, 146n). And a general
claim of the priority of the practical to the theoretical hovers in the
background of both the First and Second Critiques (the Pure and the
Practical Reason).

Yet till very recently, when I stumbled on O'Neill's work, I had
never understood the actual formulation of his supreme ethical
principle to apply to knowledge as well as conduct, nor to apply
anywhere in a regulative sense—as expressing an aspiration rather
than a rule to be literally followed. O'Neill bases her case on a very
careful analysis of the rhetoric, as well as the argument, of the Doctrine
of Method, the last part of the *Critique of Pure Reason,* which few of us
trouble to examine with any care. If she is correct, then the demand for
universality: 'Act so that the maxim of your will can at the same time
serve as a universal law', differs little from Polanyi's characterization of
knowledge claims as made with universal intent. As a finite, concretely
situated person, trying to make the best of limiting circumstances, I
cannot flatly say either, 'everybody should do as I do', or 'everyone
should say what I say, believe what I believe'. But we do, in both
practical and theoretical contexts, *try* to do, and to assert, what we
confidently hope others, in the same circumstances or with the same

evidence, would do or assert. If O'Neill is correct, it looks as if Polanyi, and I too (or I especially as his would-be guide through the history of philosophy), should have spent more time reading Kant and less perfecting new formulations of what turn out to be old solutions.

On the other hand, O'Neill's argument does depend on an unexplained reliance on the powers of 'reason' that I find hard to accept. I do have some idea, in a sort of a way, of what Kant meant by 'Vernunft', a word that is usually translated 'reason', but has little if anything to do with the 'reason' of the Age of Reason, as we know it, for example, in the works of Tom Paine. But 'Reason' as such is for me a kind of black hole, so the concept of 'Constructions of Reason' remains a mystery. In a way, I hope O'Neill is right in her generous reading; perhaps if she is, my rereading of Kant is not quite as thoroughly unKantian as I feared—though that can't be so, either, since I do firmly reject the radical distinction between appearances and things-in-themselves on which O'Neill's Kant and Kant himself equally rely. Even without that heresy, however, my distrust of 'Reason' as some self-explanatory seemingly transcendent something would remain. Perhaps that is a symptom of my inability to put myself, from the late twentieth century, back into the high and pure Enlightenment. While, as I have admitted, I believe our problems stem from that tradition, and were only obscured by pretentious nineteenth-century thinkers, I don't see our solutions lying ready-made in that serener time.

Nevertheless, as in my earlier revisionist reading of the T.U.A., so here, too, I do want, if with some misgivings, to adopt something from Kant's account of responsible action or autonomy. Thus the upshot of my remarks so far is that, however one questions the seeming formalism of the categorical imperative, or however one reinterprets that principle in a new reading of the whole Kantian enterprise, I do want to accept from Kant the notion of obligation, or, in Polanyi's terms, of commitment, as a necessary, and even central, ingredient of our existence as persons. To act freely, as a responsible center of decision and performance, is in some sense to give oneself, of one's own accord, to some principle or task or standard that obliges one's obedience or one's assent.

Here what I am saying resonates, even more alarmingly, to a second tradition, the so-called positive concept of freedom. The contrast of

two concepts of liberty, negative and positive, has been given its classic expression in our century in Sir Isaiah Berlin's 'Two Concepts of Liberty', but the distinction is in fact a long-established one.

The negative concept of freedom places freedom in the absence of restraint. If nobody stops me, I can do as I like. That conception is reflected in the 'I could have done otherwise' formula. It is reflected also in Descartes's insistence, in the Fourth Meditation, that while God has granted us limited knowledge, he has given us a free will which is necessarily, by its very nature, infinite. There is no such thing as being free-within-limits or free-up-to-a-point. One can either choose, or not. This notion may be difficult to maintain, since there always *are* limits. With the best will in the world, I could not have become a ballet-dancer, or run for President, or done all sorts of other things that are, logically speaking, within the realm of possibility. Indeed, when you push it, the notion of not-being-restrained can easily be pushed to zero. An 'acte gratuit', a wholly unmotivated piece of behavior, is hard to find—nor would it seem especially 'free' if we could find it, just arbitrary. The actions we do perform always seem to flow from something, some desire, some external command. So freedom as freedom-from easily reduces to Hobbesian determinism: as he put it, it is like the choice of the junior at meat (where the youngest student got the last, and of course worst, cut off the roast at the commons table).

Perhaps, then, a 'positive' concept is more promising. Freedom involves, again, being a center of actions, being able to act coherently and consistently in accordance with standards that one willingly accepts, that, by implication, one has imposed on oneself. Not absence of restraint, but autonomy, is what matters: action in accordance with a law that is self-given, not accepted ('heteronomously') from else-where. The trouble with this conception, however, is the political company it has kept. At the turn of the last century the fashion for Hegelian idealism made prominent the notion of freedom as responsibility: as the development of an integrated character capable of practical wisdom. That was relatively academic and relatively harmless, if rather preachy and pompous, and that fashion faded harmlessly away before a renascent empiricism. But it had sinister offshoots and affiliates. Although autonomy certainly *should* be a characteristic of individuals, the formulae of positive freedom lend themselves easily to readings in which it is some more than individual, superpersonal,

reality to which each of us must willy-nilly surrender. Augustine turned to God as the Being "whose service is perfect freedom". For Hegel it was the state, "Objective Mind", and, beyond that, "the World Mind", which exemplified, and carried, a higher freedom. Once you admit your allegiance to some claim beyond your own desires and preferences, once you say, 'I ought . . . ,' others may claim to know better than you what that 'higher' reality is to which you must submit. Thus Croce and other Italian idealists supported Mussolini as the carrier of Italy's destiny. And it was the Hegelian-Marxist 'positive' concept of liberty that was celebrated in the areas so long under Soviet control. While the West was claiming to protect the freedom of the individual (grounded in the negative conception), the East was announcing the positive ground of 'freedom' in the sweep of history to which mere individuals must gladly submit. Thus the defense of autonomy turns into the most extreme heteronomy, where the individual is swept away by the World Mind, the Revolution, the Folk, or what you will. I remember, for example, reading the memoirs of a German writer who, as the child of communists, had fled with his mother to Russia, grown up there, and later taken refuge in Britain, in disillusionment with the Soviet system. From that earlier existence, he recalled the astonishment he had felt on hearing broadcasts from the West during the Second World War, in which we talked strange nonsense about 'freedom'. But freedom, he exclaimed, everybody knows, is insight into historical necessity! That's something we don't know, and don't want to know. If that's what the positive concept entails, surely we had better leave it strictly alone.

But can we? Let's look again, and see if we can rescue something from both sides of this dichotomy. On the side of freedom-from . . . , it's true that one can always push lack of restraint to zero: one can always provide a when-then causal account of every action. But at the same time some situations are, on the face of it, less confined than others. Most situations, at least in many societies, leave some room for manouver, some room for action. For the existence of responsible persons, some such space is necessary. That's why, to most of us, for example, life in the military looks so unfree. We don't want some other person to tell us at every instant when to put a foot forward and when to stand still, which way to turn or when to stand at ease. But neither is a person just somebody left without instructions. In the heyday of the fad

for existentialism I heard about someone who stood at a street corner indefinitely because he could find no legitimate motive for going one way or the other. Indeed, Melville's *Bartleby the Scrivener* exemplifies perfectly the (vain) existentialist demand for total non-determination in human action. Not-being-pushed, by itself, produces nothing, death, not life.

But then, isn't the alternative just being pushed? Hobbes saw human life as a perpetual movement this way and that, pushed to apparent goods and away from apparent evils. As against that extreme, however, I hope we can see that even the acceptance of an apparent good as a good, an apparent evil as an evil, constitutes an action freely, and responsibly, performed. I find this good and that evil for some reason that I accept as binding on me. So we are back with Kantian autonomy and the positive concept of freedom with its awful dangers. Converts to cults, converts to totalitarian political creeds, freely give over their freedom to what appears to them an over-riding good. From my point of view, their goods are non-goods, at best utopian, at worst satanic. And in so rashly sacrificing themselves to unworthy causes, they lose the very freedom they had hoped to attain. I, on the contrary, claim to have chosen, and to chose, genuine goods, in the light of standards that would appear worthy of my commitment to them in any circumstances. But what's the difference? When I choose any apparent good as good, how do I know I am not doing the same as those fanatics whose causes I despise? I am back where I started—and I don't, alas, know the place better than the last time. I hope my maxim is universalizable, but there is no knowing for sure. As for the assertion of a knowledge claim, so for any action, responsibility is precarious. Being a person is precarious. I'm as sure as I am of anything that it's not just being a nervous system, or being a product of natural selection, or being a bunch of molecules. But what more it is both difficult to say and difficult to maintain.

One more afterthought, however. Perhaps I may make a little progress in the direction I have been suggesting if I go back after all, in conclusion, to one of the lessons I learned from the time I served with existentialism. Despite the difference in language, I was, I suppose, really concerned then with the question, what it is to be a person, a

center of actions and decisions. In particular, it was the concept of authenticity, however ill treated by Heidegger or Sartre, that I found instructive in this literature. Human freedom is not just a given, but something won or lost. Spinoza on human bondage and human freedom teaches the same lesson—again, in a very different language. But his vision, beatic though it is, or perhaps because it is, exceeds the grasp of most of us. Indeed, as I have remarked in passing earlier, his thorough determinism, his failure to acknowledge the place of contingency, and therefore of history, in our lives makes his enterprise, admirable though it be, a journey on which we cannot ourselves embark. To his contemporaries and successors he was a scandal because he left no room for a Creator; to us he appears a glorious but impossible dreamer because he leaves no room for curious chances. Yet the lesson that freedom is a rare blessing, which can be won but may be lost: that lesson is presented, even in his bad Latin, with infinitely more elegance and precision than any of our contemporaries has managed.

What is that lesson? It is a lesson learned quite ordinarily from experience, I should think, and better, perhaps from literature than from philosophy. It is a twofold lesson. People can be, and mostly are, made what they are by circumstance, by factors beyond themselves by which they are bent like Pascal's thinking reeds—even, perhaps, without too much thought. And some few, on the other hand, live their lives out of a center that is truly theirs. I noticed this when I was a student in Germany, in the early thirties, among a generation that had grown up through the deprivations of the first world war. They had been warped physically by early malnutrition and most of them had been shaped, or misshaped also, in their own persons, by the circumstances of war and loss and misery. But there were a very few who had somehow transcended that early disfigurement, who were in some extraordinary fashion *really* themselves. Of course there are limits to the conditions in which such self-attainment can occur. In the Holocaust and other cases of mass murder, it is not only the millionfold killings that horrify, but the cancelling of the very conditions for humanity. The victims of a Hitler or a Pol Pot are not only dead; they were torn away from the very possibility of living a human life. But short of such horrible extremes, within the middle range of circumstances—the kind of middle range Hume found to be a

necessary condition for the existence of justice or of society—in those 'ordinary' circumstances at least, I think it's fair to say, some few people somehow achieve a kind of integration in their lives, gathering of their lives into one, in a way that others fail to do. Such persons need not seem anything special; they need have no special professional or social status. But they just are different. Put in supernatural terms quite different from our way of thinking, the story of the tumbler of Our Lady tells of such a person. A lay brother in a monastery, illiterate and hence unable to copy manuscripts in Our Lady's honor, came secretly to the chapel every night and exercised his craft before her statue. Lo and behold, to the astonishment of a watching brother, she appeared to him rather than to any of her more learned, and seemingly more deserving, devotees.

Accounts of authenticity are often presented in terms of the contrast with its contrary: self-deception or bad faith. Apart from the classical passages in Sartre, there have been some nice descriptions of this condition in recent philosophical writing. But the best accounts come from literature, in our literature preeminently George Eliot's *Middlemarch* or Jane Austen's *Emma*. In *Middlemarch*, Rosamund Vincy, an empty-headed middle-class beauty, captivates a young physician named Lydgate, who marries her and sacrifices his scientific vocation to her demands for London life in the grand style. Rosamund Lydgate, grandly but sulkily riding in her carriage: there is self-deception personified. In contrast, serious, indeed solemn, Dorothea Brooke, though deceived into marrying the dry-as-dust scholar Casaubon, somehow nurses within herself the seeds of an authenticity that she finally achieves (despite the sentimentality of the final romance with her cousin Ladislaw).

But the contrast between these two conditions, it seems to me, had been even more strikingly presented by Jane Austen. To attempt an absurdly simple summary of the narrative for those who are not Janeites—though why one should be an English speaker and not admire Jane Austen I find it difficult to understand: her Emma, clever but spoiled younger daughter of a valetudinarian widowed father, has been playing at matchmaking on behalf of a boarding school girl of mysterious origin, laughing off the warnings of a respected neighbor and family friend, elder brother of her brother-in-law. When her

protegée ventures to cast her calf's eyes at the friend in question, Emma is suddenly enlightened: "It darted through her with the speed of an arrow", Austen writes, "that nobody must marry Mr. Knightley but herself." Her behavior so far, and the harm she has done the wretched Harriet, are revealed for the self-deceiving poses they were. It is a moment of self-revelation that philosophical exposition of the meaning of self-deception would find it difficult to match. There is no more to be said.

Or perhaps there is. At least, it must not be thought that authenticity means some sort of pure activity, unalloyed by any kind of passion or passivity. In *Wilhelm Meister* Goethe showed his hero seeing a center, a *Mittelpunkt,* out of which to live, and some such centeredness does seem to characterize the rare authentic person. Yet the center is not self-centered. Spinoza's free individual, after all, is marked by immersion in, existence through, the intellectual love of God. Such a person doesn't just choose—like Heidegger's student who said, "I am resolved, but I don't know to what." Such a person finds freedom in commitment, or devotion, to something greater than him(her)self, something one cannot help giving oneself to, because it is worthy the giving. This is my freedom, St. Augustine said, that I am subject to this truth. We need not accept his theistic reading to understand, or even to adopt, his slogan.

So in a way in the old days I *was* after all thinking about persons, though specially, I've admitted, about authenticity, a rather offbeat concept that was, however, central to philosophizing in that particular, existentialist, style. But what has authenticity to do with knowledge, or with persons as knowers, which was allegedly my chief preoccupation? Not much, I should think. Still, maybe even here there's a connection. The authentic individual, we noticed, is not, as Sartre would have it, a pure center of pure action with no moment of passivity. The person who lives out of a *Mittelpunkt* does so through *giving* him(her)self to something more than and beyond not only that center but him(her)self in general. The authentic individual is committed to some aim, some standard, some value that compels submission. And it is precisely commitment of that kind that characterizes the maker of an epistemic claim. Not that every honest claimant to knowledge in some particular thereby enters, in his(her) whole being, the sphere of

authentic existence as distinct from an inauthentic, or self-deceiving, mode. But perhaps one could reasonably maintain that the honest making of a knowledge claim does exemplify in a limited sphere the kind of commitment characteristic, more globally, of the authentic individual signalled out now and then, whether in life, in literature, or possibly in existentialist philosophy. Be that as it may, such commitment, expressed in claims to knowledge, is what Michael Polanyi was attempting to express in *Personal Knowledge.* (1958). I worked with him for eight years in the preparation of that book, and shared his work in part and peripherally for about ten years more. So all that time, in the intervals of other preoccupations, both personal and professional, I was indeed concerned to understand something about persons, and in particular about persons as knowers. The relation of persons as active knowers to the realities they seek to know is just what Polanyi was trying to elucidate. And in assisting him, I too was concerned with that problem. Some of my own efforts, also, come to think of it, dealt explicitly with the problem of the person, for example, my Davis research lecture 'People and Other Animals'.

Granted, however, this bit of excuse-giving may be itself a self-deceptive attempt to give to my almost random excursions in this or that direction more coherence than they had. I certainly cannot claim that my work for the last sixty-some years has had one integral direction. When I am asked what my specialty is in philosophy, I stammer and say, 'Oh, well, this and that.' I admitted earlier that while I was semi-, or better, about ninety percent detached from my profession, I did a lot of jobs I was asked to do because I thought that if I refused any offers with any professional respectability I would disappear altogether. But I think I also suffer from a tendency to run at this and that and fail to stick with it. Self-knowledge is difficult; I don't know. It's also boring; I don't much care. For the moment, at any rate, this is the best I can do at seeing, or saying, how the question, what it is to be a person, was involved in such work as I have been doing over the years, and decades. And if I have no well-worked-out answer, still, to that fundamental question, my thoughts of forty years ago about authenticity, as I called it then, "an existential virtue", may serve to indicate a direction, at least, in which one may search for an answer, or at least a reason why 'the' answer is so hard to find. This is far from a

'systematic' or 'substantive' conclusion. I can only hope that along the way to it—or back to where I started in my first chapter—I have shed a little light on some of the problems that have come my way, as a teacher of philosophy and as a somewhat reflective person fortunately placed in a society in which some opportunity for reflection has been permissible.

INDEX

activity, 47, 48, 64
Adickes, E., 33
affordance, 142, 143, 146, 147, 148, 149, 150
Ambrose, A., 52, 53
anthropology, 126
Aristotle, 12, 20, 22, 23, 26, 37, 55, 86, 91, 92, 96, 97, 118, 119, 129, 135, 140, 174, 176, 177
 common sense, 23, 24
Augustine, 176, 179, 183, 187
Austen, J., 186, 187
Austin, J.L., 55, 57, 58, 59
authenticity, 74, 77, 78, 174, 186-88
Ayer, A.J., 57

Baier, A., 174, 175, 176, 178
Beckner, M., 62
being-in-the-world, 14, 67-88, 145, 173, 174
belief; opinion, 10-23, 38, 40, 44, 57, 168, 169
 justified, 15-27
Benjamin, W., 36
Berg, L.S., 92
Bergson, H., 53, 92, 107
Berkeley, G., 50, 52, 60, 132, 133, 134, 136, 138, 149
Berlin, I., 182
Boethius, 20
Bouwsma, O.K., 54, 55
Brain, R., 130
Brandon, R., 102, 104
Broad, C.D., 53
Burnyeat, M., 22
Buss, L., 101

Carnap, R., 33, 91
Cartwright, N., 117
Cassirer, E., 157, 166
Cézanne, P., 174
Christman, J., 178
cognition. See knowledge
Coleridge, S., 50
common sense. See Aristotle
communication, 156
Comte, A., 30
consciousness, 13
contact with reality, 92, 126

contingency, 72, 89, 100, 102
Croce, B., 183

Dalcq, A., 92
Dalton, J., 10
Darwin, C., 89-112, 142, 153, 155, 159, 169, 170, 175
Darwin, E., 111
Darwin, F., 92
Dawkins, R., 141
Democritus, 95
Dennett, D., 142
Descartes, R., 10, 13, 14, 20-22, 35, 39, 42, 47, 49-52, 56, 57, 60, 67, 70, 71, 76, 79, 81-82, 84, 85, 114, 119, 131, 135, 136, 141, 149, 153-55, 158, 174, 182
Dewey, J., 54, 62
Dilthey, W., 63, 72, 78
Dobzhansky, T., 95, 102
Donagan, A., 176, 177
Dreyfus, H., 77, 130

Eddington, A., 119
Einstein, A., 19, 113
Eldredge, N., 105, 118, 153, 160
Eliot, G., 186
embodiment, 77, 82
Empedocles, 96
empiricism, 16, 21, 22, 36, 39, 41, 47-60, 63, 67, 81, 114, 116, 117, 123, 129, 182
environment, 17, 43, 64, 67, 77, 81, 83, 93, 108, 115, 135, 137, 139, 141, 143-45, 155, 159
epistemology, 15, 47
 evolutionary, 42, 107, 109
 naturalized, 109
Errington, F.K., 164, 165
Escher, M., 140
Euclid, 40
Evans-Pritchard, E., 168
evolution, 89-113, 131, 139, 141-42, 155, 171, 174
existentialism, 184, 187, 188

Fichte, J.G., 41, 59, 133
Fine, A., 113-23
Fisher, R.A., 104
Fodor, J., 142